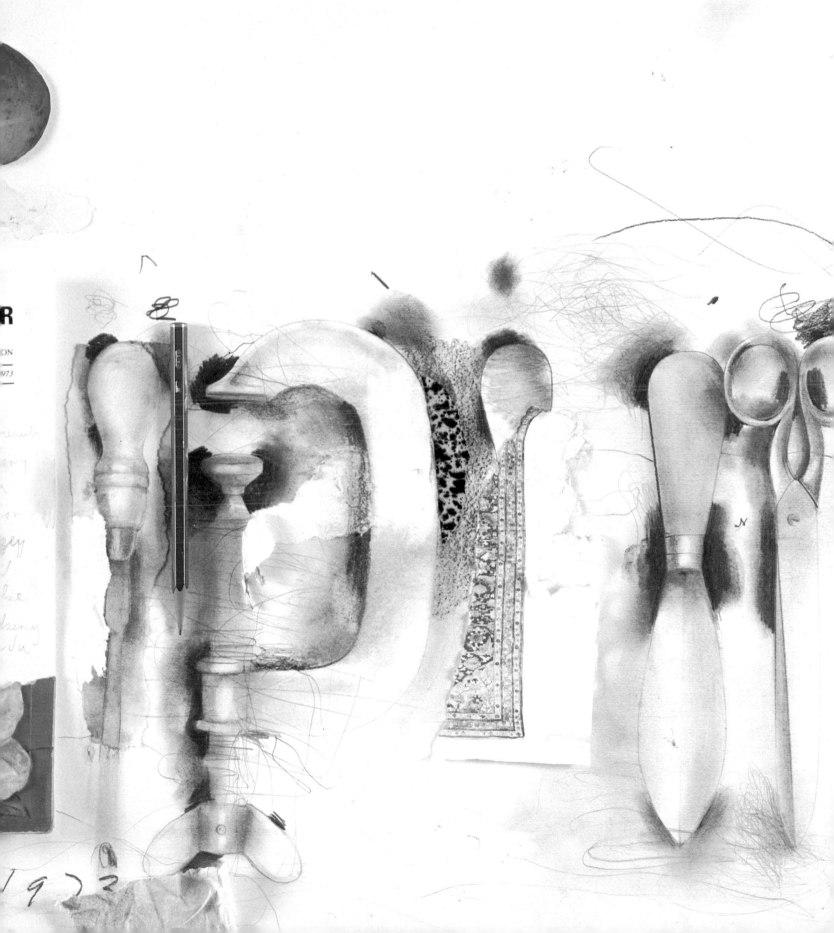

# JIM DINE
## DRAWINGS

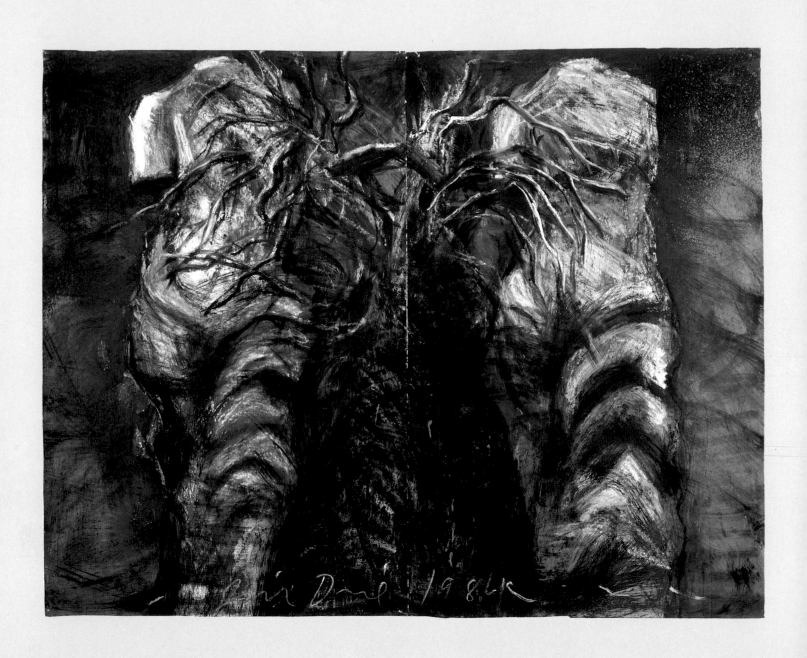

# JIM DINE
## DRAWINGS

BY
### CONSTANCE W. GLENN

PICTURE EDITOR
### CHRISTOPHER SWEET

## HARRY N. ABRAMS, INC.
### PUBLISHERS, NEW YORK

FOR JACK, LAURIE, CAROLINE, AND CHRISTOPHER

ENDPAPER
*Untitled* (detail). 1973.
Graphite and collage on paper,
23 x 30½". Collection the artist

FRONTISPIECE
1. *Two Venuses Rushing from a Tree.* 1984.
Mixed mediums on paper, 55 × 40⅛".
Courtesy Barbara Krakow Gallery, Boston

EDITOR: *Anne Yarowsky*
RESEARCH EDITOR: *Jamie G. Hoover*
DESIGNER: *Judith Michael*

LIBRARY OF CONGRESS CATALOGING IN PUBLICATION DATA

Glenn, Constance.
  Jim Dine drawings.

  Bibliography: p. 216
  Includes index.
  1. Dine, Jim, 1935-      . I. Dine, Jim, 1935-
II. Sweet, Christopher. III. Title.
NC139.D56G55 1985      741'.092'4      84-14617
ISBN 0-8109-0824-7

# CONTENTS

# ACKNOWLEDGMENTS

To Jamie G. Hoover, for her persistent and creative research; to Christopher Sweet, for invaluable assistance; to Arnold Glimcher and Judy Harney, of The Pace Gallery, for their immediate response to every request; to Blake Summers, Jeremiah Dine, and Nancy Dine for providing photographs; to my editor, Anne Yarowsky; and to my husband, Jack Glenn, who offered needed advice—along with encouraging words; to Nancy Dine, in addition, for her time and perceptions; and finally to Jim Dine for discussing drawing with me, intermittently, over the last six years, and trusting me to interpret his art and his intensity of feeling for what he does: thank you.

I am also grateful to the University Research Committee, California State University, Long Beach, for providing research assistance.        C.W.G.

# OBSERVATIONS

*...he hovers between apprehension and sublimation, between anxiety and euphoria, living his art and turning the hundred intimate details of his life and feeling into paintings and drawings and prints and sculpture.*

ALAN SOLOMON
(on Dine), 1967[1]

# DINE AND DRAWING

*...where the strangeness of the commonplace becomes noble and pervasive....*     JOHN LORING (on Dine), 1974[2]

No one of his generation has made a greater commitment to the art of drawing—or drawing as an art form—than Jim Dine. Over the years it has gradually become the *raison d'être* in all he does. In a definitive discussion of Dine and drawing it would be necessary to exclude little, if any, of his work. He draws on canvas (plate 3) and paper; on stones, plates, and printing blocks; in Plasticine and on ceramics (plate 131). The tools he uses vary from rollers, brooms, and sticks; streams of paint emitted from spray cans; grinders and sanders; gouging tools and broad brushes; to the more traditional mediums such as charcoal and silverpoint. Line, which he sees as a drawn line, is even at the heart of his sculpture. "Drawing is," as he says, "what I do."[3]

In Dine's time, and among his contemporaries, the functions of drawing have never been more diverse. Claes Oldenburg, whom Dine regards as a great draftsman, uses brilliant, witty sketches to envision ironic monuments. Jasper Johns explores and continually redefines an intentionally limited body of images in painterly drawings, which Dine notes have inspired him. Roy Lichtenstein creates stunning, often tiny, drawings, which in large part he regards as a means to an end rather than discrete

2. Jim Dine. Photograph by Nancy Dine

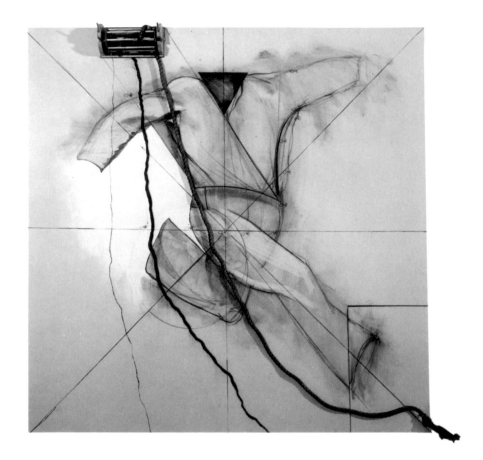

works. To articulate his prolific ideas, Robert Rauschenberg has adopted the camera as a "drawing" tool, but it was his *XXXIV Drawings for Dante's Inferno* that set a standard Dine has not forgotten. The list of his peers is long, their methodologies disparate, but no superior draftsman emerges. In an era when many accepted modes of expression are no longer tethered to the ability to draw, Dine is explicit when he says that, for him, drawing is not a process en route to something grander. "I don't make sketches and I don't make studies, for anything . . . I'm just unable to make notes, unless I make notes within the major statement. . . . I loathe little incidental drawings."[4]

Though Dine gained fame as one of the "young Turks" of the Pop Art era, audaciously appending literally everything, including his own clothing and hardware-store paraphernalia, to canvases rich with expressionist brushwork, creating Happenings that on one occasion careened to an end when he doused himself

3. *Running Self Portrait (L.L. Bean)*. 1964. Oil and charcoal on canvas with collage, 84 × 84". Private collection, London

with red paint, and devising junk sculpture from the ephemera of New York City streets, he missed the luxury of "just sitting, observing, and drawing." Today he feels totally obsessed with drawing. It is an obsession that has been growing since 1974, when, he recalls, "I specifically sat down to train myself. I went back to the figure, as it were." The six years he spent carefully observing and drawing the figure—from 1974 to 1980—have provided a new foundation for his work. "It goes into every-thing," he suggests. "Every drawing, every painting, is about those figure drawings, in that I've learned how to sense what is needed, to correct, and to love correcting. I'm interested in the drawing being a living object that is constantly changed by me—corrected and corrected."

Though it has taken many years to leave the world of Pop Art behind and to rid himself of identification with it, Dine now feels comfortable with the mining of his very substantial ability as a draftsman—an ability he once concealed with an execution that seemed "clumsy and inept because he [was cultivating] an ex-pressive awkwardness and a naïve vision."[5]

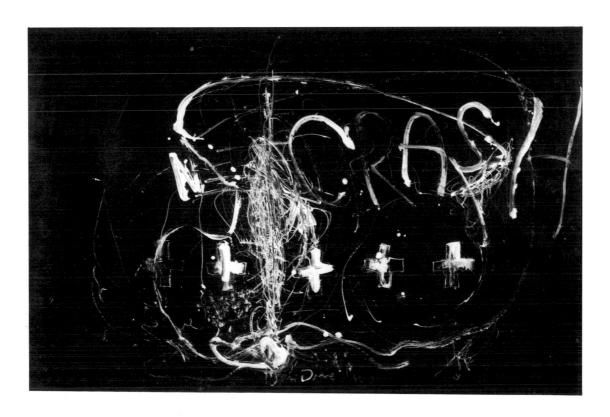

4. *Crash*. 1960. Oil on
paper, 23 × 37". Sonnabend
Gallery, New York

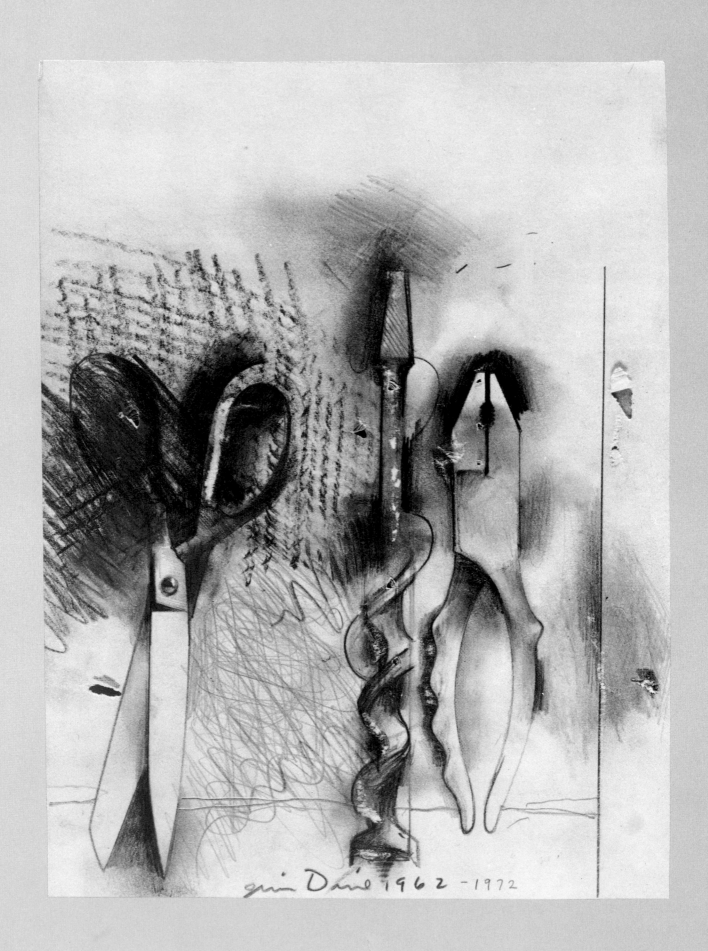

gui David 1962 - 1972

# TOOLS AND OTHER ICONS

*I presume that every family has a magic thing...that inflames and comforts and inspires from generation to generation.*

JOHN STEINBECK [6]

Much has been made of Jim Dine's childhood, due, perhaps, to the fact that in the early years he tried to explain his images to himself, and to the public, in the light of his background as he attempted to come to terms with it; perhaps also because his childhood environment offered to writers and critics a convenient explanation for his unconventional art. Pop Art images were thought to spring from both a personal repertoire and from a particular devotion to the accoutrements of popular culture. Therefore the tools that Dine adopted as friendly signifiers were seen as representing his grandfather's hardware store; the hearts were thought to represent his wife, Nancy. As late as 1970 Dine wrote:

From the time I was very small I found the display of tools in [my grandfather's] store very satisfying. . . . My father also had a store. He sold paint [house] and tools and plumbing supplies. From the age of nine 'til I was eighteen I worked in these stores. I was completely bored by the idea of selling but in my boredom I found that daydreaming amongst objects of affection was very nice.[7]

Tools continue to be objects of Dine's affection—not just comfortable remembrances of the warm place he found with his grandparents, when at the age of twelve he was uprooted by his mother's death and his father's remarriage—but familiar forms that release him to draw and paint.

The tools—and later, hearts, bathrobes, palettes, and paintbrushes—have customarily been referred to as icons; and among the various interpretations of the word icon—"to resemble," "a

5. *Untitled.* 1962, reworked 1972. Graphite on paper, 12⅞ × 9½". Collection the artist

pictorial representation," "a sacred image," "a sign that signifies by virtue of sharing common properties with what it represents," or "an object of uncritical devotion,"[8]—all are applicable, although the last is best allied with Dine's work. The objects of his affection *are* objects of uncritical painterly devotion. In 1962 Nicolas Calas wrote:

Jim Dine, the grandson of a hardware merchant, manipulates tools with a child's aggressive handling of toys. He spills color over his tools: vises are coated battle grey, axes streaked with surf green, knives stained cherry rouge, oil cans brightened by international orange, torches extinguished in a heavenly blue, shovels daubed an inexpensive black. . . . Jim Dine's understanding of tools is entirely personal. He is a sensitive and impassioned observer. His view, it would seem to me, is reconditioned by those hours of the night when sleep has been interrupted and the censoring of the unconscious has not yet asserted itself. He is a poet.[9]

Though Dine's handling of the tools and other long-held personal icons now displays greater skill and has become more distanced from his Abstract Expressionist heritage, the presentation has grown increasingly anthropomorphic. Even their scale can suggest human size. They stand like personages—with human attributes—in the middle of large pieces of handmade paper, worked and reworked until they seem to possess memory. In particular, Dine's 1974 exhibition of drawings at the Sonnabend Gallery in New York is remembered as celebrating tools: pitchforks, crosscut saws, hammers, awls, and screwdrivers stationed about like portraits of venerated ancestors. For that matter, Dine not only regards all of his images as autobiographical, he specifically regards tools as extensions of the human body, of the hand. Rather than ending his relationship with them as his childhood fascination recedes, he continually renews his acquaintance with these common yet mysterious utensils, haunting paint and hardware stores wherever he travels, finding not only new objects, but new industrial/commercial mediums that can be adapted to his aggressive working methods. Like that of a poet, which he is, or a musician, which his mother wanted him

to be, his art revolves around a spare number of melodies. The tools and icons he has used for years are the themes of his fugue—successively repeated, interwoven in the fabric of his work, providing structure for the expression he seeks.

In 1983 Dine recalled his initial encounter with tools as vehicles for art.

I used them because they felt right. They felt like relatives of mine, as though their last name was Dine. It was like coming upon a brother who had been separated from you at birth. They were absolutely mine—relations. I would always use them. I think if my grandfather hadn't been in the hardware business, I still would have found them. I still would have found these extensions of the hand. They harken back to the beginning of man, tool-making man, because of what they are.

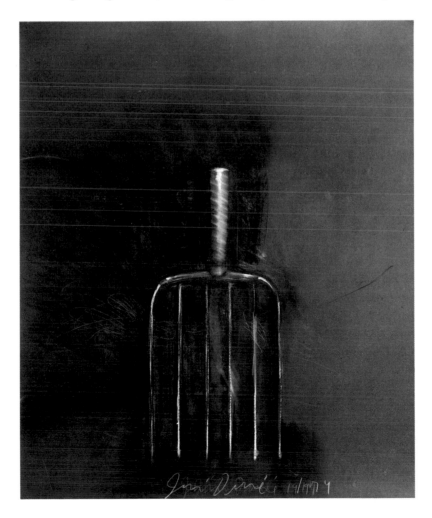

6. *Untitled*. 1974. Charcoal and pastel on paper, 35¾ × 30″. Collection Mr. and Mrs. Julius E. Davis

They are primarily objects that come out of what we do. Yes, they still fascinate me, though figure drawing took the mystery from them for me. I still do them in a way, but it's different now.

Dine's intentionally limited repertoire is composed of, chronologically, items of personal clothing (ties, shoes, coats); hand tools; bathroom images (the shower paintings and drawings, sinks, tumbler and toothbrush holders); what Dine refers to as "tools of the trade" (palettes, paintbrushes); hearts; bathrobes; self-portraits; portraits; figure drawings; still life and botanical subjects; drawings after artists; and the Crommelynck Gate. If there is a hierarchy, it is the figure drawings that have been most important to him in recent years. Rather than replace old themes, however, the figure drawings have given each of these themes new vigor and made it possible for him to attack such daring projects as the brilliant Van Gogh drawings of 1983. Often asked about his preferences for various images, which vacillate from year to year with the focus of his compulsive nervous energy, ultimately he will give the same answer with regard to each: "I use it because it makes it possible for me to be an abstract artist—to work more abstractly." Here he provides the key to understanding not only his drawings, but all of his art—which is not, in the end, about icons and images, though it is, by his own admission, figurative. "It is," he confesses with a combination of confidence and frustration, "about making something more meaningful—not absurdly more meaningful, but more meaningful to the viewer and to me as an art experience." In this context the drawings, risky and assertive, examples of virtuoso draftsmanship and technical innovation, are at the very heart of Dine's *oeuvre*.

# DRAWING AND PAINTING

*Artifacts mystically quickened with sentiment await their
reappearance in the imagination, a re-enactment and a
confirmation. Each time these tokens are handled they give
off sparks.*     WRIGHT MORRIS[10]

Many writers have attempted to come to grips with the particular
nature of drawing, to determine its place in the artist's *oeuvre*
throughout the centuries, and to separate modern and contempo-
rary drawings from those deemed more academic. In a catalogue
that accompanied a recent exhibition of contemporary draw-
ings—including two by Dine—the author drew, from a consen-
sus of opinion, a number of reasonable conclusions: "A drawing
is an experiment which opens further possibilities. A true draw-
ing is an intention of which the conclusion is uncertain. . . . The
complete work of art is the unfolding of a single thought which is
already contained in sketch or drawing."[11] One of the elements
that distinguishes Jim Dine's drawings is the lack of any of these
characteristics. His drawings are not sketches, not representa-
tions of the germination of an idea, not experiments (though of-
ten experimental), not uncertain in their conclusion. The most
elaborate differ from his paintings only in that they are works of
art on paper; while the delicate silverpoint portraits rival Ingres
in the definity of their statement. Because of what he thinks of as
the almost infinite "toughness" of paper—in the face of his ex-
tremely physical attack—he regards them as often much more
fully worked than his paintings on canvas, which he believes are
inherently more fragile and therefore restrained. Whether he is
making paintings on canvas, sculpture, or ceramics, he con-
sistently maintains, "My drawings are equal in effort and
importance."

For Dine, scale is no less critical—nor is it a limiting factor—
in drawings than in paintings. Today the drawings express the
"reach" of his arms. They are not confined to the size of a single
sheet of paper; Dine simply collages the sheets together or cre-

ates drawings comprised of as many as fifty-two individual pieces (see *Fifty-Two Drawings for Cy Twombly*, 1972; plate 43). This focus on scale—a scale he insists he needs—began with the figure drawings, which have a life-size presence and, in many cases, depict (on sheets of handmade paper that average forty-two by thirty inches) proportionally accurate sections of the torso. With the Van Gogh drawings the scale exceeds life-size and would predict larger drawings in the future if it were not for his habitual insistence that everything he does must be within reach of his hand and its extension by virtue of the drawing tool. In the seventy-six-foot painting *The Gate (Pershing Square)*, 1982, this same consideration determined the eight-and-one-half-foot height and the width of the individually worked segments that form the whole. He thinks of visually traversing the span of an unusually wide painting or drawing as analogous to browsing along a row of shops, savoring the visual experience the windows offer in their similarity or diversity.

If Dine's recent drawings cannot be differentiated from his paintings in intention, level of realization, or scale, does technique or medium set them aside? Charcoal and pastel are central to a majority of the drawings, but characterize the paintings as well; industrial products appear on paper and on canvas; both paintings and drawings are washed, obliterated, worked and reworked. The grinders and sanders he uses often rupture the canvas, while they only gouge the paper, throwing up richly textured burrs in their wake. On paper he feels free to use less traditional materials, aware of the potential cracking and peeling of industrial paints on canvas. His intensely vigorous methods of working result in an attack on the paper or canvas. "I like to try to harness [the] paper," he says. "That's part of the subject of the drawing."[12] It is in this "harnessing" that he vents his passion for expressionism—a passion he believes stems from the affinity he feels with a humanist European expressionism, rather than from his origins in American abstraction. In the end he is at a loss to explain where—for him—drawing ends and painting begins, except to say that the "careful observation" inherent in all his drawings is what makes his paintings possible.

# DRAWING AND PRINTMAKING

*...require of the artist the quality of naïvete and the sincere expression of his temperament, aided by every means...technique provides.* CHARLES BAUDELAIRE, 1846[13]

Jim Dine does not make paintings, *or* prints, *or* drawings, *or* sculpture. He works in all mediums simultaneously, readily admitting that drawing is a discipline, as well as a pleasure, which he uses to precipitate periods of frenetic energy. "Drawing," he says, "is like lifting weights to get ready for physical contact. I'm possessed most of the time. So possessed I'm a bit of a wreck, but I love that feeling. It's a double-edged thing. It makes me uncomfortable—even physically uncomfortable sometimes."

Dine has been making prints as an integral part of his art since 1958—the first published group of six lithographs created in concert with a Happening he devised called *Car Crash*. Since that time he has become a prolific, highly inventive—even eccentric—printmaker, unexpectedly mixing print mediums, drawing, watercolor, and collage. He has said, "My prints are

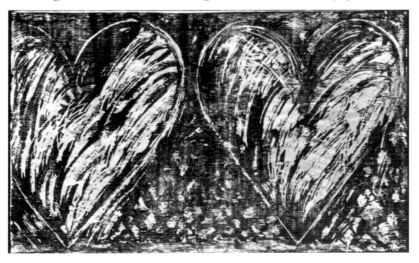

7. *Two Hearts in the Forest.* 1981. Lithograph and woodcut, 36 × 60″. Edition of twenty-four. Pace Editions, Inc., New York

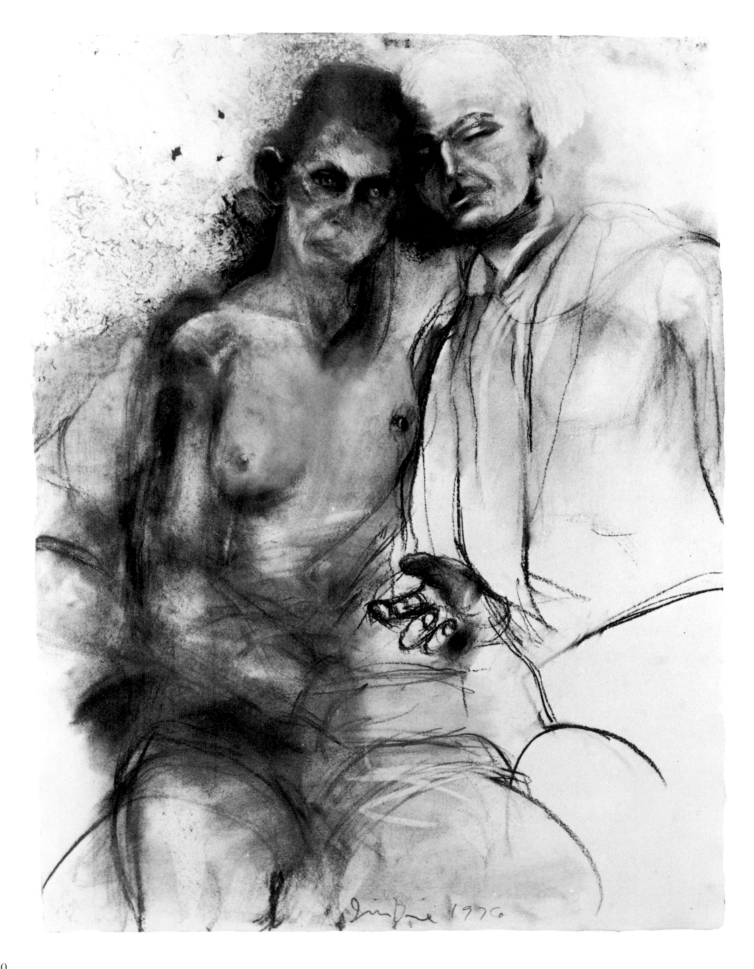

my drawings. It's just that I happen to be drawing with acid or on wood but they are still about drawing. Everything is about drawing."[14]

In addition to treating plates and stones as surfaces for drawing, he has recently begun to "draw" on woodblocks with a power tool that makes "precise accurate lines." One especially successful marriage of graphic processes, *Two Hearts in the Forest* (plate 7), is a color lithograph overprinted with a black woodblock that he printed the traditional way—rubbing it with a wooden spoon. Further mixing all the graphic processes irreverently, he often handcolors prints with crayons, watercolors, or pencils; combines etching with offset lithography, monotype, oil paint, or pastel; or photomechanically transfers drawings to

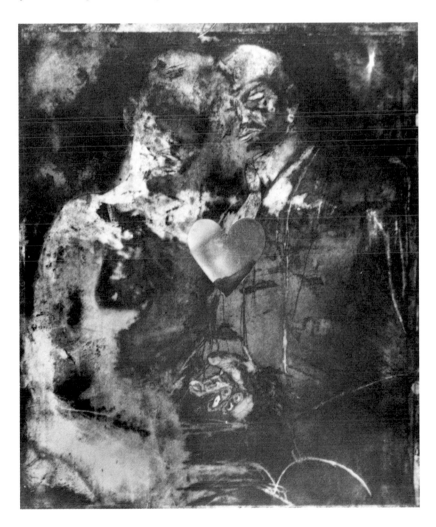

OPPOSITE
8. *2 People Linked by Pre-Verbal Feelings*. 1976. Charcoal, oil, and crayon on paper, 39¾ × 29¾". Private collection

9. *Two Figures Linked by Pre-Verbal Feelings*. 1976. Etching with drypoint and handcoloring in watercolor. Edition of thirty. Pyramid Arts, Ltd., Tampa, Florida

printing plates and then reworks them by hand as in *Two Figures Linked by Pre-Verbal Feelings* (1976; plate 9).

Expressing a fondness for building on a single idea, Dine makes paintings, drawings, and prints in series (see plate 85). In the case of drawings, he lines his studio walls with large sheets of paper, moving from one image to another at will, bringing the works to fruition simultaneously. Similarly, paintings emerge in naturally ordered groups—variations on a single theme. Printmaking offers Dine the opportunity to create serial images linked either by a common conception, as in *Eight Sheets from an Undefined Novel* (1976; plate 10), or by the sequential alteration and printing of a single plate. The manner in which Dine reworks plates, producing new "tracks" over old, does not differ essentially from the way he reworks drawings—partially obliterating and reconstituting certain passages, whole surfaces.

Prints prompt drawings and drawings become prints. There is seemingly no end to the possible variations, but more often than not his images exist in both formats. On the one hand there are almost literal translations; on the other, each work is distinguished by the particular characteristics of the medium. The characters depicted in the *Eight Sheets from an Undefined Novel* come to life in soft ground etchings pulled from steel-faced copper roofing plates, but they are also the subjects of "elaborate preparatory drawings" in charcoal and pastel. These drawings and handcolored etchings differ not only in scale (the prints are smaller than the drawings) and in orientation (in creating photos of the drawings and transferring them by hand to the plates, the images were reversed), they co-exist without being dully repetitive because each amplifies the other, each stands alone. Dine explains that in the process his goal is to be able to "speak as plainly as I can through etching or through drawing."[15]

The title *Eight Sheets from an Undefined Novel* offers one more clue to what propels Jim Dine the printmaker/draftsman. His love of literature has suggested the creation of prose and poetry, and illustrations for his own and other texts. The illustrations range from recent woodcuts for his *livre d'artiste, Apocalypse: The Revelation of Saint John the Divine*, to drawings for

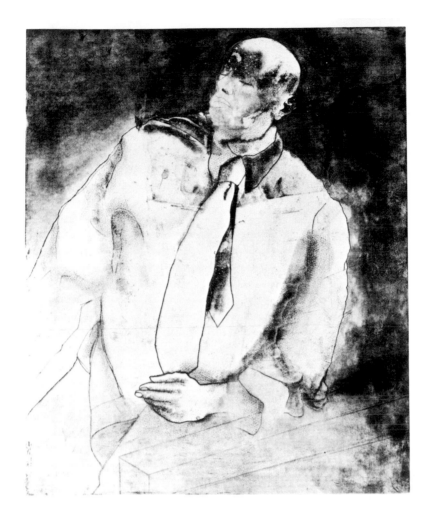

*Welcome Home Lovebirds*, his own poetry. Like the characters in the undefined novel, many of his illustrations predictably lead a double life as both prints and drawings. For example, his working script for the stage presentation of Oscar Wilde's *The Picture of Dorian Gray* was published in 1968 in three editions (one with lithographs, one with etchings, and one with both lithographs and etchings), while a series of gouaches is devoted to the same theme (plate 35). But for all the similarities, make no mistake: "Prints look different than drawings," says Dine. "Look at the drawing and print of the *Russian Poetess*.... The prints have qualities that are totally unique. I love to make prints.... It's not that I necessarily want a more democratic art for all the people, it's just that I like printmaking."[16]

10. *Cher Maître* from *Eight Sheets from an Undefined Novel*. 1976. Etching, 42 × 30″. Pyramid Arts, Ltd., Tampa, Florida

# ON METHODOLOGY

*I do a picture—then I destroy it. . . . In each destroying of a beautiful discovery, the artist does not really suppress it, but rather transforms it . . . makes it more substantial.*     PABLO PICASSO[17]

With the exception of those rare occasions when Jim Dine confines himself to making silverpoint drawings, his works—in any medium—reveal the physicality of his approach. He draws or paints with his entire body: the broad sweep of his gestures apparent in the arcing shapes of the grinder tracks; the great splashes of industrial "whiteout" he uses to create new surfaces over the old acting as foils for the generously drawn and redrawn charcoal lines that describe a figure, a tree, a bathrobe. He repeatedly says, "I need to work that way," and does not reject the suggestion that the habit—compulsion—may hark back to the bravado that was so typical of his grandfather's attempts at carpentry.

In the course of Dine's heightened momentum of activity, as a single work or series of works progresses, the result is layer after layer of drawing. The layers contain what he refers to as the "history" of his involvement. The involvement ends, or the drawing is finished, when his attention is exhausted, when no further avenues for alteration present themselves, when boredom sets in.

The rhythm of involvement, crescendo, conclusion is not confined to single drawings. It emerges in clearly discernible sequences in series of works circumscribed by particular time frames and places.[18] The figure drawings, for example, can be roughly divided into four groups: the 1975–77 Vermont drawings shown at the Waddington and Pace galleries in 1977 (see plates 11, 12, 61, 65–74, 76–80); the 1978–79 drawings for California State University, Long Beach (see plates 96–99); the 1978–79 works created in New York for the Galerie Claude Bernard exhibition (see plates 101–104, 107–121); and the 1982 *Jessie with a Shell* series (see plates 141–143).

The first group begins with understated charcoal renderings (*The Nurse*, 1975; plate 66), intensifies in luminous drawings such as *A Blue Nude*, 1975, or *The Red Glove* (1975–76; plate 11), and reaches a visible climax with *Model on the Gloucester Road* (1976–77; plate 12)—its embattled surface scrubbed, torn, and the charcoal so dense its contrasts leap from the paper. The full-blown Long Beach works are an extension of the Vermont drawings, but their progression slowly focuses on refining and subtly balancing figure/ground relationships *(Turquoise Chalk on Jessie's Face*, 1978; plate 96)—the apogee of this engrossment attained in *Mauve Figure* (1978; plate 13).

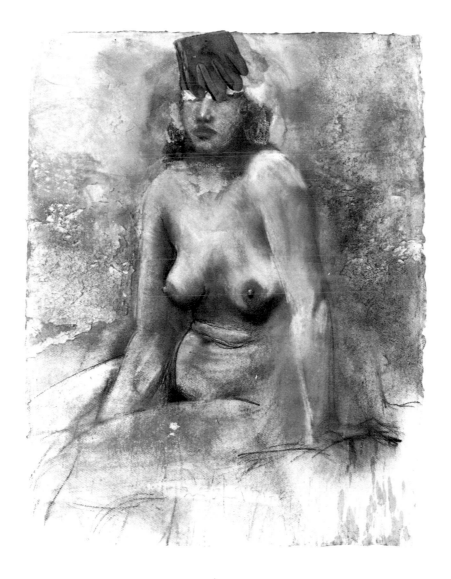

11. *The Red Glove*. 1975–76. Charcoal, oil, and crayon on paper, 39½ × 30″. Collection Dr. and Mrs. Paul Sternberg, Glencoe, Illinois

OVERLEAF
12. *Model on the Gloucester Road*. 1976–77. Charcoal and pastel on paper, 42 × 36″. Private collection

13. *Mauve Figure*. 1978. Charcoal, oil, and crayon on paper, 45½ × 31¾″. The Arkansas Arts Center Foundation

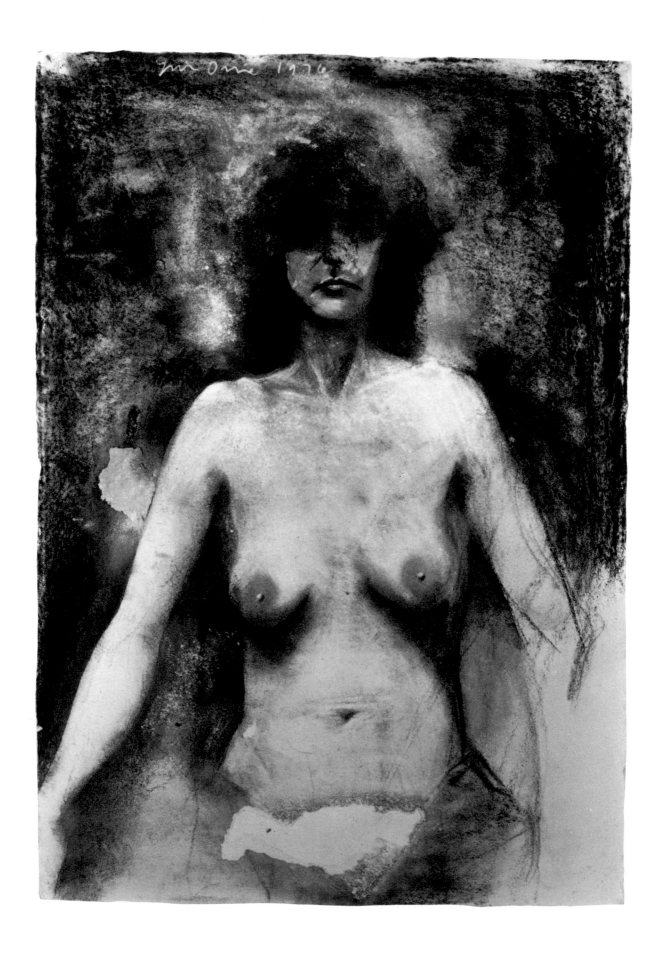

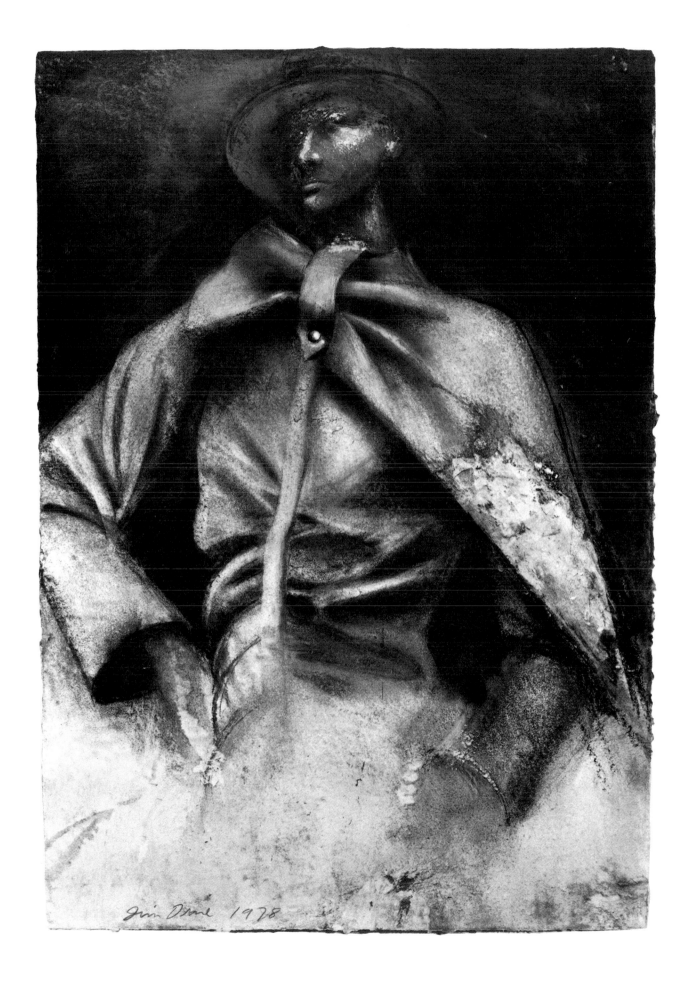

Jim Dine 1978

In the subsequent 1978–79 Claude Bernard series, Dine returns to beautifully explicit portrait/figure drawings—only to follow with mixed-media drawings developed to a point of such density that the figures barely emerge from the frenzied surfaces (the *Jessie with a Shell* works). Once again at the baroque end of Dine's spectrum, these Jessie drawings—though they could not be confused with the most complex of the 1977 works—signal the climax/conclusion of a particular cycle.

The same pattern flows through sub-series of gate drawings (see plate 15). The drawings begin with (for Dine) great economy of means *(Fragment of the Gate*, 1981; plate 134), finally reaching a period where the use of layered surfaces, collage, and heated colors peaks in impassioned passages *(Study for The Crommelynck Gate with Tools [Hobby Horse]*, 1983; plate 148), foretelling the introduction of a new subject, new direction, or the return to delicately worked black and white charcoal drawings.

In layering the mediums and images, collage frequently becomes an essential element. Whether he includes commercially printed photographs of vegetables, collages pieces of drawing paper together to simulate "kimono" shapes *(The Tree [Kimono]*, 1980; plate 128), or covers a figure's face with an incongruous

14. The Crommelynck Gate, Paris. Photograph by Nancy Dine

OPPOSITE
15. *Study for The Crommelynck Gate with Tools (The Black Shoe).* 1983. Mixed mediums on paper, 70½ × 89″. Courtesy The Pace Gallery, New York

red glove, the intent is not to flaunt his unconventional means, but to emphasize the unexpected, to challenge expectations about the nature of drawing.

If Dine completes a passage he feels is good—captures the likeness or attitude he has sought—in all likelihood he will rub it out and begin again, believing that if it was good the first time it will be better the second. He finds great satisfaction in proving to himself that anything done well once can not only be repeated, it can be improved. This process, in his mind, is a "struggle," and in this context he expresses his admiration for

Giacometti—for the artist's unlimited patience with the "struggle to get it right."

Dine's ongoing struggle imparts distinct visual characteristics to the work—especially to the most densely packed drawings. These drawings have roughly abraded surfaces—chiseled and burnished; while the niceties of academic drawing (which are sometimes mistakenly equated with *good* drawing) disappear in a haze that implies a kind of movement or passage of time, not unlike that depicted in Thomas Eakins' photographic motion studies.

Photography, in fact, plays seldom noticed roles in Jim Dine's methodology. Beyond using collaged photographs, he draws regularly from newspaper and magazine images—the most noted example being his adaptation (for a self-portrait) of a robe advertisement from *The New York Times*. Fashion illustration provides models for figure drawings (see plate 127). He photographs his own works in order to transpose them into new images in new mediums. He has even collaborated with his friend the photographer Lee Friedlander in the creation of a *livre d'artiste*.[19]

Anything for Dine is, as he says, "grist for the mill." Drawing from the model and from photographs; drawing still life objects (many with *vanitas* associations) he keeps in the studio, or gates in the garden of his Paris printer; creating responses to nineteenth-century botanical prints; drawing from sculpture in the Louvre or The Metropolitan Museum of Art; making portraits of friends, of his wife, Nancy, of himself; tracing the outlines of an endless assortment of tools and imbuing them with "hairy," "sexy," quirky personalities: all provide inspiration. Sources are at once respected and brutalized in the transformation his vision requires.

# CONVERSATIONS

*Art interests me very
much, but truth interests
me infinitely more.*

ALBERTO GIACOMETTI[20]

# JANUARY 1983: THE EARLY YEARS

DINE: In art school, in college, I was not aware of draftsmanship. I wasn't even aware that I was a draftsman or had the aptitude. I was trying to paint. But toward the end of my stay in school, a man called Fred Leach became the head of the School of Fine Arts at Ohio University. He was interested in so-called master drawings and spoke about them—about Goya, about Ingres, things like that. I started to look very earnestly and tried to draw, but not to imitate them. I suddenly got involved with draftsmanship, and I made some very accomplished self-portraits—two or three. But the rest wasn't very good. There are some drawings of Nancy from that time that are just terrible. They weren't well observed. I was too interested in making the piece rather than observing. I believe that, for myself, I must observe closely to train myself. For instance, the reason I now feel obsessed with drawing—among other things—is that I am *able* to be obsessed with it. I just don't have to think about it anymore. I have a lot of knowledge stored up. But, at any rate, that's when I started to think about drawing a lot. Then in New York I never really sat down and drew specifically to train myself until 1974, when I went back to the figure, as it were. I was always involved to a point but I was just making drawings, like harvesting radishes, at the end of the fifties and in the early sixties. William Lieberman came from The Museum of Modern Art to buy some, and I was totally shocked—totally shocked that he even cared. With everything I was doing I was always making a big group of drawings. There were bathroom drawings with real screws in the toothbrush and tumbler holder (plates 25–26).
GLENN: And those were concurrent with the three-dimensional bathroom paintings?
DINE: That's right. I used real screws in those drawings. Then I started to make drawings of palettes (plates 32–34).

GLENN: What was your order of priorities at the time?

DINE: You mean versus painting?

GLENN: Well, at the time you were doing Happenings, you were painting, you were making prints, and you were drawing. Was one more important to you than the others? What were your goals or priorities in the late fifties and early sixties?

DINE: I was always drawing. I never thought about what my goal was. The kind of person I am in other fields would be called obsessive. But, also, I believe I'm put here to draw and paint— because it's all I can do. It's the only thing that gives me pleasure. I don't take vacations. For me it is a vacation every time I go to my studio. It's a total pleasure. If there's pain at all, my pain is in real life, it's certainly not in drawing and painting. I'm positive I can make things work.

GLENN: You haven't always had that kind of confidence.

DINE: I've had the confidence always, whether I knew it or not, that I could make something work. Through the years I have taken people's advice. Years ago Ileana Sonnabend was awfully nice when she said, "You can do what you want to do." I would say I was destroying things and she'd say, "You're crazy to destroy those things. They're awfully fine." I've never been satisfied though, never. I'm not satisfied with the end product, and until it's taken away I keep on messing with it, correcting it. I really appreciate those stories of Bonnard sneaking into museums with oil paint because I would like to do that all the time. As I change and grow, I think I get better. There are things I could fix.

GLENN: But then they would be different works of art.

DINE: Yes, I know that, but while I'm still alive I'd like to improve them.

GLENN: Why do you now want to leave behind a different body of work? Why not allow progressive development?

DINE: Because I'm not interested in teaching about myself. I'm interested in leaving the best possible thing.

GLENN: When did you become more comfortable with your ability to achieve what you wanted to achieve?

DINE: In the early 1980s. It was then I realized how the experi-

ence of those six years of solid drawing had given me a foundation. It goes into everything I do now, every painting is about those figure drawings. I would love to be able to make drawings like Matisse, with a single line, but it doesn't really interest me. I'm more interested in the drawing being the living object.

GLENN: Do you want other people to see your working processes, the constant changes?

DINE: Yes, like Giacometti—not in his drawings so much as in the sculpture, in the way it was corrected and corrected. That's about drawing too. That really *is* about drawing. He gave himself a rather simple task in terms of imagery, so that the work could be constantly corrected.

GLENN: Haven't you done the same thing, at least to a certain extent, even though you've been expanding the body of images more rapidly in the past ten years?

DINE: Yes. That's because I was limiting myself. I didn't know how far I could go. I think that I went into high gear because of my experience of rigorous observation in drawing. There is almost two years' work—mostly figures—that has never been shown. It is not necessarily inventive but certainly sometimes pretty good.

GLENN: Then your *oeuvre* contains two distinct bodies of drawing—the drawings that simply accompany your other work, and the drawings precipitated by the figure drawing period? Where do you draw the line in your own mind and say, "These are the mature drawings"?

DINE: The best I ever got was just before I started to make figure drawings. It was the period of the big tool drawings that The Museum of Modern Art owns (plates 44–50). If I'd ended there I would have been quite proud of myself—really proud of myself. On the other hand, once I started to draw the figure I realized that up to then I'd been dealing with a much easier problem. Just drawing living flesh and observing and reinventing the figure is more difficult and a bigger task than dealing with specific objects that you know about—a hammer and a saw. The tools were drawn very dumb, you know, deadpan, in the sense they were straight up and down. There was no illusion of space. I would

trace them to get the exact shape, and then I elaborated on them by looking at them. But you can elaborate and look at a hammer all you like and it's not the same thing as a hand. It just isn't. Everybody's hand is different, for instance, and everyone's hand changes each minute.

GLENN: If the first drawings you made were portraits of you and Nancy, self-portraits and drawings of Nancy, what was the next body of imagery? Was it tools?

DINE: No. During the summers of 1958 and 1959, both of which I spent in Kentucky at my uncle's cabin, I made about a hundred head drawings that I invented, but that was after I had a year in New York, or I'd been living in Long Island and coming to New York. They were like expressionist heads, not from anybody, just heads (plates 19–20, 22).

GLENN: You had not started to draw tools then?

DINE: No. The heads were in progress when I first met Claes Oldenburg. They are from the Judson Gallery time. There I had a chance, whether I knew it or not, to be with the man who was potentially the greatest draftsman of the century, Oldenburg.[21]

GLENN: Was what you drew influenced by what he was drawing?

DINE: No. I didn't have that kind of skill. I was naïve, both in my hand and emotionally. But of course he was six years older.

GLENN: What did you draw after the summers in Kentucky?

DINE: I'm not sure that I drew as much as I painted. I made big constructions. I started to draw *really* all the time with the ties (plates 23–24).

GLENN: About 1960?

DINE: Yes. I started drawing all the time.

GLENN: Why did you use the ties?

DINE: Why did I use them? It was the time of primary objects and glorifying that sort of thing. It was an idea I had and I loved—I probably saw them on Rauschenberg's paintings, too.

GLENN: Were you also aware of Johns' drawings?

DINE: They were beautiful. They influenced me as a serious kind of drawing of surface. The drawings were not emotional for me, but they were mysterious, and I liked them—I learned from

them. I learned about the surface and the kind of frottage technique he used. Later Twombly probably meant more to me. I saw a show of his at Leo's [Leo Castelli Gallery] in about 1971. It consisted of a whole series of little drawings in ball-point pen, which went around the room. I said to Nancy, "Let's get out of here. I'm going back to Vermont to work." And that's when I made *Fifty-Two Drawings for Cy Twombly* (1972; plate 43). It took me about a year, but that's what inspired me.

GLENN: Going back again to 1960, were the ties the first so-called Pop Art images?

DINE: Yes, and then bathroom images. The toothbrush and tumbler images.[22]

GLENN: Where did the bathroom images come from?

DINE: From the paintings. It was the same thing as the tools. I was making a show of tools and tool drawings then too (plates 27–29).

GLENN: This was the period when people talked about using the refuse of the city to make art. Was it an idea that really interested you—in the Happenings or in the drawings and paintings?

DINE: It was the natural thing to do. It was the coming upon the city as a collage.

GLENN: Is that what the Happenings were about?

DINE: No, the Happenings were about trying to become famous. We were having fun; we were still children.

GLENN: What was the next major image after the tools and the ties?

DINE: The next image was palettes.

GLENN: Because they were in the paintings?

DINE: Because they were in the studio.

GLENN: So all the imagery in the drawings at this point was basically derived from things you used?

DINE: Yes, tools of the trade. Then the bathrobe (plates 30–31) came because I wanted to make a self-portrait, and I found this thing in *The New York Times*, and it looked like I was in it. That *is* fact. I did a little drawing over it. I've always looked at photographs. I just have to look at everything. I also go through long periods of looking at paintings, and then I just don't. I haven't

been to a museum in years because I haven't had the opportunity; I just don't need it right now. I don't go out of my way to go to a museum when I go to Europe for instance. But on and off I go, and look, and go crazy from seeing paintings. I love looking at paintings.

GLENN: Do you think you concentrate on particular works of art in relationship to where you are in your own work?

DINE: Yes.

GLENN: You look at Giacometti at one point in time, and Van Gogh at another?

DINE: Absolutely. They are always with me. I'm very, very sure about my roots, my sources. I'm very sure that I come from a long line of people, of draftsmen, as it were. I'm respectful of art history, but I'm not interested in being erudite. I just want to see paintings.

GLENN: When you began to look beyond drawing ephemera from your studio, what kind of drawing were you interested in other than that by friends such as Oldenburg?

DINE: Well, I looked a long time at Ingres, really a long time. I couldn't believe it. I still can't sometimes. Not that I even like it all the time, it's just amazing—technically amazing. The observation, the distortion, is so weird much of the time. It's like collage. At times Rembrandt thrilled me, not always, but thrilled me. Not until I really got into printmaking and learned about etching was I able to look at Rembrandt all the time. And Leonardo—the Leonardo notebooks. I came to them through Rauschenberg, in that Rauschenberg's *Dante* looks to me as if it comes from the Leonardo notebooks. I didn't think I'd ever be able to do anything like that. And Van Gogh—but I didn't ever really understand Van Gogh until the mid-seventies. I had a book as a kid, as an art student—the Paul Sachs book *Modern Prints and Drawings*—that influenced me a lot. I bought it when I was eighteen years old. I still have it. I found it in a bookstore in Ohio and have always kept it with me. I've had it rebound since. I like almost everything in the book. I like the Redon, and Maurice Stern, and Ingres, Van Gogh, everything. I liked all the Expressionist woodcuts—Munch, Kirchner, and Nolde, and Max Beckmann's self-portrait. There just was nothing bad in the

book as far as I was concerned. As I look at it, I still get just as much pleasure from it.[23]

GLENN: With the exception of Ingres, you were more drawn to expressionist drawings?

DINE: As is my wont, I'm drawn to expressiveness.

GLENN: You've referred to yourself as a Northern European expressionist. What is your European background?

DINE: It is actually Eastern European—Poland and Russia. My grandfather Morris Cohen came from a town in Poland called Lodz. He actually lived outside on a little farm. My great-grandfather was a miller there, and he had five boys.

GLENN: When did your grandfather leave Poland?

DINE: He left when he was eighteen, before the turn of the century. He went to New York first. The five brothers had a cousin there who indentured them. They had to pay him back for years. My grandfather went around fixing fences with a blow torch—cast-iron fences. Then he went to Cincinnati and worked for the milling machine company in town. He lost the end of one finger in a machine. All the grandchildren played with it because the nail was ground so that it came out the top like a kernel of corn. He had these huge hands, and no nail, but then right at the end of his finger it grew like a pencil lead. It was really weird, but for us little kids it was a mysterious object—this strange little phallus tickling you, you know, all the time. He was a great guy.

GLENN: Did he have many children?

DINE: Two. My mother and my uncle. I was twelve when my mother died, and I left home. Then I went to live with my grandparents because I had no place else to go. That's when I became an artist, I just did what I wanted to do. My mother had been quite artistic. She painted a lot. But the fact is that I was always drawing, all of the time.

GLENN: To please your mother?

DINE: No, to please myself, and certainly the teachers in school, too. That's how I got through school until the seventh grade—by drawing—because I just couldn't concentrate. I'm dyslexic, and I couldn't read, but for me drawing was always a celebration. My mother also pushed me to play the piano, too, but I couldn't do it. She pushed me in a lot of ways, but the only

thing that took was the painting, and there I didn't need any pushing. I think I would always have been an artist. What else could I be? It's the only thing I can do. It's the only thing I care about. Whatever problems I have today come from my childhood, certainly not from my contemporary life. It's taken many years of analysis and old age to understand it, and I'm never going to be free of it totally. On the other hand it is my source material, and I'm an artist because of it—in spite of it—and that's all I care about.

GLENN: Are there other people in your life who have been important to you as an artist?

DINE: Oh, my grandpa. He was a very crude man whom everyone thought was exceptional—because he *was* exceptional. He thought he could do anything. He probably could do anything. The lesson was there. It was clear. You work hard, and you force the issue, and you can do it. If you want it, you make it. You make it yourself. He built everything. He built it in this really junky way because he didn't know what he was doing half the time. It wasn't fine carpentry. But he was always there, always available.

GLENN: He worked with his hands—which you do?

DINE: He worked with his hands, exactly. He had a store, but he worked with his hands. He left the intellectual part of the business to other people, to his son, to his brothers. He wanted to be out on the street all the time, tossing things, loading trucks, or fighting with people in the street.

GLENN: He was a highly physical person.

DINE: Yes, very.

GLENN: Did he think that what you did with your hands, unlike what he did with his hands, was very strange?

DINE: No, no. Actually, when he died in 1954 I was painting—at the time—in the basement, but he wasn't able to get down to the basement.

GLENN: You were in college?

DINE: Yes.

GLENN: He sounds like someone whose approval you didn't have to seek.

DINE: Absolutely. No problem with my grandfather or my grandma. She was lovely. Thank God for her.

GLENN: She lived to see your success as an artist?

DINE: Yes. She was really proud of it.

GLENN: Where did you meet Nancy?[24]

16. *Nancy in a Big Sweater.*
1979. Graphite and charcoal
on paper, 50 × 32¾″.
Collection the artist

DINE: In college.

GLENN: And she has been your most important source of support since then?

DINE: Yes. She's supportive and she's my model, which is important. For twenty-six years now she has been my model. Nancy—it's her eyes that I trust. All these years she's grown with me and understands the work. I trust what she has to say as a critic, although she doesn't ever say anything unless I ask. But I ask frequently. She is my other set of eyes, so she's totally invaluable to me as an artist.

GLENN: Is it legend that the hearts represent Nancy?

DINE: That's just journalism. The hearts represent what they are. They're hearts (plates 35–39). Because of what they are, they are easily related to her, but they didn't begin that way. They just began as another object I was interested in. It's something intimate, anthropomorphic, and physical. I'm a figurative artist, and that's what it's about.

GLENN: How early would you have said that?

DINE: Well, not so early. It wasn't so simple to say. I wasn't even aware of it until recently.

GLENN: Is that, in part, because figurative art was not the art of the time?

DINE: Right, we thought it wasn't modern. If you were a figurative artist, it was like being Raphael.

GLENN: And is it essentially true that most of your generation aspired to a De Kooningesque existence?

DINE: I can't speak about others but I certainly did. I would still aspire to such a life in art.

GLENN: De Kooning is, in one sense, a figurative artist. You just didn't want to say that at that time?

DINE: Right, he was called an Abstract Expressionist. He's a romantic figure, and he's a European who Americanized himself. He became the extension of Gorky's hand—in a way—and all of the things that Gorky taught about Picasso.

GLENN: De Kooning represented a genre to which you aspired—a figurative expressionist genre that derived from Gorky?

DINE: Well, it came out of Europe—out of Picasso.

# FEBRUARY 1983: THE VAN GOGH DRAWINGS

GLENN: Recently you have turned for inspiration to a series of drawings by Vincent van Gogh (plates 149–153), and in discussing them you used the word traditional. Are these traditional drawings?[25]

DINE: No, I don't think they are traditional drawings at all. In fact, if they were on canvas, you would call them paintings. Once, as paintings, I would have built them up more physically, used more layers. But in another way, these have a million layers. Also, this is the foremost example of my use of a certain tool to erase and to draw with—a power tool, a car grinder, a rotary grinder that you put sanding disks on. I use it to erase, but I also use it to bring white to black areas. In the Van Gogh drawings, the stroke it makes is very reminiscent, in a mechanical way, of his swirling strokes.

GLENN: You also used the grinder on the Jessie drawings?

DINE: Yes. Now I use it more than ever. I've gone through two grinders on these drawings. I burned out the motor I was going so

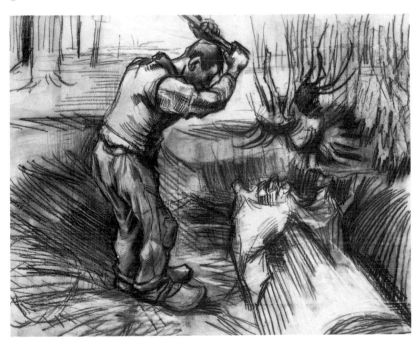

17. Vincent van Gogh.
*Peasant, Chopping Wood.*
Black chalk on paper,
17⅜ × 21⅝". Rijksmuseum
Vincent van Gogh,
Amsterdam

hard. I never sweated in drawing before. These drawings are truly action drawings. I've been so intense trying to get them done in this short period of time. They seemed to take forever because they are—the subject is—so complicated for me. I feel, I don't think unreasonably, a tremendous responsibility and fear. I always feel a tremendous responsibility to make something work. It's the most difficult thing you can do, to put yourself up against Van Gogh. I have this facility. It's all up to me. It comes out of *Grimm's Fairy Tales*, and it's the Midas touch. I love the magic. I mean, not absurdly, my life is based on *Grimm's Fairy Tales* in a way that I never thought of before—in that I'm influenced by childish and childhood superstition and myths. And I find it thrilling to go against a grain. *Literally* to make a silk purse out of a sow's ear—that is my point in life in a certain way.

GLENN: Then these are very risky drawings?

DINE: Risky in that way. But I also think they're risky as drawings. There is always the possibility of failure. They are somewhere between abstraction and realism—fragmented abstraction from the figure. I tried to invent the figure—reinvent the figure through Van Gogh, using Van Gogh as a still life. But you can't say it's like using an anonymous cup and saucer, you just can't. Van Gogh's drawings are so charged—charged with everything. Also you realize how deeply disturbed he was when you draw from his work because there are distortions that could have come only from an eye that wasn't seeing properly. I do feel like I'm in control, that if I only sit with them and take certain chances, I can do it. With most of them I would make the drawing, and then I would throw ink and paint at it, obliterate it with the sander, and go back and do the same drawing again, over and over. The process was succeeding and then destroying and leaving the pentimento of destruction. I love the pentimento, I love the memory, I love the tracks, showing my tracks, but I also like the power of control.

GLENN: At what point in the succeed-and-destroy cycle do you quit?

DINE: Before the paper is totally gone physically. I think that it is important for the paper to remain if I want a whole drawing—

that's one of the ways I quit. Another way I quit is I lose interest. It becomes too much for me—too much of a good thing. I've gone as far as I can go. It could take forever, it's endless. But you stop when your mind blocks off.

GLENN: The only thing that distinguishes a drawing from a painting, for you, is that it is a work on paper? You expend the same energy, use the same materials . . .

DINE: The only difference is that oil paint on canvas is handled differently. I'm much more risky, technically, on paper because it's less fragile than canvas. When I use acrylic on canvas, I can be risky, but oil paint on canvas is so fragile. I like to buy industrial paint, car paint in spray cans. It's used in automobile trunks, and there are all kinds of clear metallic lacquers. What I do is take the valve off and shove a nail into it, and it shoots up like a volcano. It's a very exciting thing to do. What it does is obliterate things. It's like an eraser, you can block things out. I love that white. I wouldn't use it on canvas because it could crack, but I feel on paper it can be controlled. The paper I'm using is tough, and what happens is the colors sink in. They don't sit on the surface and form a gloss that could crack. I think that cars could run over these.

GLENN: You are also drawing with charcoal?

DINE: Charcoal, a little bit of India ink, but mainly white chalk and charcoal—also a little bit of black grease paint.

GLENN: And on canvas you draw with rollers and brushes?

DINE: Right, but I use charcoal on canvas a lot, particularly with acrylic because it has a tooth.

GLENN: You draw with such a spectrum of things that it makes no difference to you what you hold in your hand?

DINE: Right, it makes no difference at all actually. I like sticks. I like to pick up stuff. I've taken to not putting the sanding pad on the grinder, just drawing with the grinder itself because it's black and it smudges across the drawing. I could never use a grinder on an oil painting because it would destroy the way the painting dries. It would go through, and I couldn't patch it. I use it on acrylic paint because I can patch it. Of course we're talking about the Van Gogh drawings—the painterly drawings. When

you talk about the botanical drawings, they are very clearly the work of a draftsman with just a pencil.

GLENN: Do you feel differently about draftsman's drawings?

DINE: I long for them. I'm just too ambitious, that's all. I don't sit down and do them. I'm too ambitious for my art—to make a bigger statement, as it were. But I'd like to have a year when I did just botanical drawings, carefully observed drawings with a pencil.

GLENN: Why not do that?

DINE: Because, as I said somewhere else, I go where my romance takes me. I'm waiting for that moment when I can sit. I yearn for the kind of decision in Picasso's pencil drawing of Max Jacob. That's what I long for. But I don't sit with it. I don't do it right now because I'm too ambitious for the art. I want big things right now, and I want to express myself.

GLENN: When you say big, you're referring to expressionist drawing?

DINE: Well, no, I'm talking about scale.

GLENN: What is the importance of scale to you?

DINE: That's an interesting question because I've been thinking about it lately, and I realize that the drawings are getting bigger and bigger. Everything is getting bigger and bigger.

GLENN: The drawings are the size your paintings were ten years ago.

DINE: The drawings are the size of me with my arms out. I'm just thinking personally of my needs. I'm attending to my artistic needs.

GLENN: You've been looking at the Van Gogh drawings for a long time. Will they continue to appear in your work?

DINE: I think what I'm going to do now is consolidate and use the same ones, use two or three, that I think are terrific, that I could use to abstract drawings that would become emblematic. I'd like to do the whole Van Gogh *oeuvre*. I really would. It's so instructive, and it seems so much akin to what I do. For these I used the small drawing book and I tore the pages out. I also bought another Van Gogh book because there were some other drawings that I was going to use but I haven't. At present, the last one is the tree, a seductive tree.[26]

# MARCH 1983: COLLAGE

GLENN: Collage has been important in your drawings over the years. Were there particular artists who used collage in ways that interested you?

DINE: I've made a lot of collage drawings—primarily in the sixties. I was interested in Schwitters, Picasso, Braque, Motherwell. The paper was torn so beautifully in Motherwell. De Kooning wasn't really making collage. He would lay the newspaper on the paint and leave the imprint of the type, or apply newsprint to paper or to the canvas. I like the letters—they're romantic. I looked at the Russian Constructivists. I was looking at Picasso when I was fifteen. The idea of being able to tear a piece of newspaper and make a leg—it was expedient. I used to walk along the streets in London, kicking up junk, thinking it was really possible to make all the art without ever using the paint, just laying the pieces, scraps, side by side, and creating a surface. It didn't seem so appropriate with the figures, and the *Red Glove* was one of the last collage drawings, although the paintings made in California in 1982 have collaged sections of fabric. Collage was part of the time in New York—the interest in the street culture, in found objects; I still use found objects in the sculpture.

GLENN: Has using bits and pieces from contemporary printed matter ever provided a way to express social concerns?

DINE: No. I first found a way to express my concern when I made *Lessons in Nuclear Peace* (1982–83; plate 144).[27] I've always been concerned with social issues, I just never found a way to express my concerns in my art until I found a Japanese book (*Unforgettable Fire*) with drawings by the survivors of Hiroshima. They are beautiful, naïve drawings, very Japanese, made from their remembrances of the day the bomb was dropped. I've been using them. I'm going to continue using them. I want to go

to Japan and spend six months—just see things—to observe the landscape, architecture, the things in the stores, in displays, and on the street—in relation to the people, the size of the people. All objects are part of a cultural history. In Paris, or wherever I travel, I go to the store—department stores, markets. I've been living out of a suitcase the last three years. I like the stimulation of different places, different people, different environments—it's my constant need to observe. I've thought of spending a year in a museum drawing everything—but I can't draw in museums. People are always hanging over your shoulder.

GLENN: Is it important to you to draw from the model or from other works of art that inspire you?

DINE: I don't draw from memory—except perhaps the hearts or bathrobes, though I have to keep correcting the hearts, and I do have bathrobe pictures I use. I like what happens between the eye and the hand—observing, translating. I like the process of observing and drawing, the inventing, the changes that take place. The recent drawings of Jessie are not as closely observed. They're figures with a shell, rather than Jessie doing things. Perhaps it's because I've drawn her so long, know her so well, she has just become a figure. With observation, everything in my background becomes possible material for my art—from the collages of Picasso and Schwitters, to Derain and Van Gogh, to the model and still life. I make what I observe my own.

# JULY 1983: SOURCES

GLENN: When you speak about artists who have meant a great deal to you personally, you often begin with Giacometti.

DINE: Giacometti's is an exemplary life in art. It's inspiring to me, as is the idea that he spent all that time just looking. In James Lord's book on Giacometti, Lord tells the story about Diego and Alberto at the end—when Alberto was on his deathbed. Giacometti was observing Diego as if he were about to change a drawing.[28] You know, his life as a draftsman inspires me more than any other, although I don't think he is necessarily a better draftsman than Matisse or Picasso. But his life—there's a romance about looking that I like very much. The other day I was making a painting in Aspen, and I'd been drawing, too, but I'd been making a painting of Nancy, and I was sitting there looking at her, and I said to her, "You know, I can't think of anything I would rather be doing." It's the most pleasurable, privileged thing to do, to be able to observe, and on some days to see totally clearly. Other days, I just cannot put my hand and my line together. It comes very slowly, but there are days like the other day, when, looking at her, I saw everything I wanted to do right there. Then it goes well, then it is pleasure and privilege.

GLENN: In addition to Giacometti, you often say you have been inspired by artists such as Balthus, Picasso, and Matisse.

DINE: Well, other draftsmen have meant something to me, but usually it is a drawing rather than a draftsman. Certain works by Cézanne, by Degas, have meant a lot, and certainly drawings by Van Gogh.

GLENN: Have you made drawings after artists other than Derain and Van Gogh?

DINE: No. Certainly I wouldn't touch Picasso, Matisse, Giaco-

metti. They are too close. Derain was different because it was just one thing I wanted. It was a drawing after a painting. There is one little drawing I have after Prud'hon.

GLENN: You have also mentioned De Kooning's influence.

DINE: He was my big hero as a young American painter. I felt he was the most heroic figure in American painting, much more so than Pollock. Pollock meant very little to me. There's a book of De Kooning drawings that I look at quite a bit. I like the early Ingres-like drawings—the drawing of Elaine de Kooning. It was very precise—just beautiful. Then, of course, there is Picasso. Picasso is endless for me. The drawings are great, quirky, and wonderful. I've just seen some drawings from 1968; they are so lively the line just flies through the air. And Matisse! I own a Matisse. I think it's the greatest Matisse drawing ever done. It's a nude—an abstracted nude from 1937, worked over, worked over and reduced, with great knowledge of what he wanted to do.

GLENN: And Balthus?

DINE: I find some of the drawings very moving. I used to find them erotic, but I don't anymore. There's just something about the romance of this strange European artist, who relates to Giacometti, the circle of Giacometti—generally to artists after the war. In Denmark I saw the show called "Aftermath."[29] There were four or five great drawings by Artaud [Antonin]—just great drawings; a drawing by Léger of legs or pants—one a nude; but the Artaud drawings are really superb. Like Van Gogh, which is just great drawing, this is not easy drawing. I feel akin to it in the sense that it's awkward, like I am. I mean I'm not so slick. Where did he learn to make figures so angular? It's something very strange. He had a way of seeing that is quite different, certainly it is not naturalistic. It's somehow an obvious abstraction from the figure. Every time I look at a Van Gogh drawing I'm struck—particularly by the landscape drawings. They're just amazing. I have always looked at the landscape drawings, the drawings of trees particularly.

GLENN: It doesn't seem especially important to you to see these drawings firsthand. You've been working from a small book of Van Gogh drawings.

DINE: It doesn't matter to me. I love reproductions. They seem closer and more neutral. I like to take reproductions and have them blown up photographically so they are more abstracted, not so personal, not so much the artist himself. I don't need the physicality of the work. Sometimes it is too much for me—like the Matisse I own. It's so great—the physicalness of it is so great—I can't get near it. It's so wonderful what he has done to paper.

GLENN: Then you are simply using, not really drawing *from*, the Van Gogh drawings? You are drawing from the inspiration of his drawings?

DINE: Right. I'm interested in the inspiration, not necessarily in the drawings themselves. Otherwise I would be copying them.

GLENN: The drawings are getting bigger and bigger.

DINE: My drawings are getting a lot bigger. I seem to need that. I don't know why. The five Crommelynck gates are about eight feet long by six feet tall.

GLENN: You said to me that you never go beyond the reach of your own arm, of the tool you're using.

DINE: You can't believe me all the time. Honestly, I do contradict myself. I just do what's appropriate. But I wouldn't go too high, just to the side. I like to walk down a row of shop windows. The gate drawings are made up of big sheets of paper, then collaged on top with objects. They're usually double—two sheets abutted—because the gate is that way too.

GLENN: The physicality of these drawings is important to you?

DINE: Yes. I'm very proud to be a workman. I'm proud that I work hard, and I find it difficult to understand artists who don't work as physically hard as I do. This is really prejudice on my part, and it's ridiculous. I don't really want to know how long something took anymore, but then I am impressed with things that take a long time.

GLENN: Is part of your interest in European expressionism related to the obvious physicality of the works?

DINE: Yes, but it relates to the fact that I also think I'm a natural European—an Eastern European expressionist; yet I yearn, in some sort of nostalgic way, to take the time to sit and draw precisely with a rather hard pencil.

# CONCLUSION

*I say that I am . . . stating every phase of that identity to the fullest and clearest intent.*     CLYFFORD STILL[30]

In the evolution of abstraction from Kandinsky to Motherwell, there is a plea for an art of content, of subjects—subjects stated abstractly but nevertheless persuasively, as in Motherwell's *Spanish Elegies*. In contrast, by the second half of the twentieth century, the subject was purported by many to be the canvas itself ("What you see is what you see"[31]), as artists denied the romanticism of abstract painting that issued from spiritual persuasions or passionate responses to events that stirred minds and hearts. The poetic (though not literary) canvases that barely masked social and philosophical concerns gave way to the cool Pop icons created by Dine's generation.

Taking what he needed from Abstract Expressionism—energy, ambition, motion and emotion, scale and audacity—Dine rejected the nonfigurative tradition out of a persistent urge to see the world autobiographically. His drawings (and paintings) remain painterly poetry in the abstract tradition, and his images, like those of the Symbolist poets, function as visual metaphors for sensations. His figurative devices are not unlike the suggestive abstract forms and colors of his immediate predecessors. Not only are the hearts, tools, and robes abstracted from Dine's real world, they have become equivalences for his emotions. The habitual use of certain symbols has become a way—though uncalculated—of eliciting responses that emulate his moods, his turmoil, his "gritty" passions.

Dine's use of color, which he insists is also utterly uncalculated ("Black and white are often enough"), reinforces the signific roles he assigns his images. The same image may, on occasion, appear mournful or celebratory. Color, as in expressive abstraction, evokes sensations allied with universal feelings—joy, de-

sire, anguish, gloom. Genitals are splashed blood red. Forests of trees grow murky green, blue, and black in forbidding density, or offer admittance through hastily scrubbed pastel patches. Hearts drip cheerful valentine colors or tremble in dark washes of sadness.

Jim Dine does not think of himself as a colorist. He says, matter-of-factly, that it is something he does not think about at all. "I just pick one up [a color] and make it work." The implication is that instead of selecting certain combinations of images and hues in a knowing way—predetermining a response he wishes to evoke—he works on the sheer tide of his feelings. The magical transference of these feelings to the surface and then to the viewer, as if by will alone, verifies, for him, whether he has made it "work." He does not attempt to manipulate responses with either *overtly* symbolic images or colors, but is only intent on working, leaving the visible remains of his intuitive progress to speak of the intensity of his involvement.

When Mallarmé suggested the crux of the matter was to "Describe not the object itself, but the effect it produces,"[32] he reckoned without artists of Dine's temperament who *need* to describe the object in order to paint *about* "the effect it produces." Though Dine refuses to spell out everything in the manner of the realist painters, the symbols and subjects he does select allow him to commit his feelings to paper or canvas and convey them to us—in both a catharsis and reaffirmation of his love of drawing. It is in this context that he calls himself a figurative artist. Twenty-five years ago Dine's reviews were almost uniformly negative, bewailing his awkward draftsmanship and his bad-boy perversity. Today—almost as uniformly—they extoll his prodigious ability as a draftsman and his serious contribution. It is entertaining to wonder who has grown up in the interim—the artist or his audience. Now unquestionably accessible to a much wider public, the work has lost the nasty edge of the early sixties. It may well be the increasingly painterly surfaces and the now comfortably familiar subjects that make it more ingratiating. But it may also be that Dine is a better artist, a better painter because, as he says, "I finally sat down and learned how to draw."

PLATES

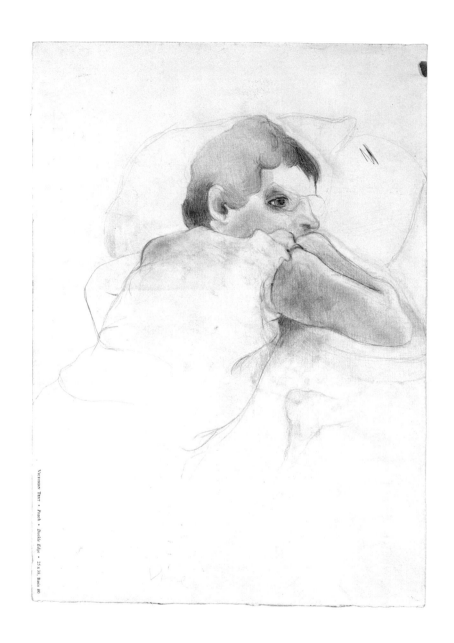

18. *Nancy Dine*. 1958.
Graphite on paper,
17 × 12″. Collection the
artist

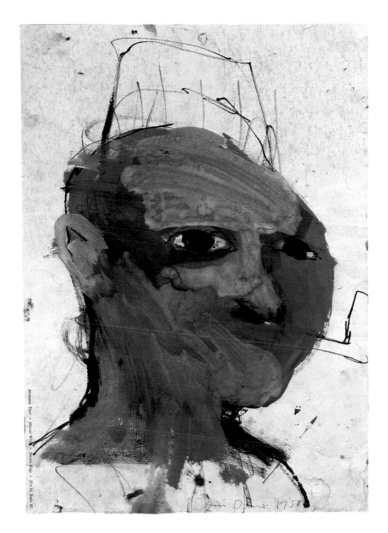

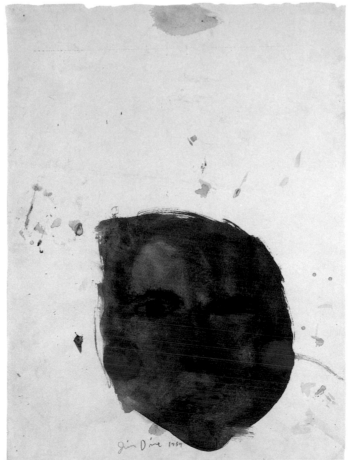

19. *Head.* 1958. Ink and gouache on paper, 17⅞ × 12″. Collection the artist

20. *Head.* 1959. Watercolor on paper, 24 × 17⅞″. Collection the artist

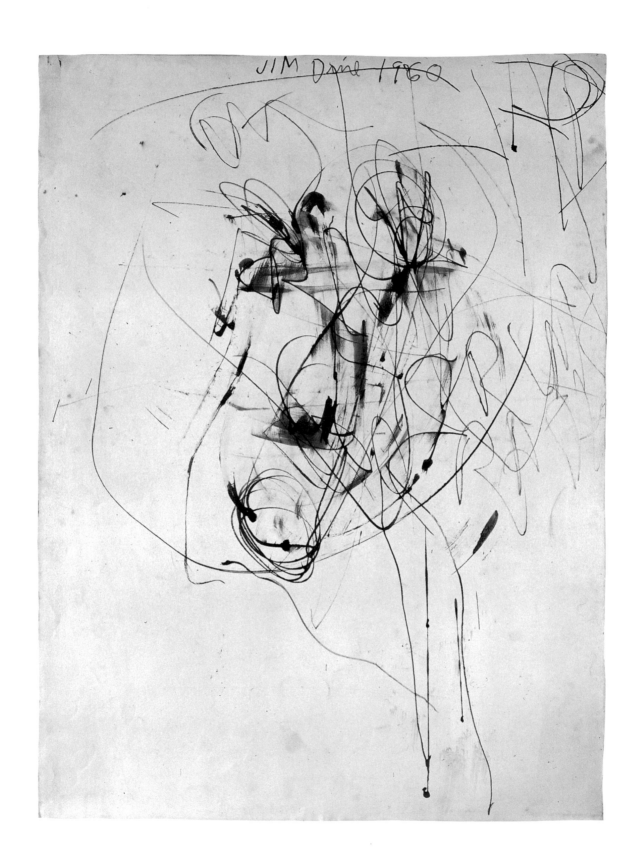

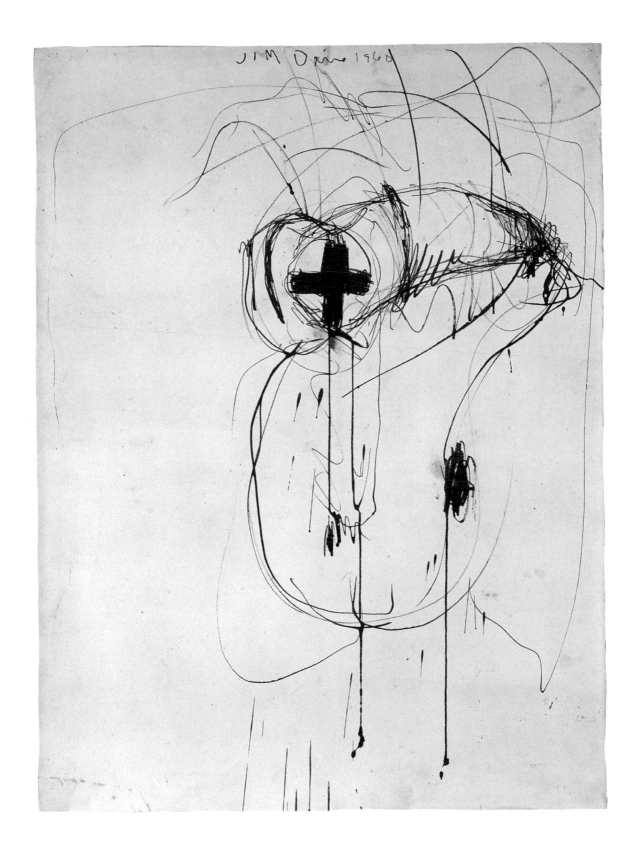

21. *Crash*. 1960. Ink on
paper, four sheets,
30 × 22¼″ each. Collection
the artist

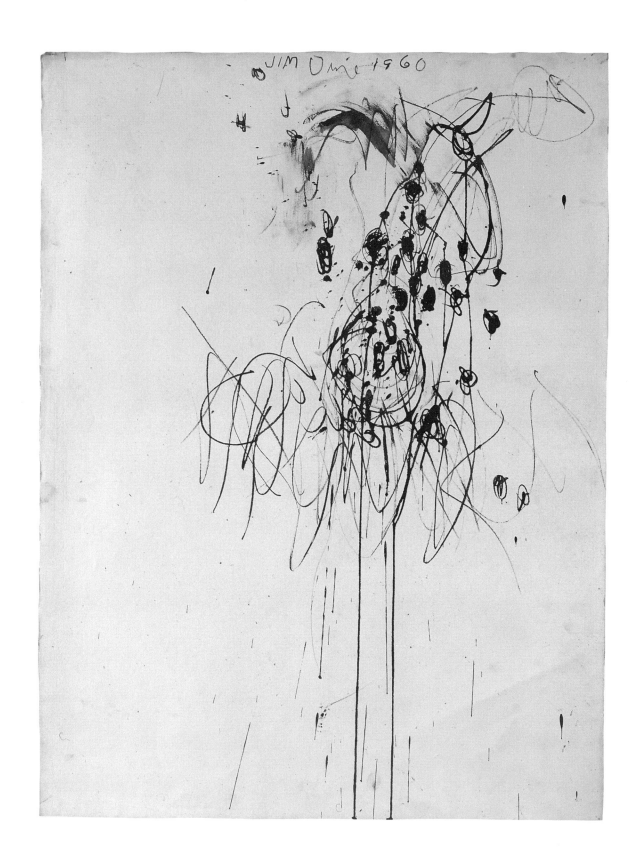

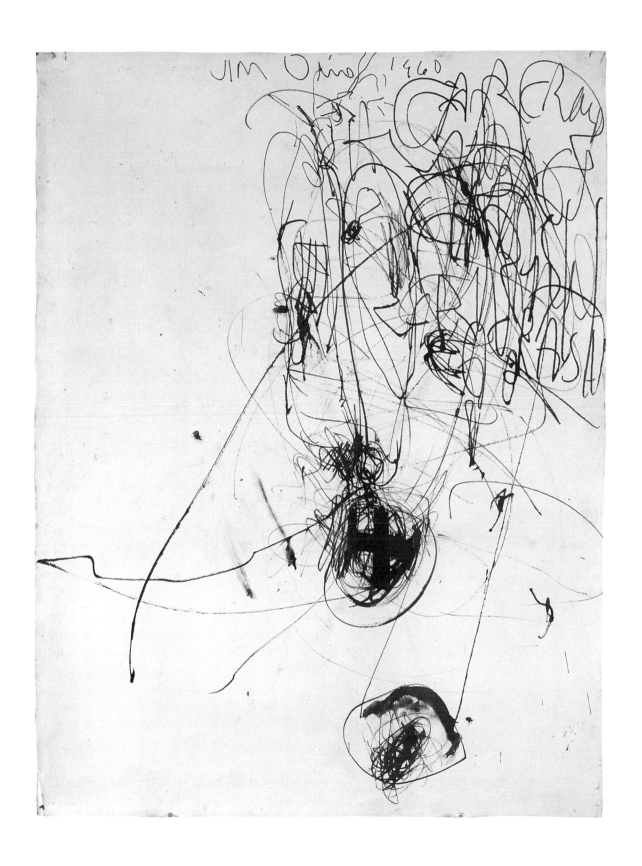

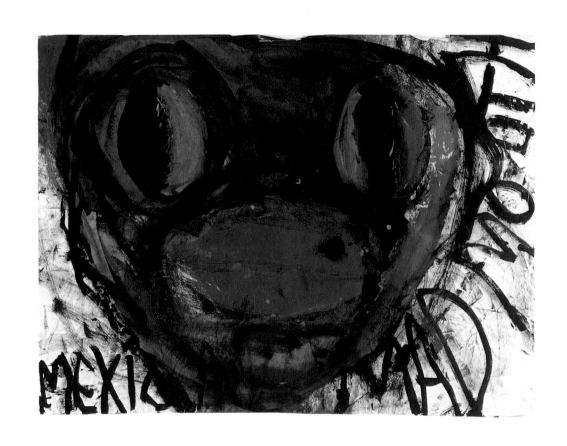

22. *Mexicali Mad Mouth.*
1960. Gouache on paper,
18¾ × 24½″. Collection the
artist

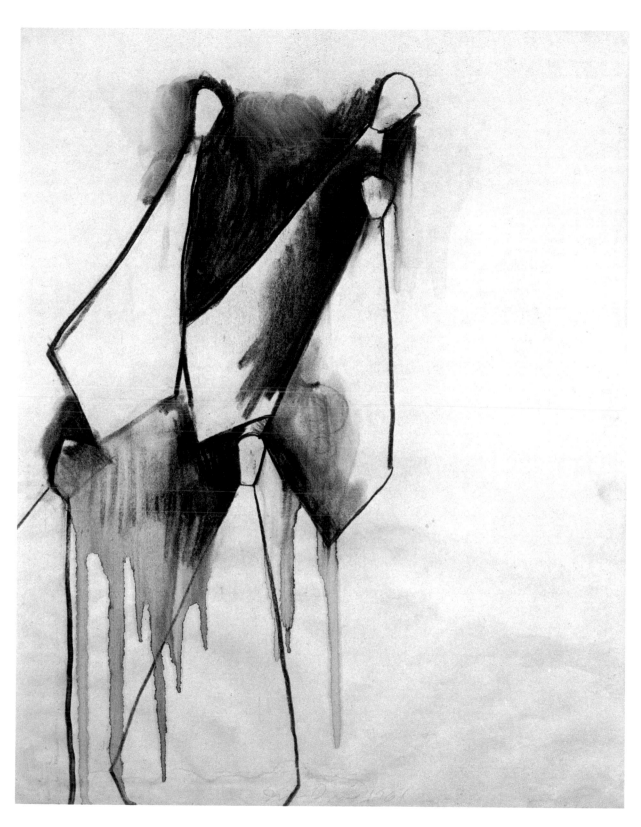

23. *Ties*. 1961. Charcoal and
wash on paper,
24¼ × 19¼″. Courtesy
Barbara Krakow Gallery,
Boston

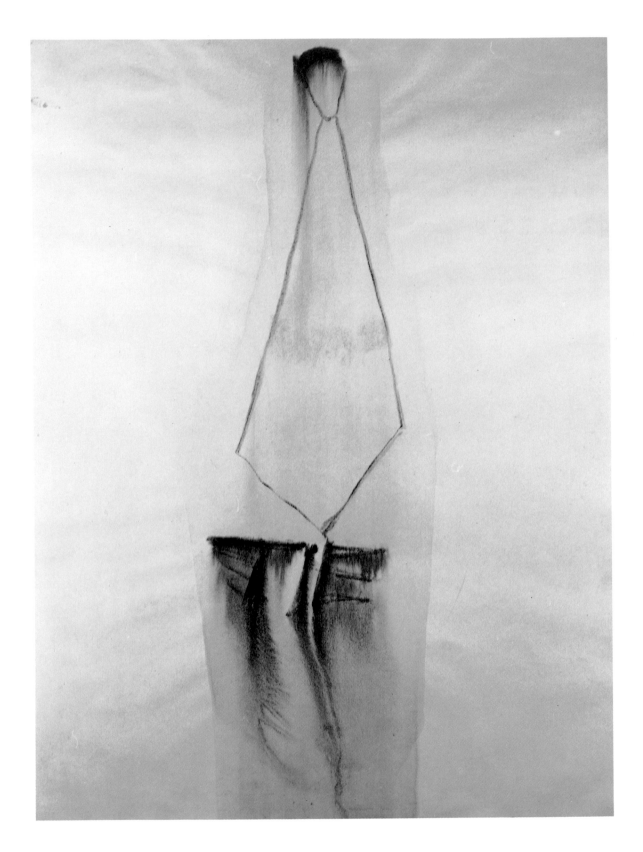

24. *Wash Tie*. 1961.
Charcoal and wash on paper,
26 × 20″. Collection the
artist

25. *Toothbrush and Tumbler with Screws*. 1962. Gouache and screws on paper, 29⅛ × 22⅞″. Collection the artist

26. *Toothbrush and Tumbler with Screw*. 1962. Gouache and screw on paper, 28¾ × 22½″. Collection Francesco Pellizzi

27. *Untitled.* 1962. Graphite
on paper, 9¾ × 13".
Collection the artist

28. *Untitled.* 1962. Graphite
on paper, 9½ × 12⅞".
Collection the artist

29. *Screwdriver*. 1962.
Graphite and colored pencil
on paper, 29¾ × 20″.
Collection the artist

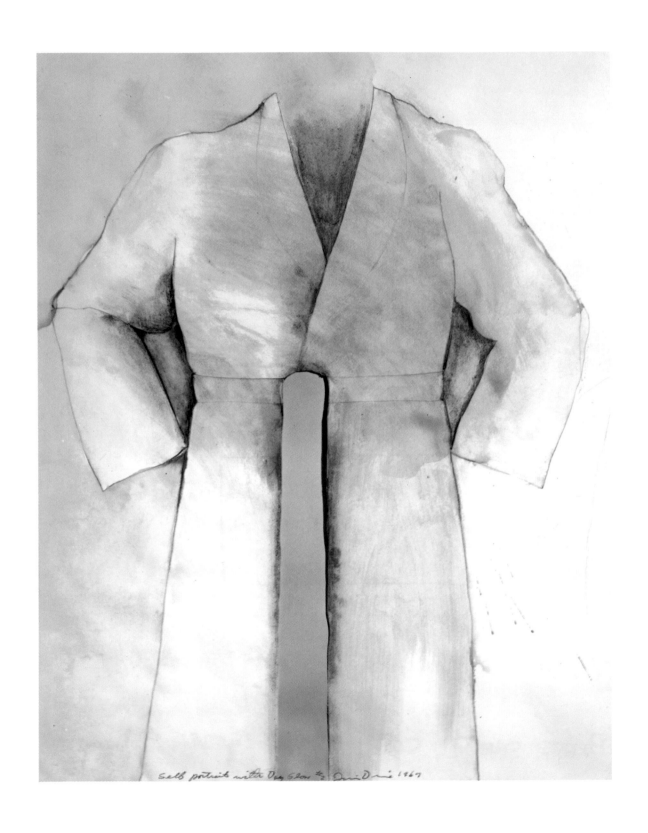

Self portrait with Day Glow #2 David Dine 1967

30. *Self-Portrait with Day-Glow #2*. 1964. Day-Glo, charcoal, and wash on paper, 25 × 20″. Collection Dr. and Mrs. Paul Sternberg, Glencoe, Illinois

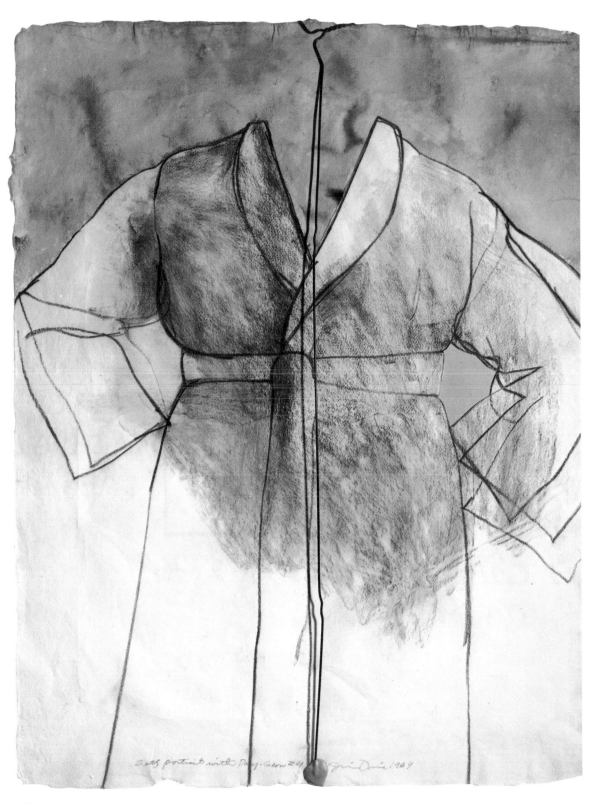

31. *Self-Portrait with Day-Glow #4*. 1964. Day-Glo, charcoal, and wash on paper and collage, 34½ × 26″. Collection Mr. and Mrs. Philip Gersh, Beverly Hills, California

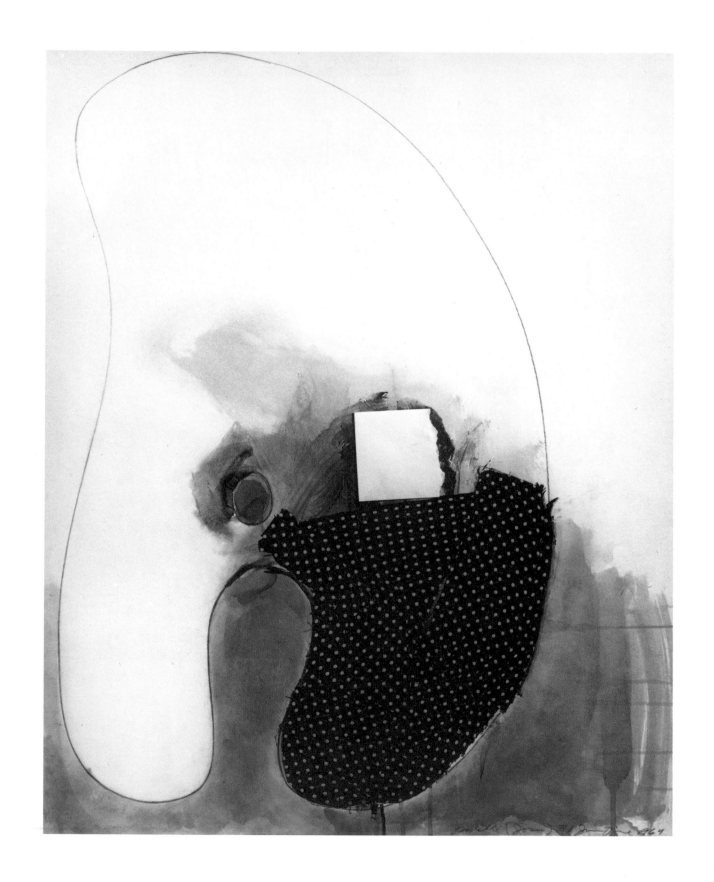

32. *Palette (Joan) #1.* 1964.
Collage, 29 × 23″. Summers
Collection

33. *Double Palette*. 1963.
Watercolor and collage on
paper, 17½ × 25¼″.
Private collection, London

OVERLEAF
34. *Four Palettes*. 1963.
Watercolor and collage on
paper, 25¼ × 48½″.
Collection Mr. and Mrs.
Lewis E. Nerman, Overland
Park, Kansas

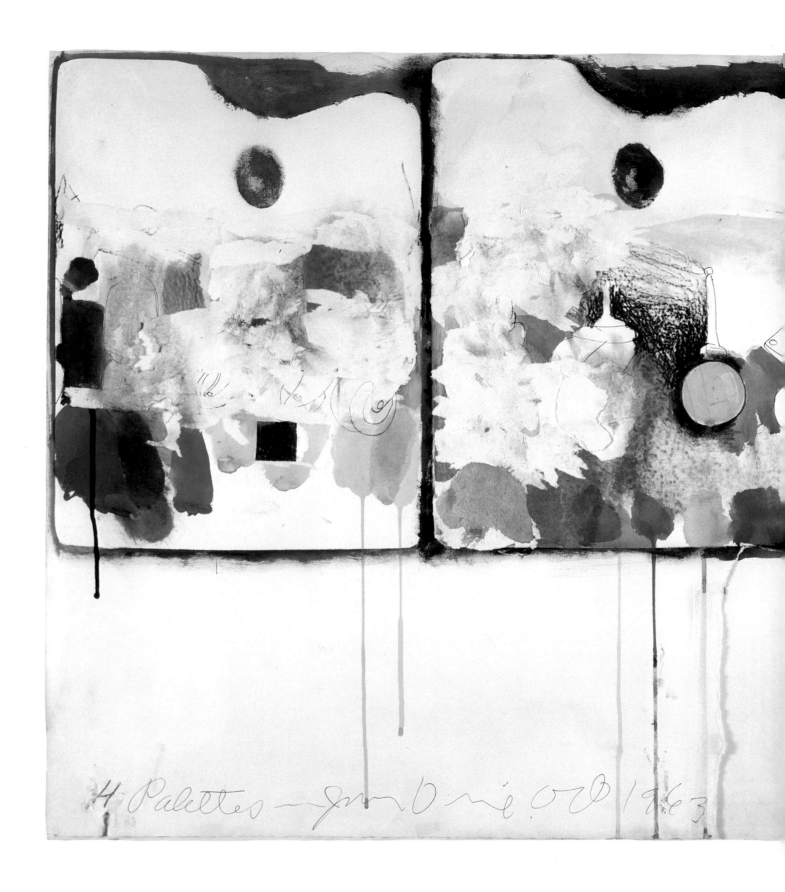

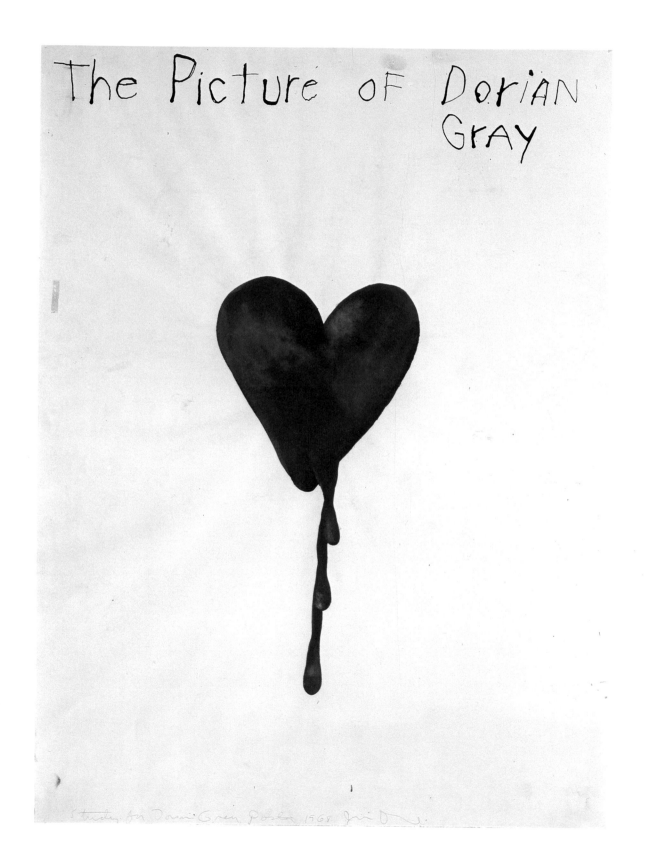

35. *The Picture of Dorian Gray.* 1968. Ink and gouache on paper, 30 × 22″. Collection the artist

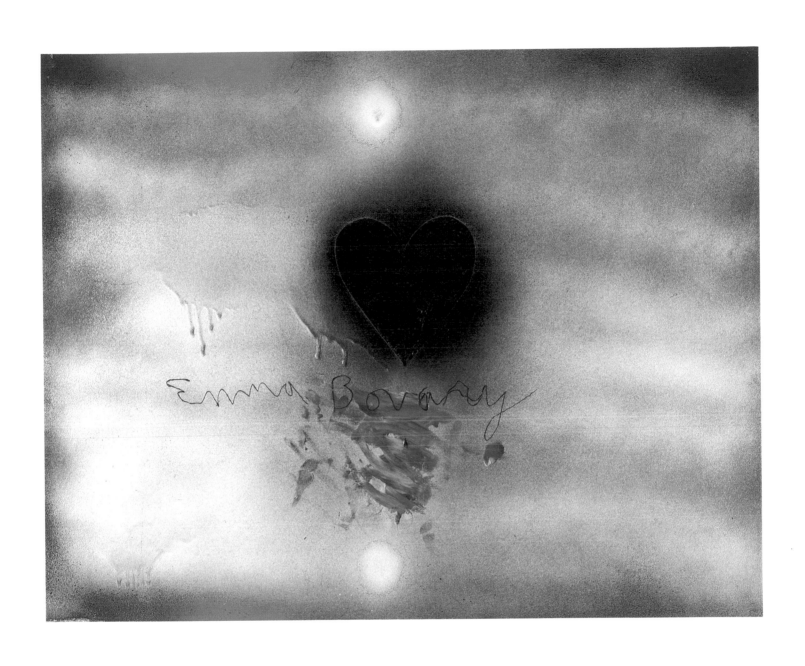

36. *Emma Bovary*. 1970.
Enamel on paper,
22½ × 28½". Collection the
artist

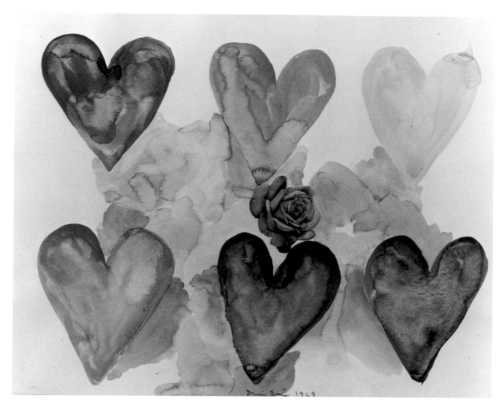

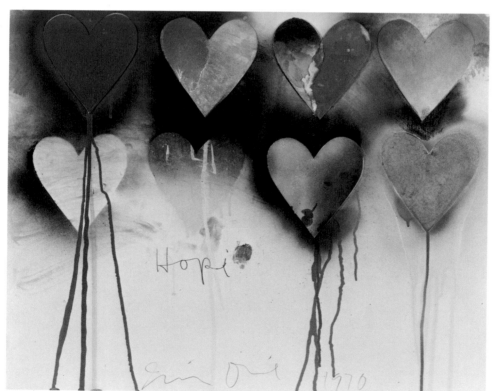

37. *Hearts with Flower.*
1969. Watercolor and collage
on paper, 20½ × 25½".
Collection the artist

38. *Hopi.* 1970. Gouache
and enamel on paper,
22½ × 28½". Collection the
artist

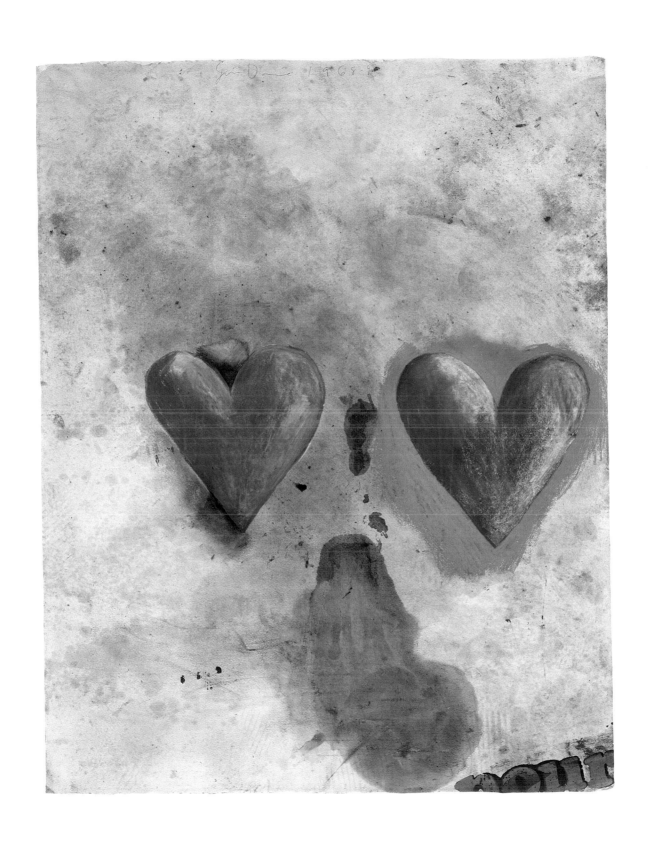

39. *Two Hearts*. 1968–69.
Charcoal and pastel on
paper, 30⅜ × 25⅝".
Collection the artist

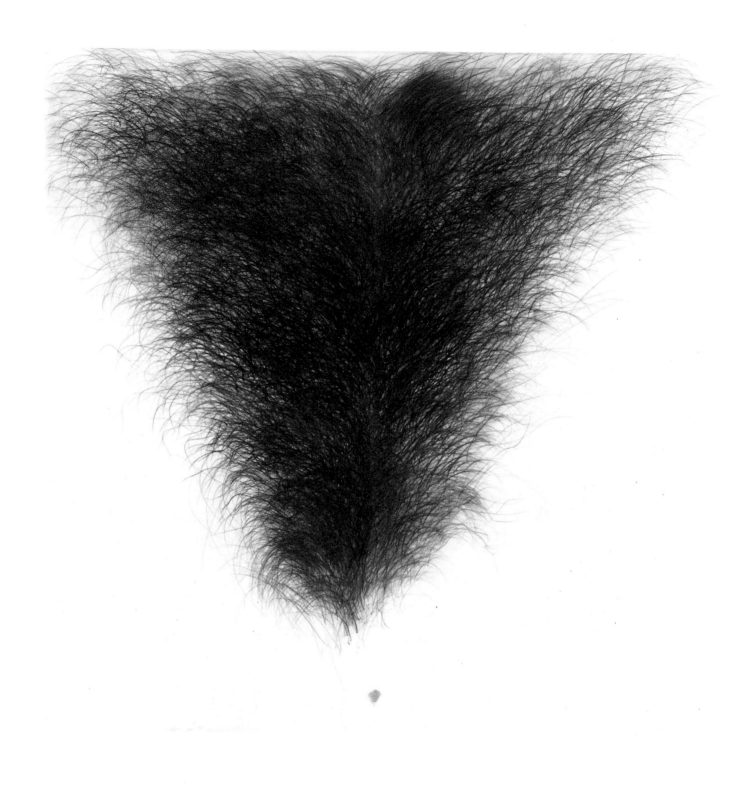

40. *Hair*. 1970. Graphite on paper, 22¾ × 23″. Collection the artist

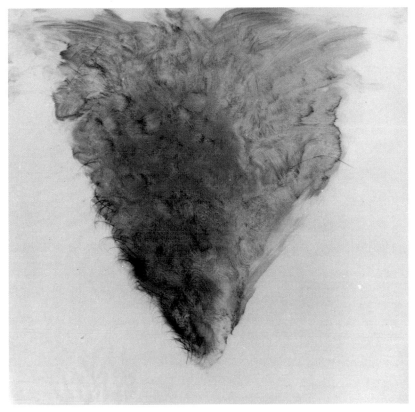

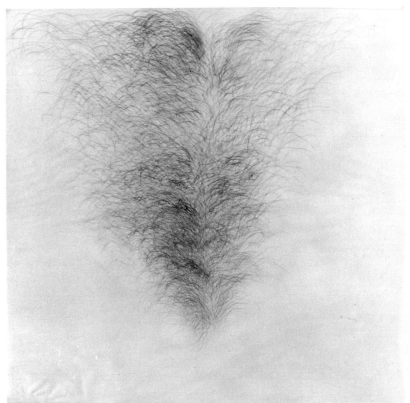

41. *Hair*. 1971. Graphite on
paper, 22¾ × 23″.
Collection the artist

42. *Hair*. 1971. Graphite on
paper, 22¾ × 23″.
Collection the artist

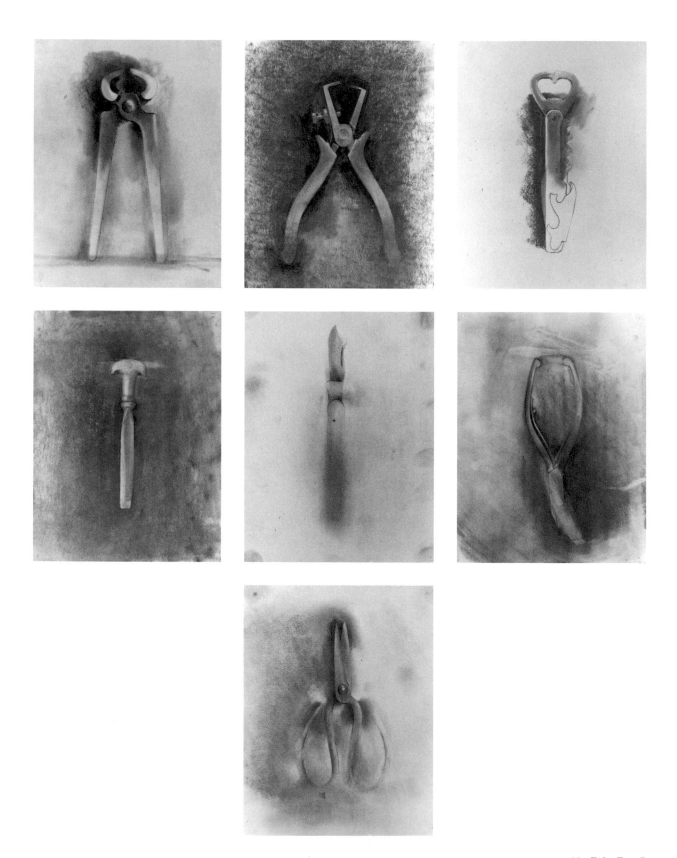

43. *Fifty-Two Drawings for
Cy Twombly.* 1972. Graphite
on paper, fifty-two sheets,
8¼ × 6¼″ each. Collection
Mr. and Mrs. Bagley Wright

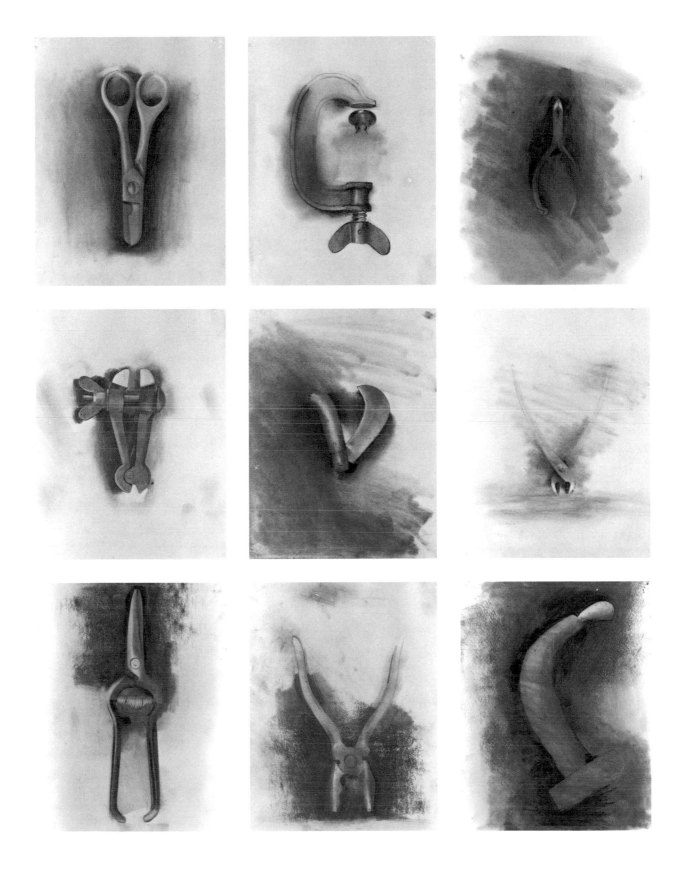

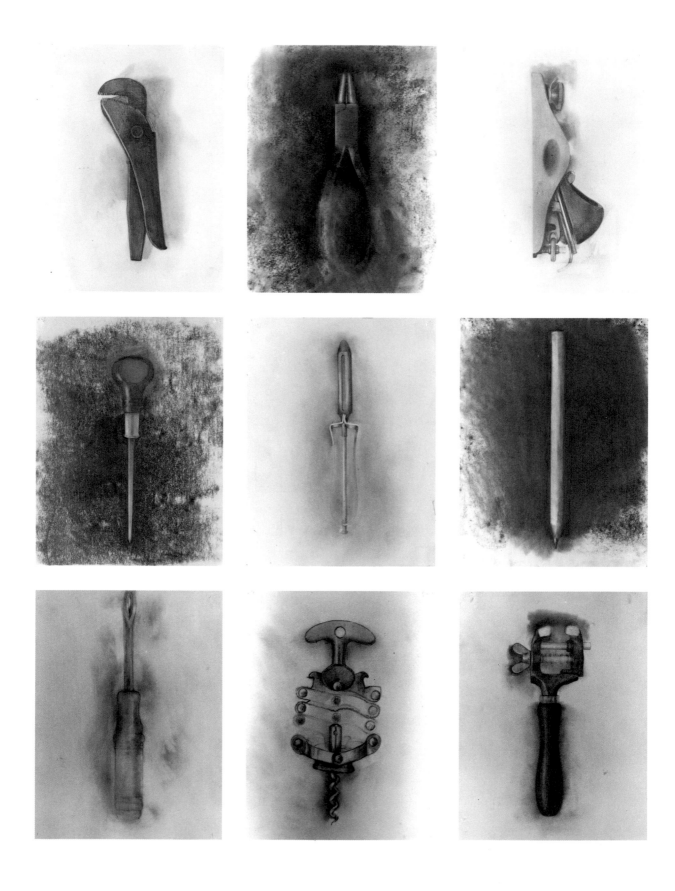

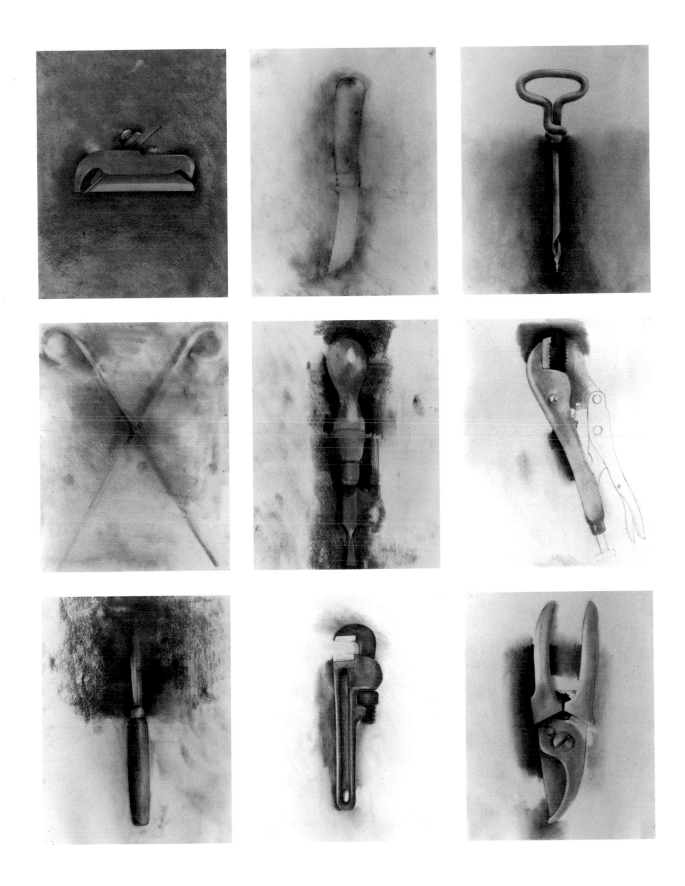

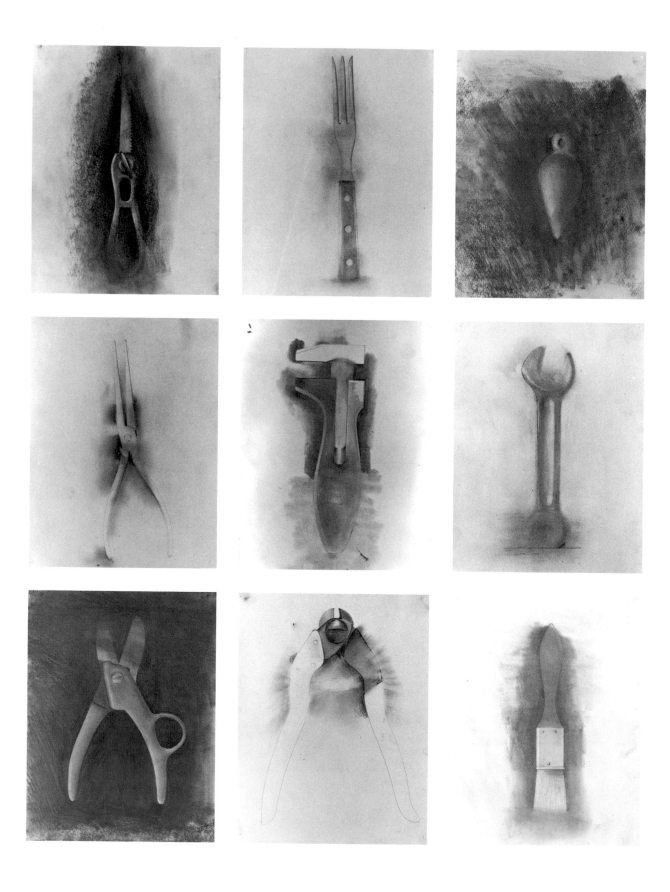

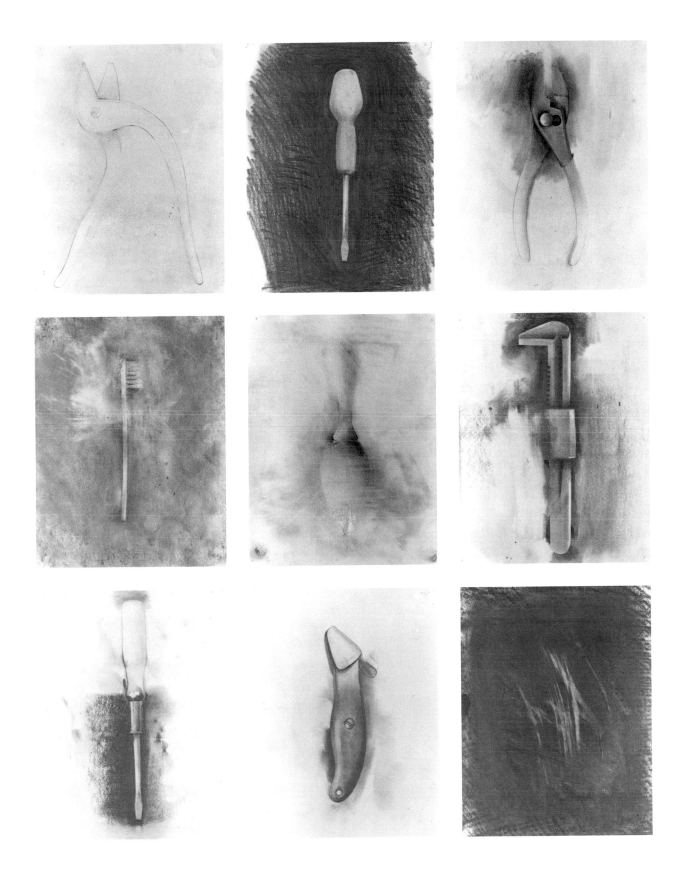

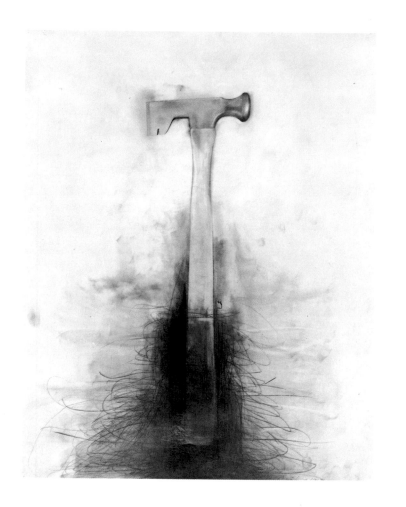

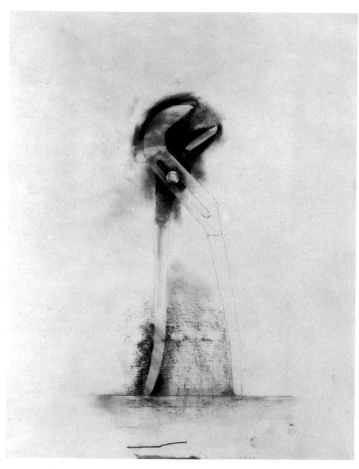

44. *Untitled (Dry Wall Hammer)* from *Untitled Tool Series*. 1973. Charcoal and graphite on paper, 25⅝ × 19⅞″. The Museum of Modern Art, New York. Gift of the Robert Lehman Foundation, Inc.

45. *Untitled (Pliers)* from *Untitled Tool Series*. 1973. Charcoal and graphite on paper, 25⅝ × 19⅞″. The Museum of Modern Art, New York. Gift of the Robert Lehman Foundation, Inc.

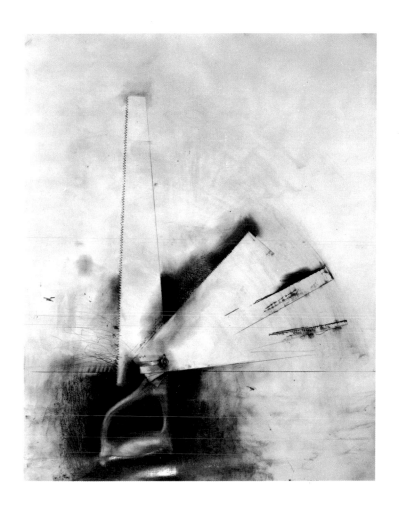

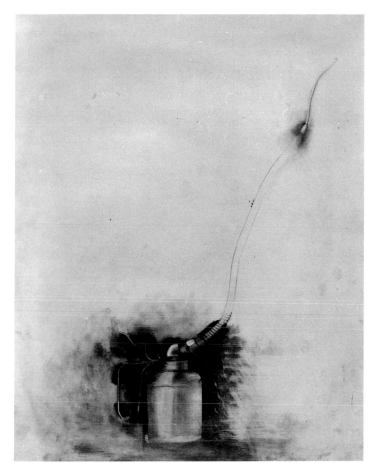

46. *Untitled (5-Bladed Saw)*
from *Untitled Tool Series*.
1973. Charcoal and graphite
on paper, 25⅝ × 19⅞".
The Museum of Modern Art,
New York. Gift of the Robert
Lehman Foundation, Inc.

47. *Untitled (Oil Can)* from
*Untitled Tool Series*. 1973.
Charcoal and graphite on
paper, 25⅝ × 19⅞".
The Museum of Modern Art,
New York. Gift of the Robert
Lehman Foundation, Inc.

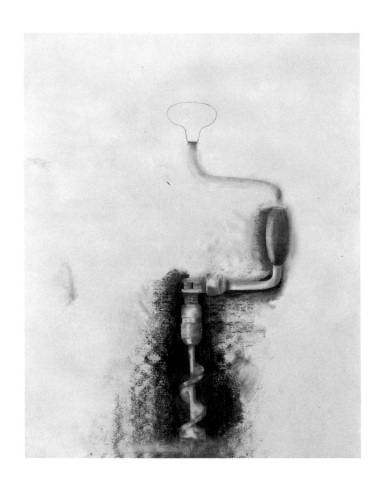

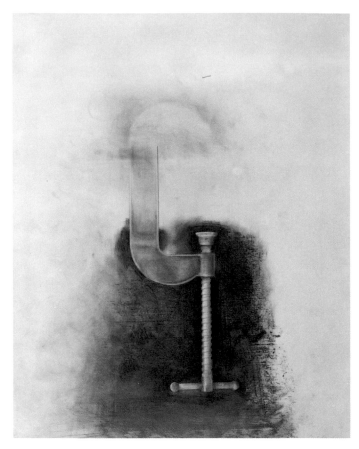

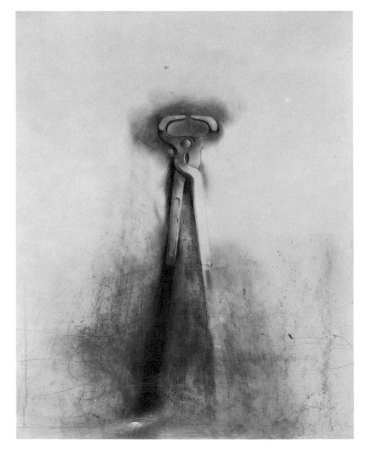

48. *Untitled (Brace and Bit)* from *Untitled Tool Series.* 1973. Charcoal and graphite on paper, 25⅝ × 19⅞". The Museum of Modern Art, New York. Gift of the Robert Lehman Foundation, Inc.

49. *Untitled (C Clamp)* from *Untitled Tool Series.* 1973. Charcoal and graphite on paper, 25⅝ × 19⅞". The Museum of Modern Art, New York. Gift of the Robert Lehman Foundation, Inc.

50. *Untitled (Hoof Nippers)* from *Untitled Tool Series.* 1973. Charcoal and graphite on paper, 25⅝ × 19⅞". The Museum of Modern Art, New York. Gift of the Robert Lehman Foundation, Inc.

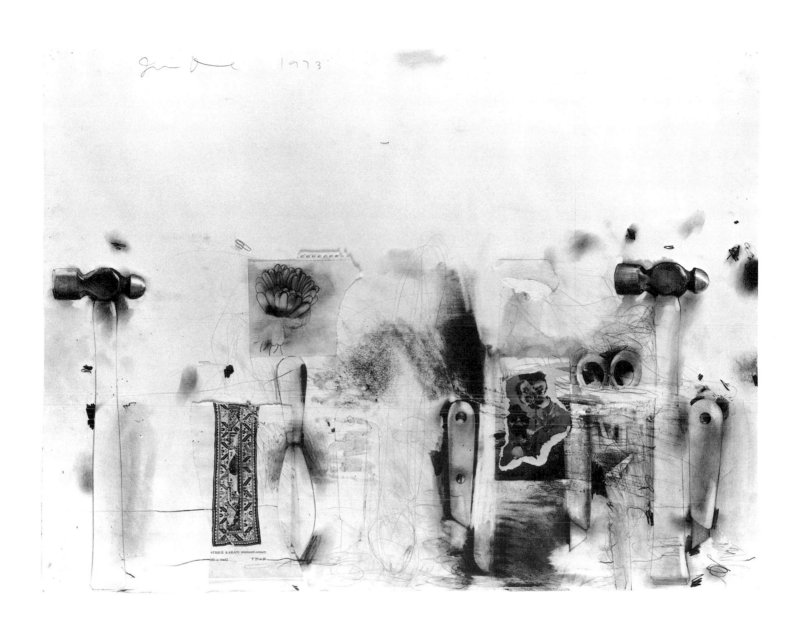

51. *Untitled.* 1973. Graphite
and collage on paper,
23¼ × 30¾". Collection the
artist

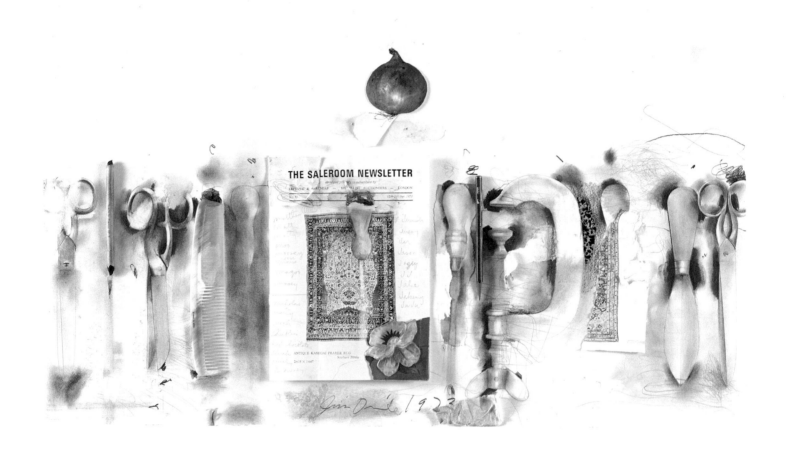

THE SALEROOM NEWSLETTER

ANTIQUE KAMDAI PRAYER RUG

52. *Untitled.* 1973. Graphite
and collage on paper,
23 × 30½". Collection the
artist

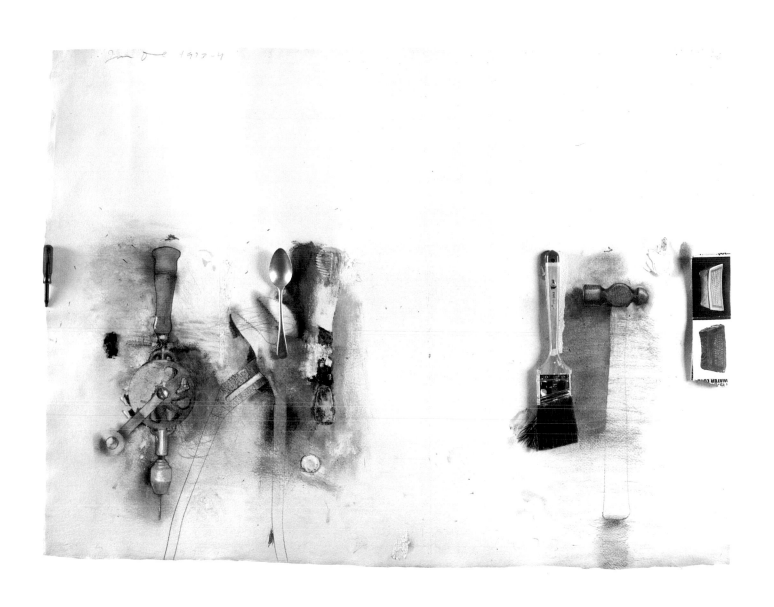

53. *Untitled.* 1973–74.
Graphite, watercolor, and
collage on paper, 30 × 40″.
Collection the artist

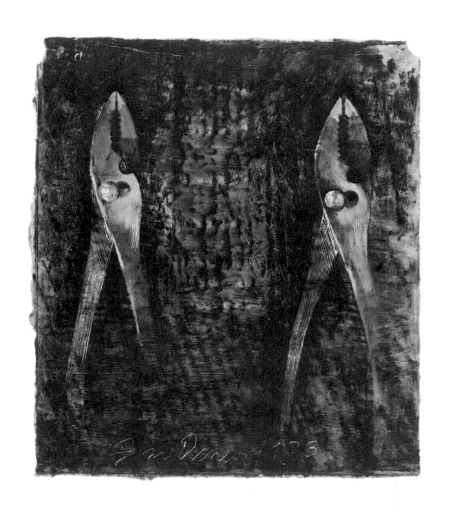

54. *Untitled.* 1973. Litho
crayon on paper, 9⅛ × 8″.
Collection the artist

55. *Saw.* 1973. Charcoal and
graphite on paper,
35¾ × 23⅜″. Collection the
artist

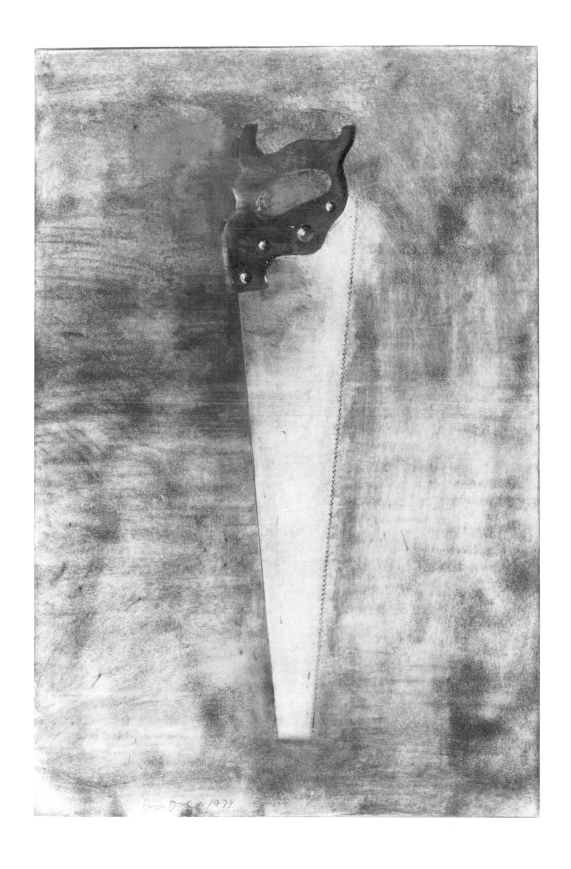

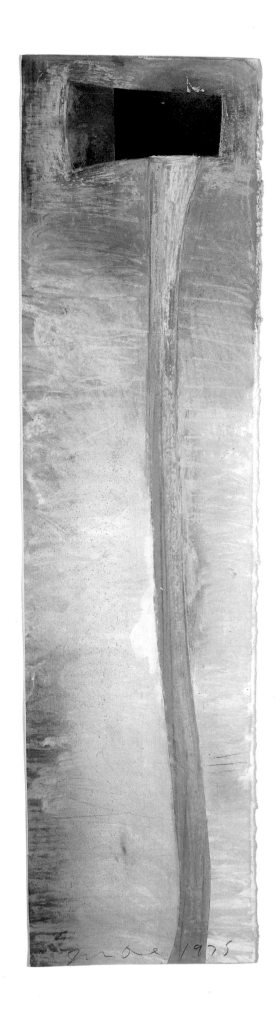

56. *Axe*. 1975. Pastel and
mixed mediums on paper,
64¼ × 21¾″. Collection
Douglas S. Cramer

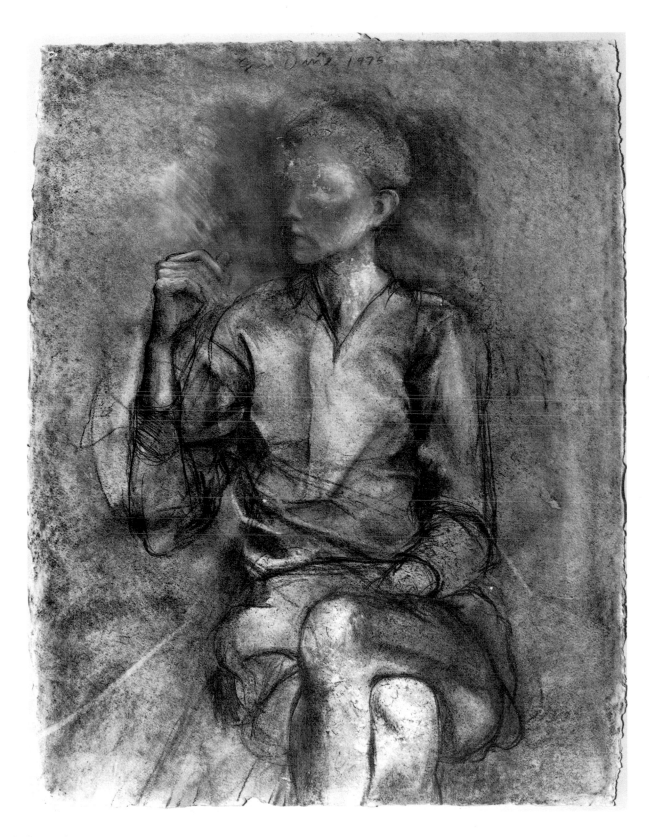

57. *The Early Sitter.* 1975.
Charcoal and pastel on
paper, 40½ × 31″. Museum
of Fine Arts, Boston. Gift of
Michael Mazur

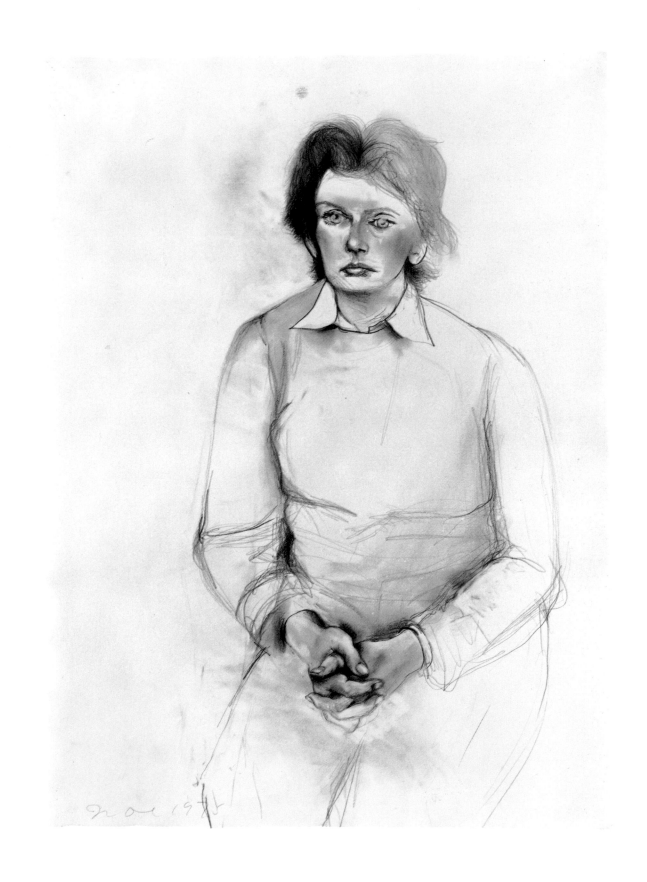

58. *Nancy.* 1975. Graphite
on paper, 31½ × 23″.
Collection the artist

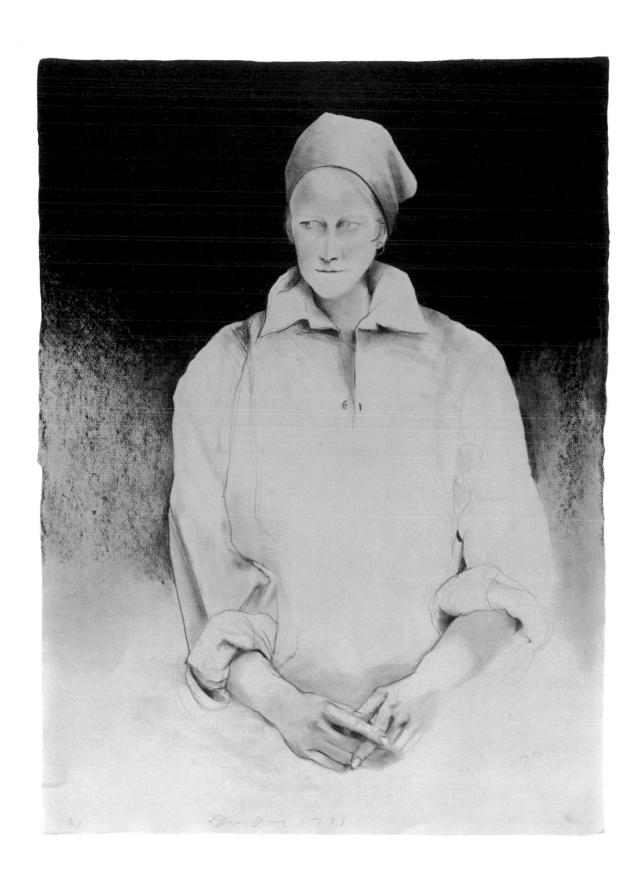

59. *Jessie*. 1975. Graphite on
paper, 31½ × 23″.
Collection the artist

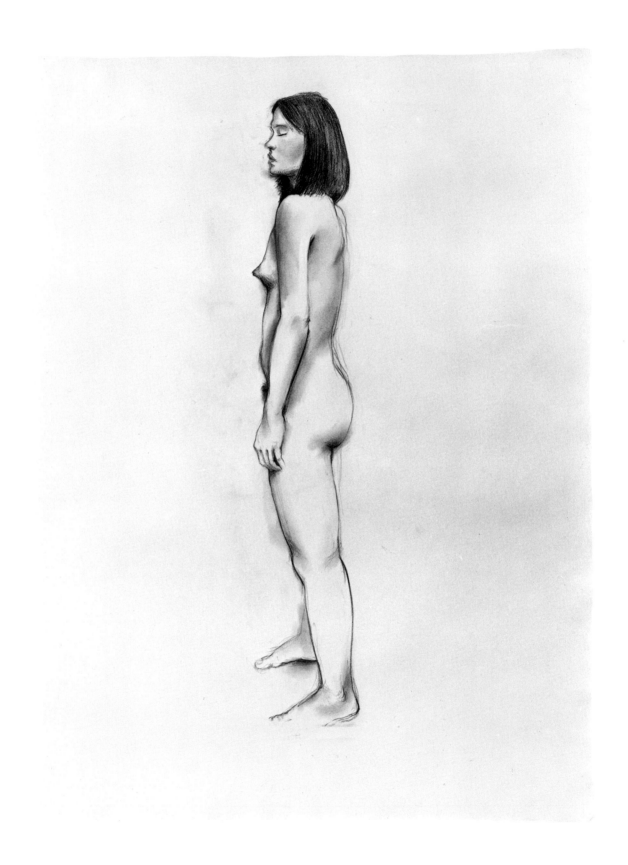

60. *Untitled (Nude)*. 1975.
Graphite on paper,
31½ × 22¾". Collection the
artist

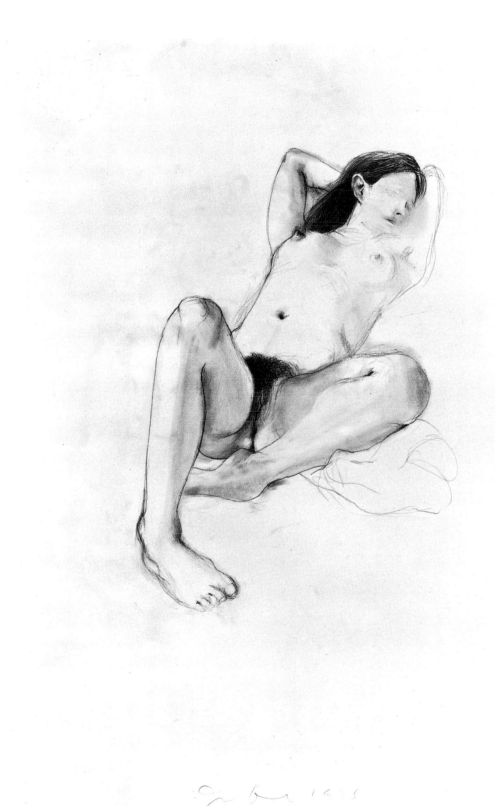

61. *Untitled (Nude)*. 1975.
Graphite on paper,
31½ × 22½″. Collection the
artist

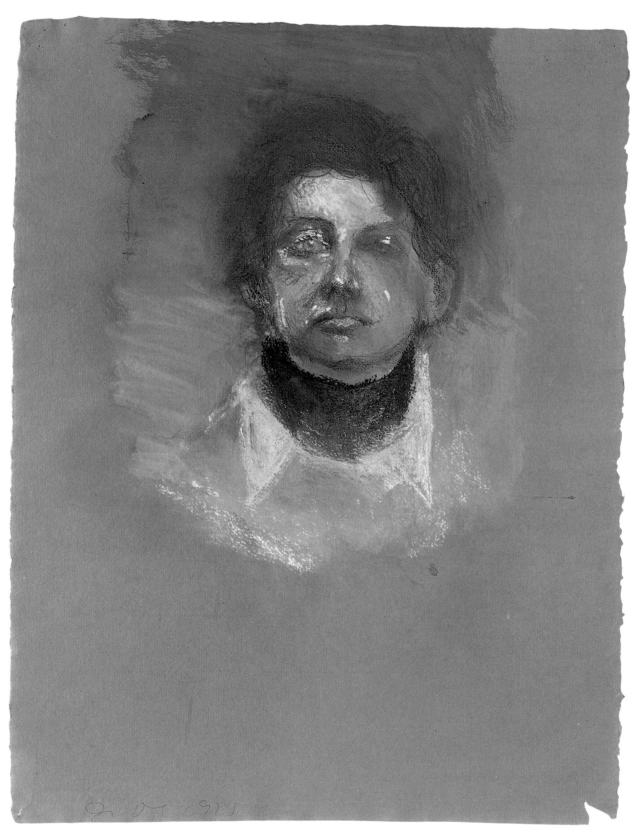

62. *Nancy.* 1975. Graphite
and pastel on paper,
25¾ × 19⅞″. Collection the
artist

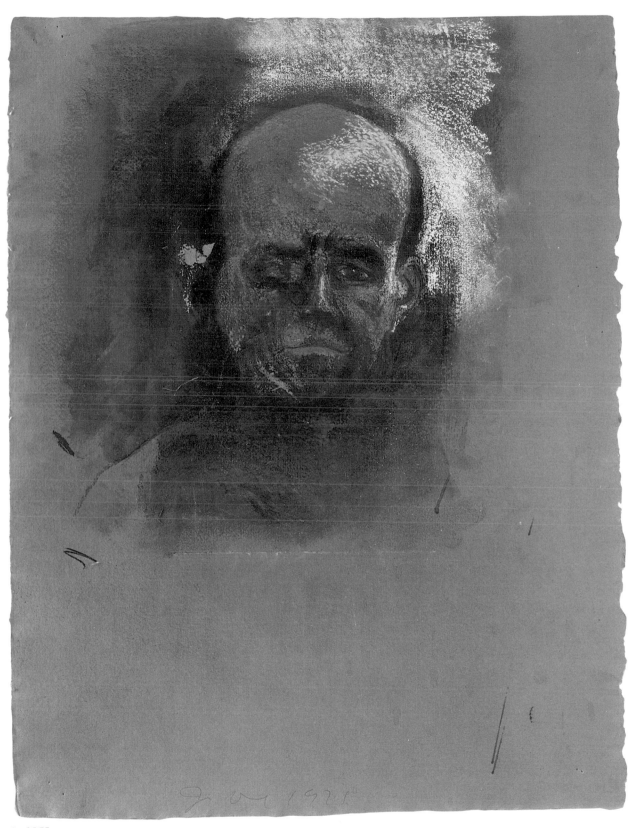

63. *Self-Portrait*. 1975.
Charcoal, graphite, and
pastel on paper,
25¾ × 19⅞″. Collection the
artist

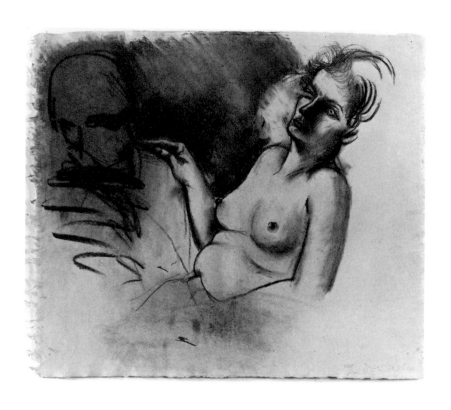

64. *Untitled.* 1975. Charcoal
on paper, 24½ × 28″.
Collection the artist

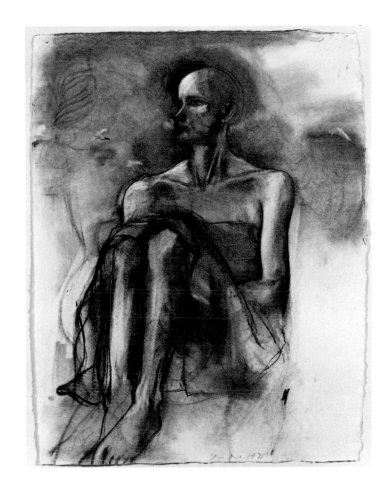

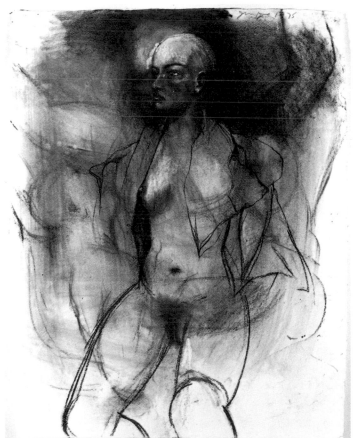

65. *Study for the Nurse.*
1975. Charcoal, oil, and
crayon on paper,
39½ × 30″. Collection
Nelson Blitz, Jr.

66. *The Nurse.* 1975.
Charcoal, oil, and crayon on
paper, 40 × 30¼″. Courtesy
Waddington Galleries,
London

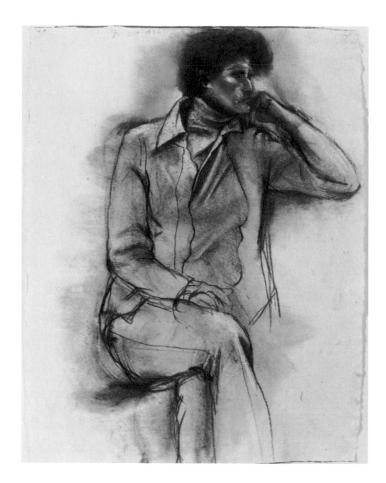

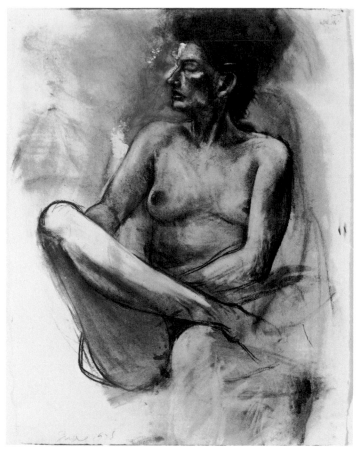

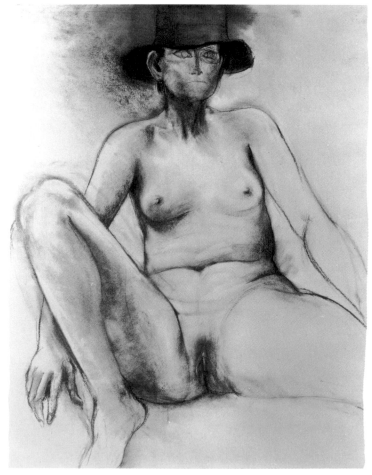

67. *The Russian Poetess*.
1975. Charcoal, oil, and
crayon on paper,
39¼ × 29¼″. Collection
Mr. and Mrs. Jos. B.
Zimmerman

68. *The Cellist*. 1975.
Charcoal, oil, and crayon on
paper, 39¾ × 29½″. The
Art Gallery of Western
Australia, Perth

69. *A Fancy Lady*. 1975.
Charcoal, oil, and crayon on
paper, 40 × 30″. Private
collection, London

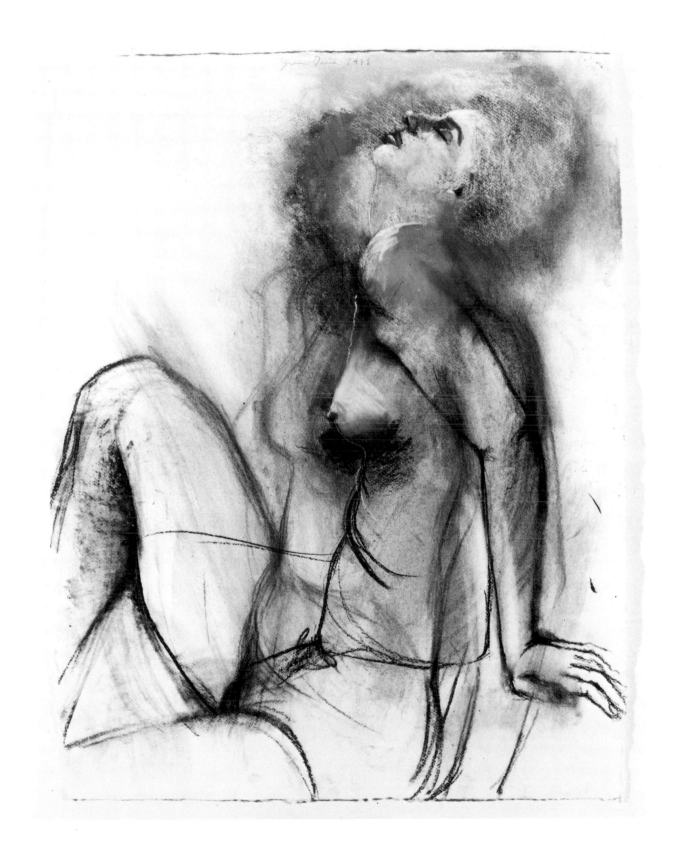

70. *The Swimmer*. 1975.
Charcoal, oil, and crayon on
paper, 39¾ x 29¼″. Private
collection

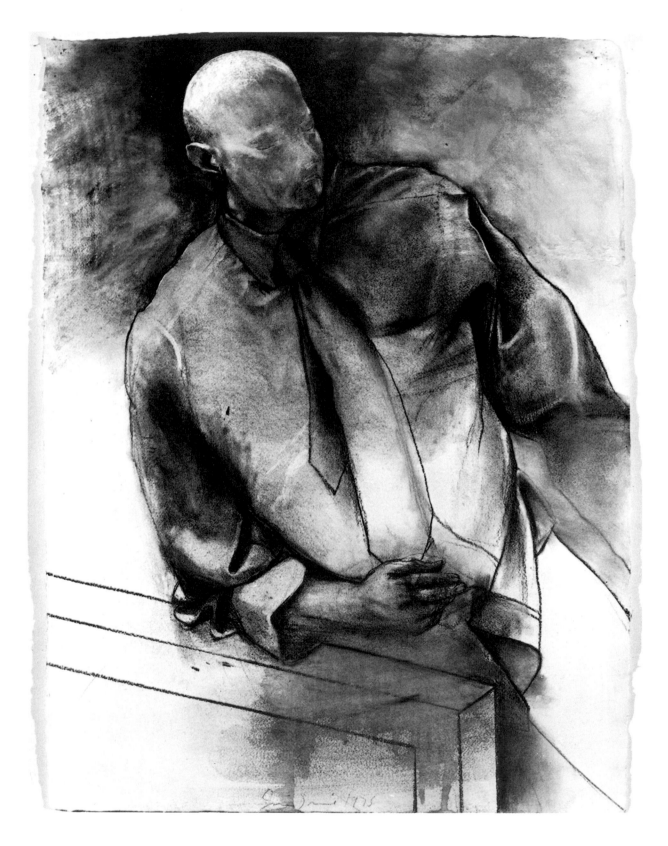

71. *Cher Maître.* 1975.
Charcoal, oil, and crayon on
paper, 40 × 29″. Collection
Lord and Lady Hartington

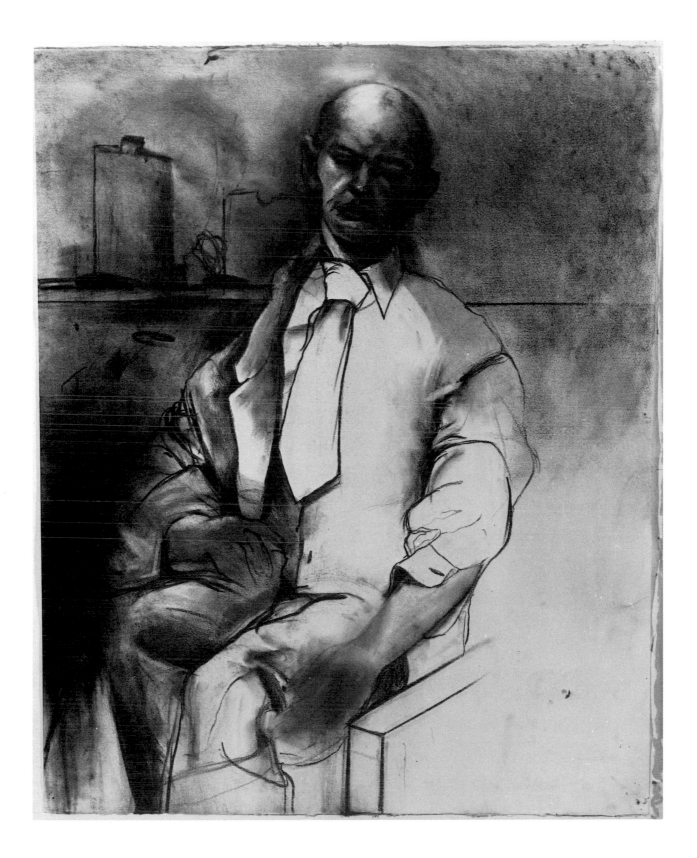

72. *The Die-Maker*. 1975.
Charcoal, oil, and crayon on
paper, 40 × 30″. British
Museum, London

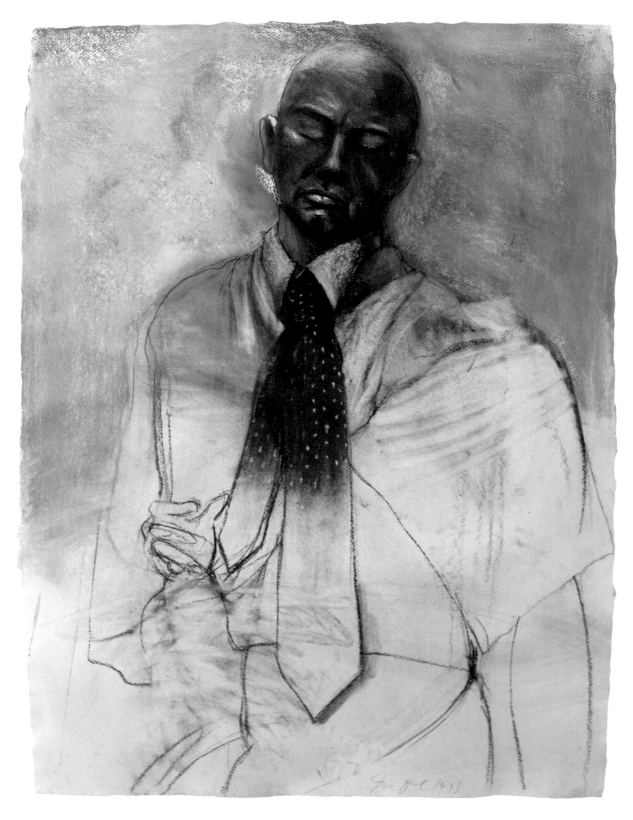

73. *The Green Polka-Dot Tie.*
1975. Charcoal, oil, and crayon
on paper, 39½ × 29¾". Collec-
tion Mr. and Mrs. Edward L.
Gardner, New York

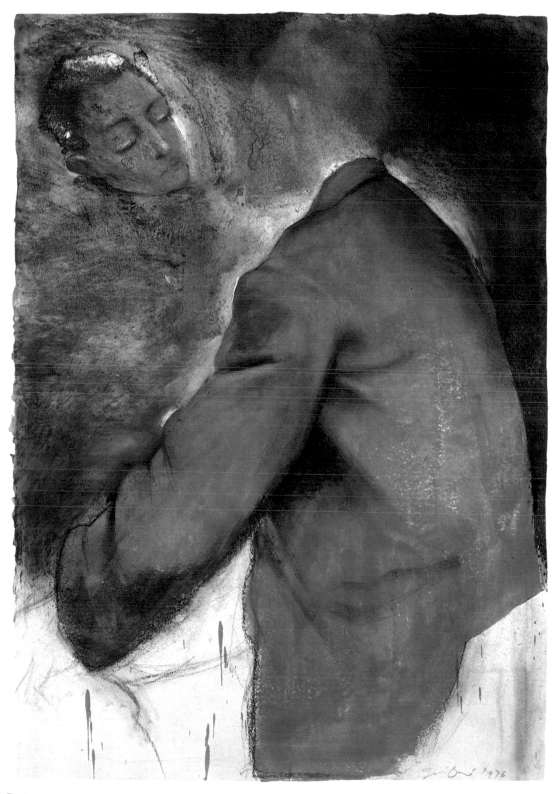

74. *Man in a Brown Coat Visiting the Sick*. 1976. Charcoal, oil, and crayon on paper, 45½ × 31½″. The Cleveland Museum of Art. Gift of Mrs. Albrecht Saalfield

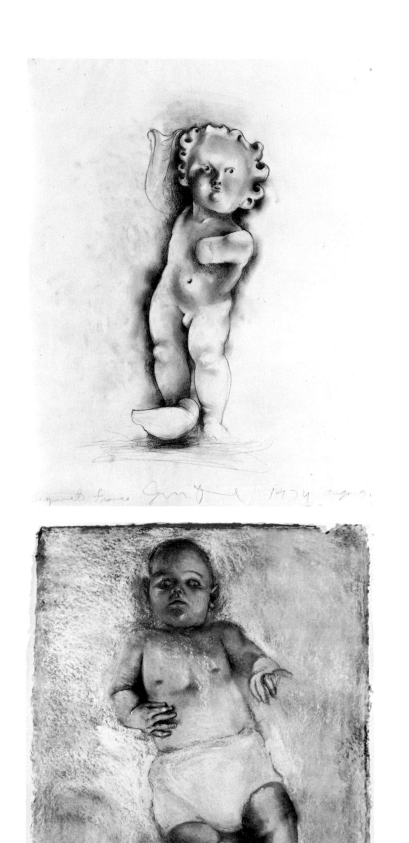

75. *Untitled*. 1974. Graphite on paper, 23½ × 17⅝″. Collection the artist

76. *First Baby Drawing*. 1976. Charcoal, oil, and crayon on paper, 40 × 30″. Private collection, Tokyo

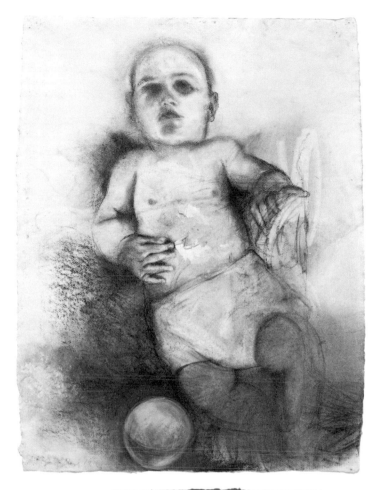

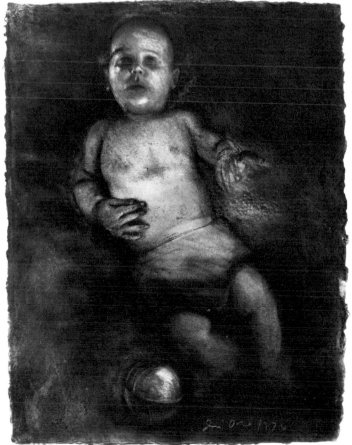

77. *Third Baby Drawing*.
1976. Charcoal, oil, and
crayon on paper,
39⅞ × 29″. The Museum of
Modern Art, New York. Gift
in honor of Myron Orlofsky

78. *The Second Baby
Drawing*. 1976. Charcoal,
oil, and crayon on paper,
39½ × 30″. The Museum of
Modern Art, New York. Gift
of Mr. and Mrs. Douglas
Auchincloss

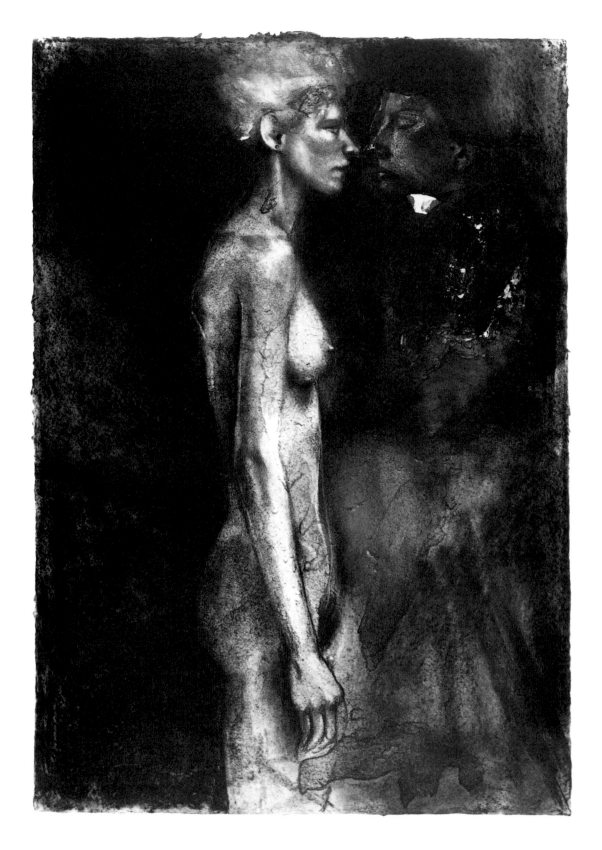

79. *The Thin Model.* 1976.
Charcoal, oil, and crayon on
paper, 45½ × 31½".
Private collection

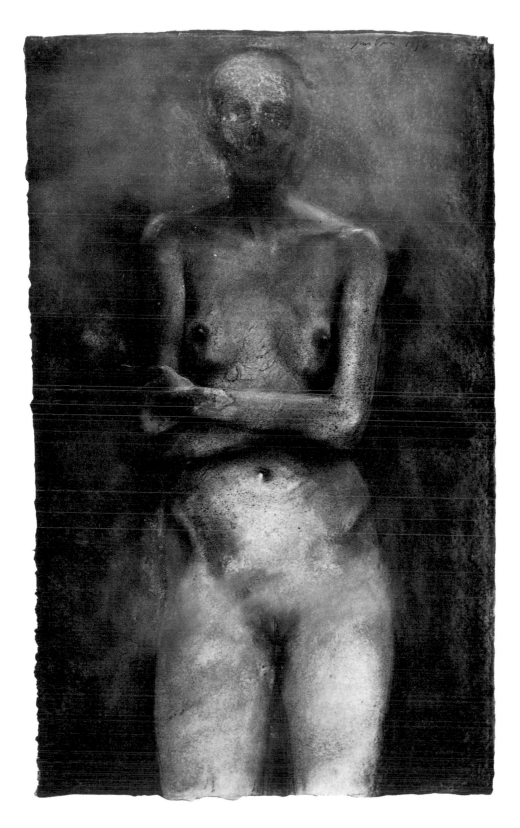

80. *A Study from Blake.*
1976. Charcoal, oil, and
crayon on paper,
45½ × 28″. Collection the
artist

115

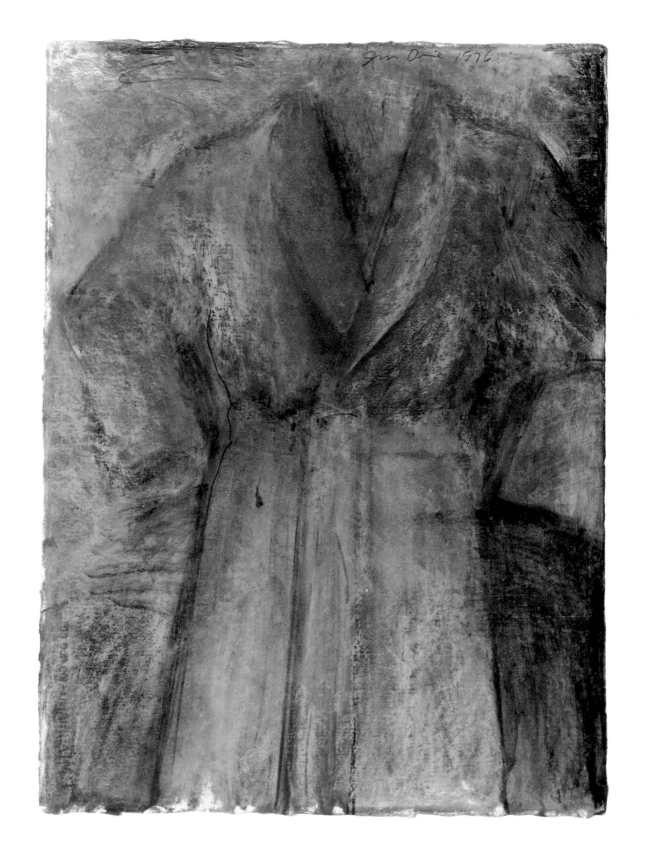

81. *Untitled (Robe)*. 1976.
Oil and charcoal on paper,
30¼ × 22". Private
collection

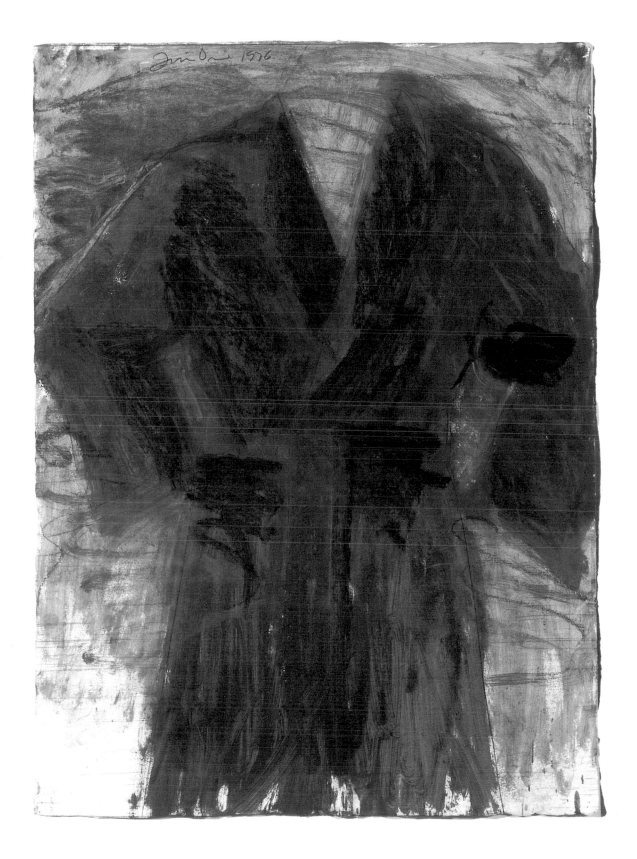

82. *Untitled (Robe)*. 1976.
Oil and charcoal on paper,
30 × 22¼". Collection
Marcia and Irving Stenn, Jr.

117

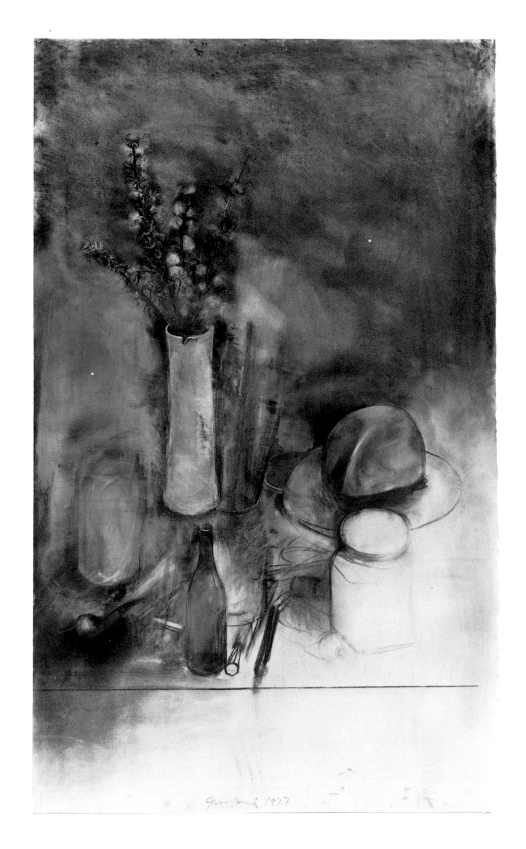

83. *Untitled Still Life*. 1977.
Charcoal and pastel on
paper, 60 × 36″. Collection
the artist

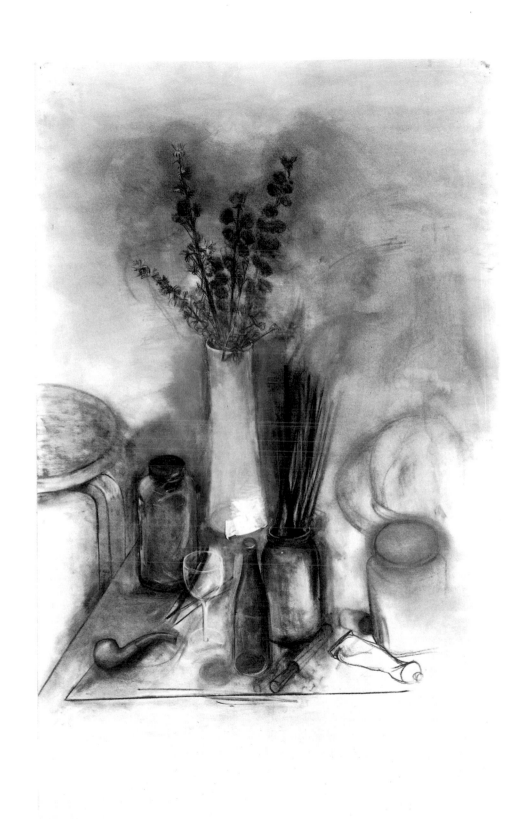

84. *Untitled Still Life*. 1977.
Charcoal and pastel on
paper, 60 × 36″. Collection
the artist

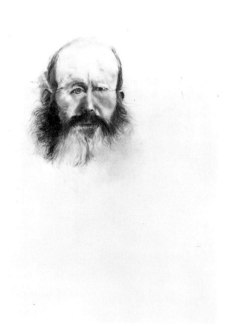

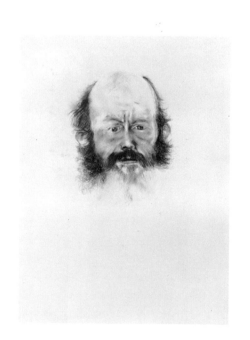

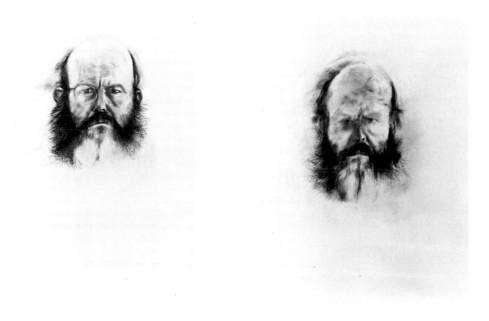

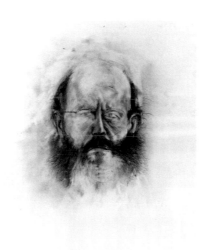

85. *Nine Self-Portraits (With a Very Long Beard)*. 1977.
Graphite on paper, nine
sheets, 30 × 22″ each.
Collection the artist

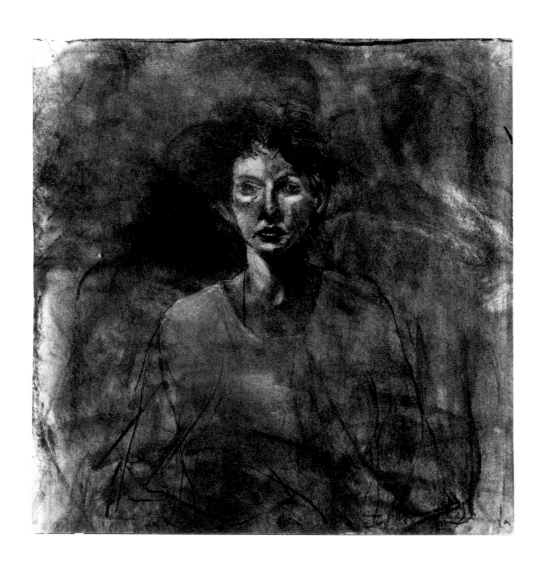

86. *Nancy in Grey, Putney.*
1975. Charcoal and chalk on
paper, 33 × 31¾″. Galerie
Alice Pauli, Lausanne

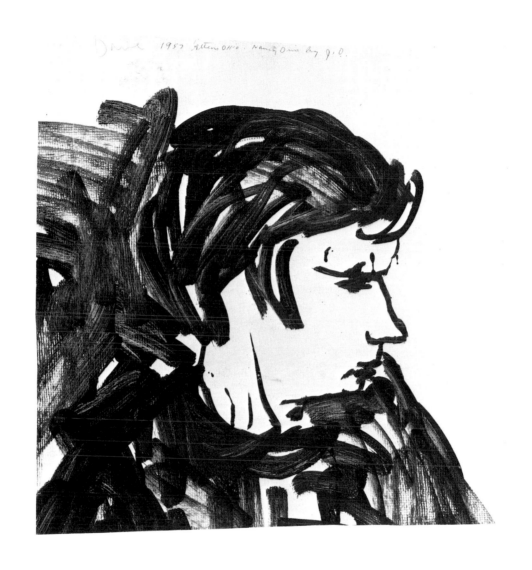

87. *Nancy Dine.* 1957.
Gouache on paper,
19¾ × 19⅛″. Collection the
artist

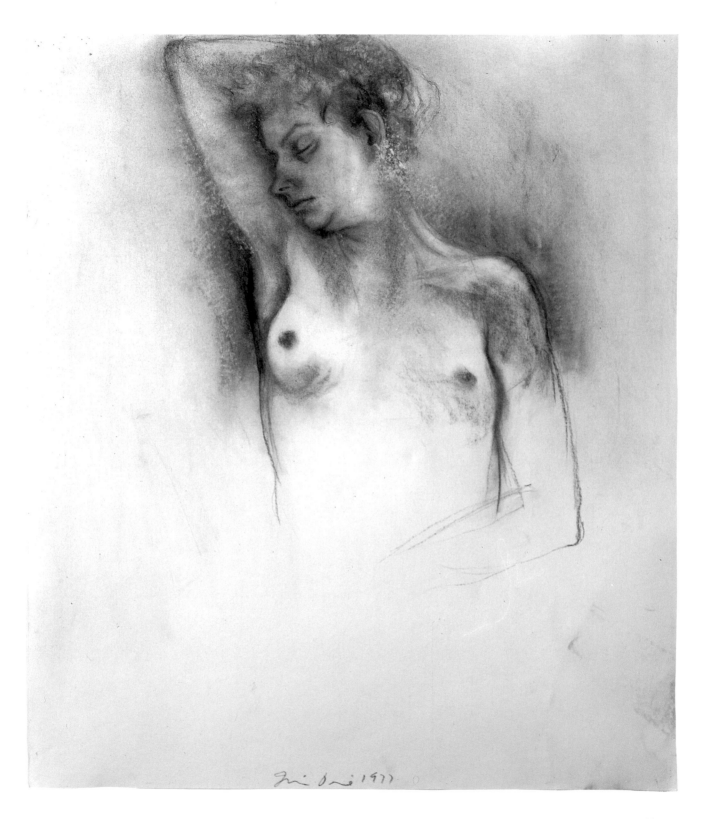

88. *Nancy, Sleeping in a Green Light.* 1977. Charcoal and pastel on paper, 45 × 38″. Collection Mr. and Mrs. Edward L. Gardner, New York

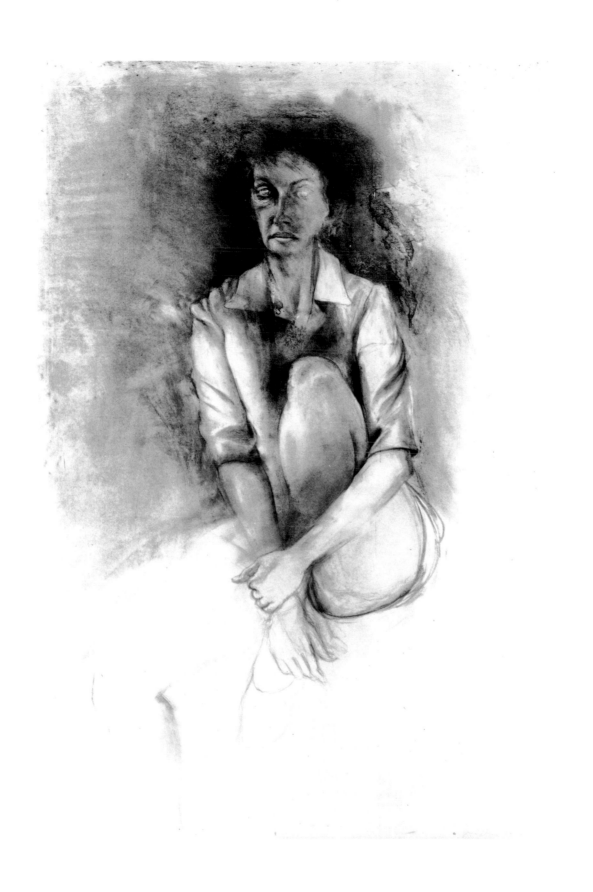

89. *Untitled*. 1977. Charcoal
on paper, 60 × 40″.
Collection the artist

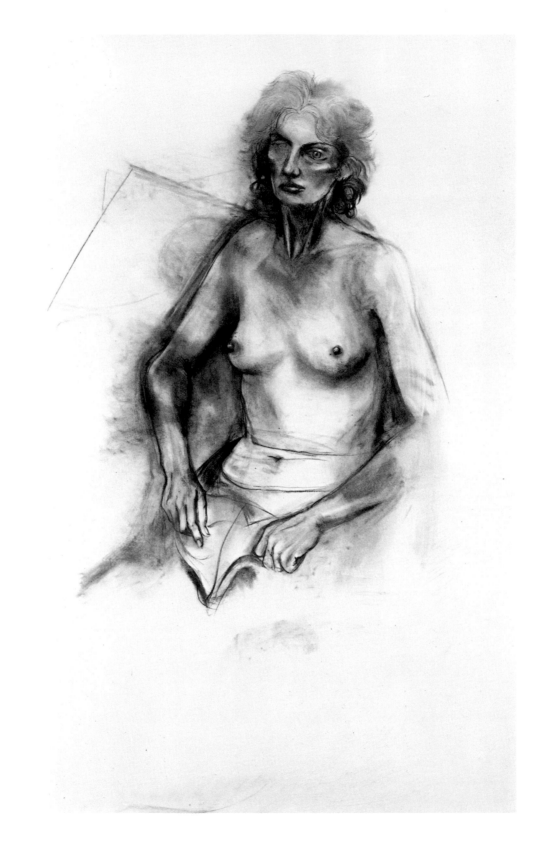

90. *Untitled.* 1977.
Charcoal on paper,
60 × 40″. Collection the
artist

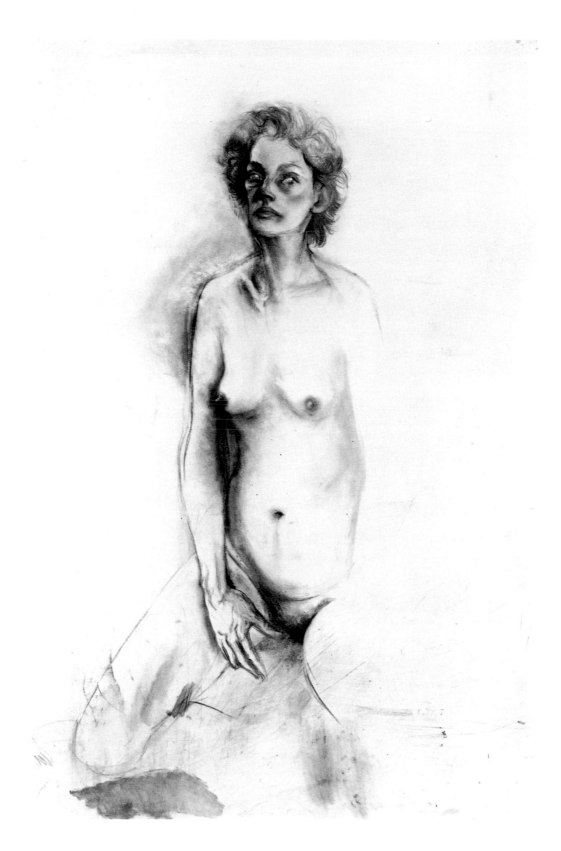

91. *Untitled.* 1977.
Charcoal on paper,
60 × 36″. Collection the
artist

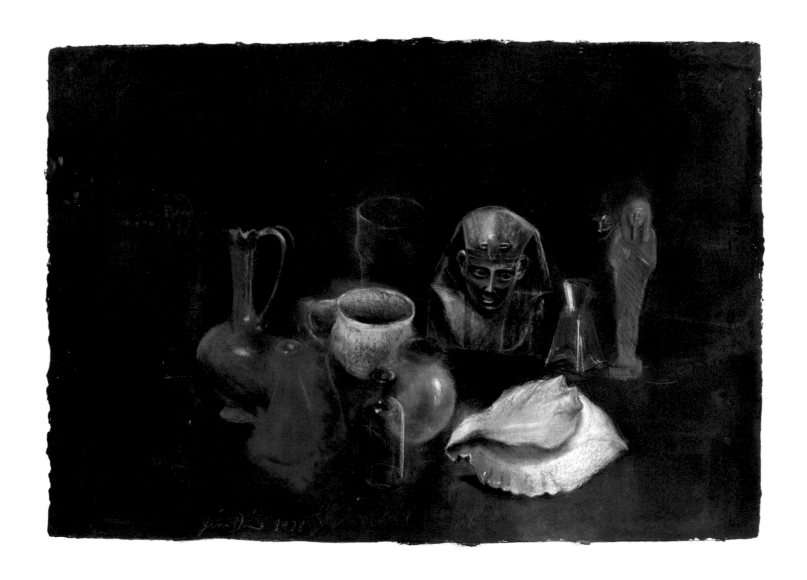

92. *Untitled Black Drawing #3.* 1978. Mixed mediums on paper, 31¾ × 45½". Charles Foley Gallery, Columbus, Ohio

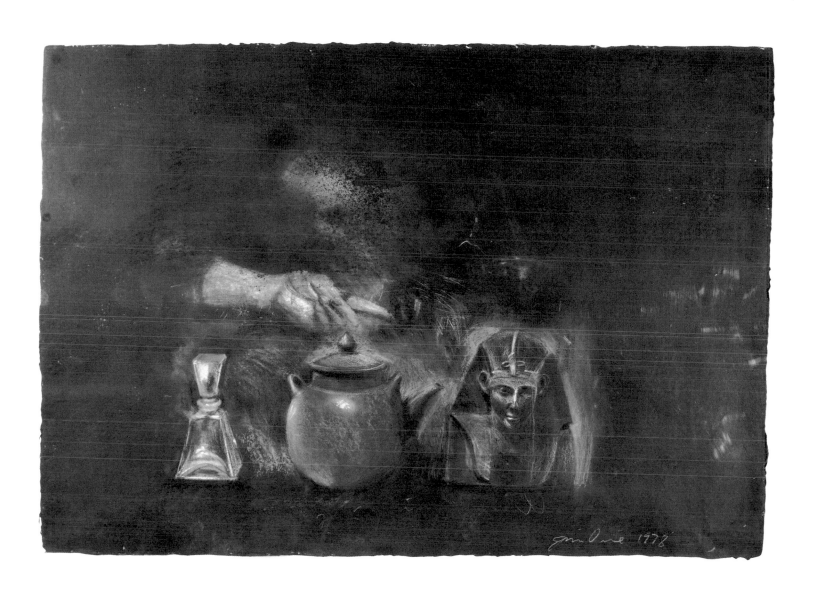

93. *Untitled Black Drawing
#5.* 1978. Mixed mediums
on paper, 31¾ × 45½".
Private collection

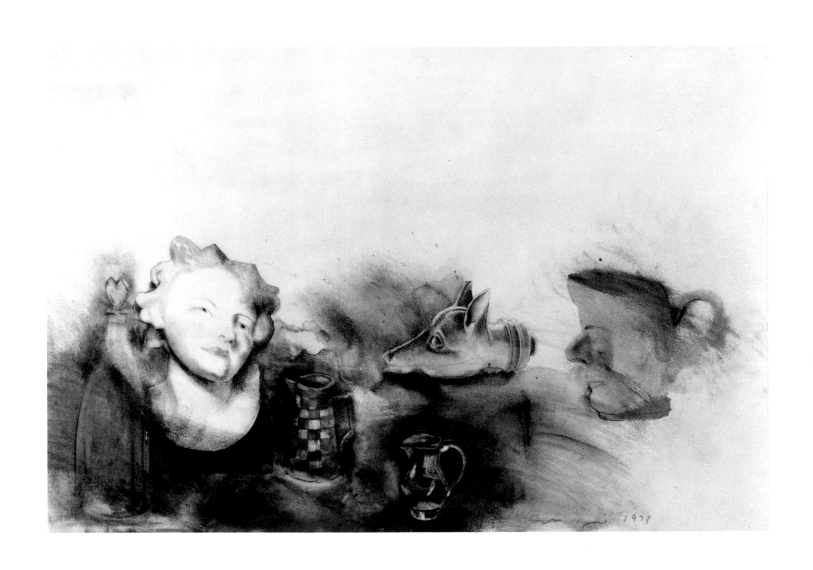

94. *Untitled Still Life
(Chelsea Head)*. 1978. Mixed
mediums on paper,
27½ × 40″. Courtesy The
Pace Gallery, New York

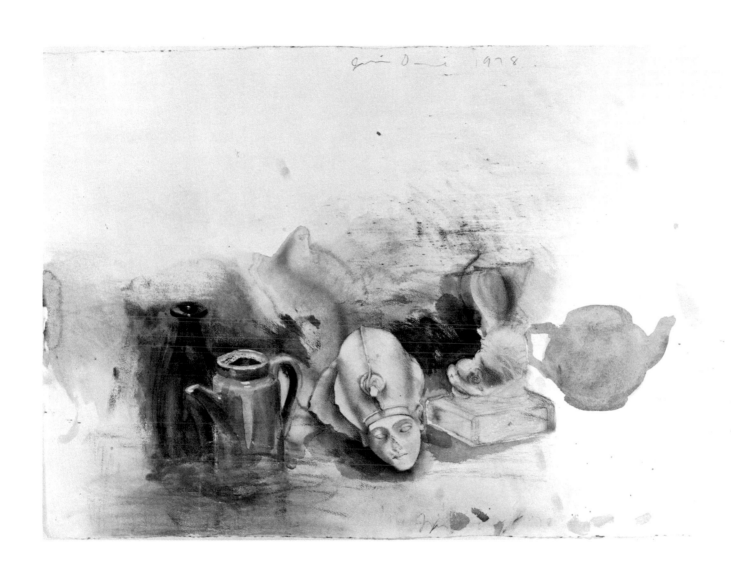

95. *Untitled Still Life*. 1978.
Mixed mediums on paper,
27¼ × 40¾″. Private
collection

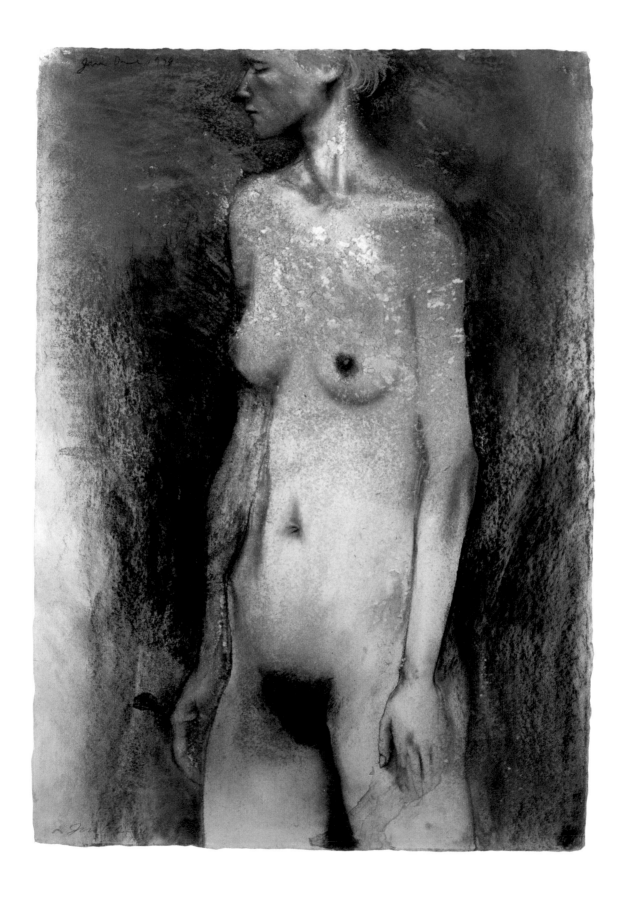

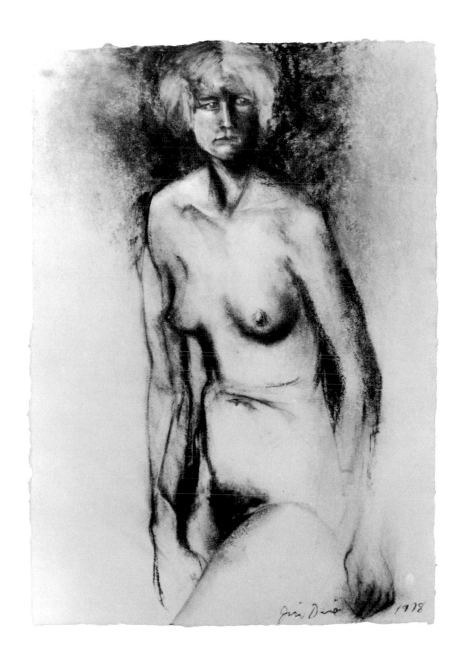

96. *Turquoise Chalk on
Jessie's Face.* 1978. Charcoal
and pastel on paper,
41½ × 31¾″. Private
collection, New York

97. *The Blond Runner #1.*
1978. Charcoal and pastel on
paper, 41½ × 31¾″.
Collection the artist

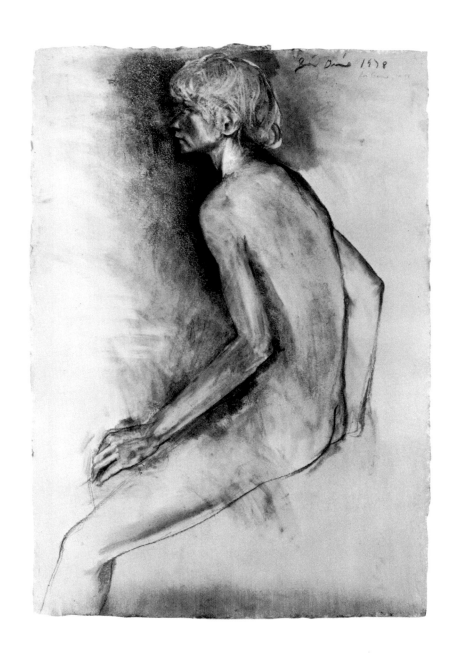

98. *Untitled.* 1978. Charcoal
and pastel on paper,
46 × 32″. Private collection

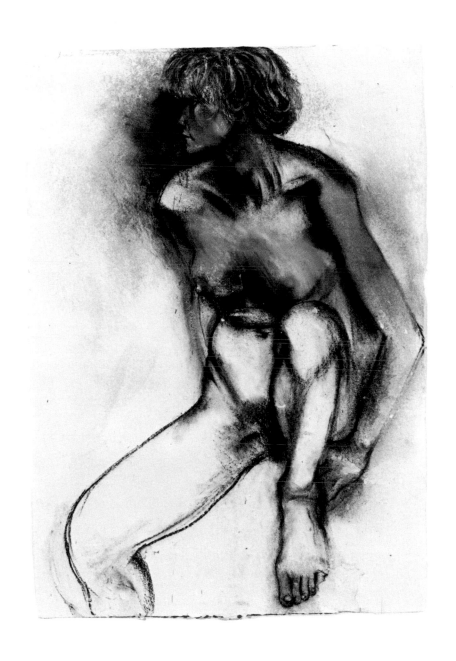

99. *The Blond Runner #2*.
1978. Charcoal and pastel on
paper, 45½ × 31¾″.
Collection Nan and Gene
Corman, Beverly Hills,
California

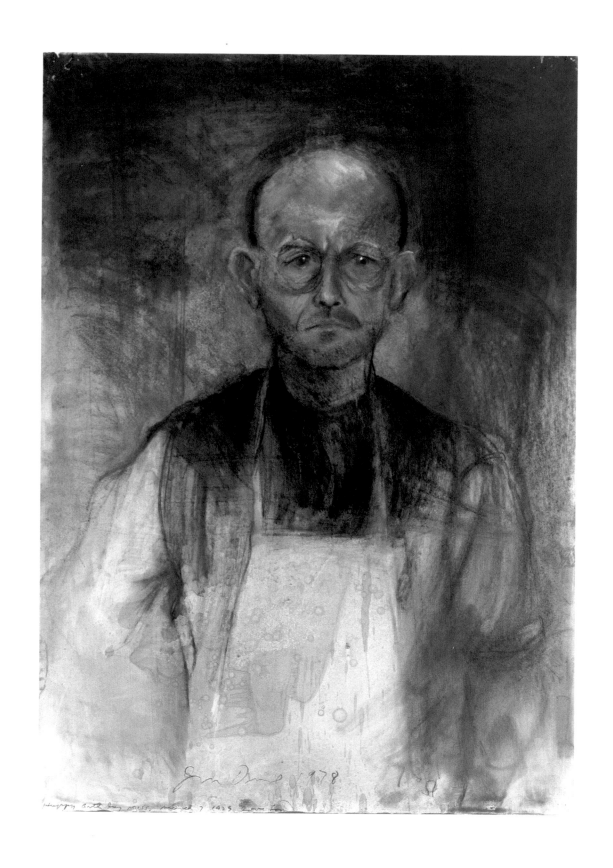

100. *Self-Portrait*. 1978.
Charcoal and pastel on
paper, 41½ × 29½".
Collection the artist

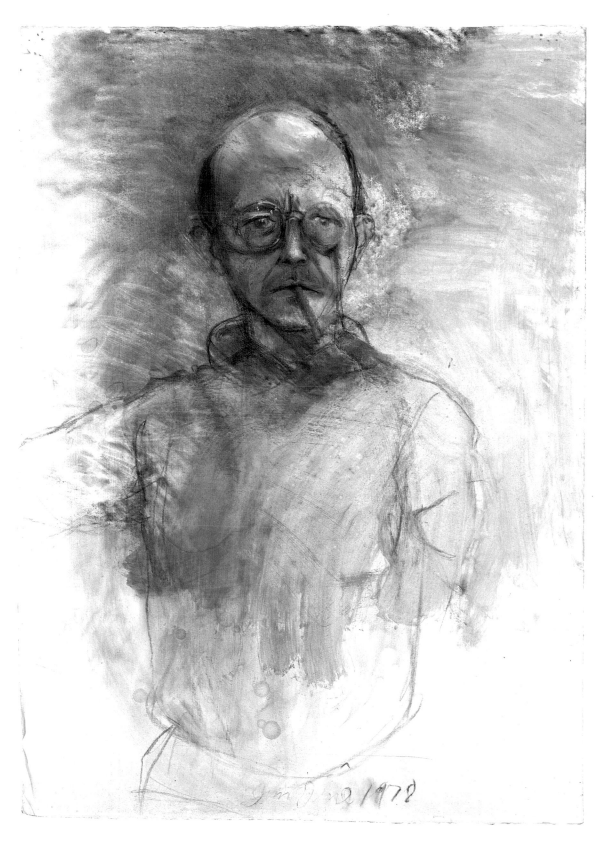

101. *Self-Portrait with Cigar.*
1978. Oil and pastel on
paper, 44½ × 29½″.
Private collection, Lausanne

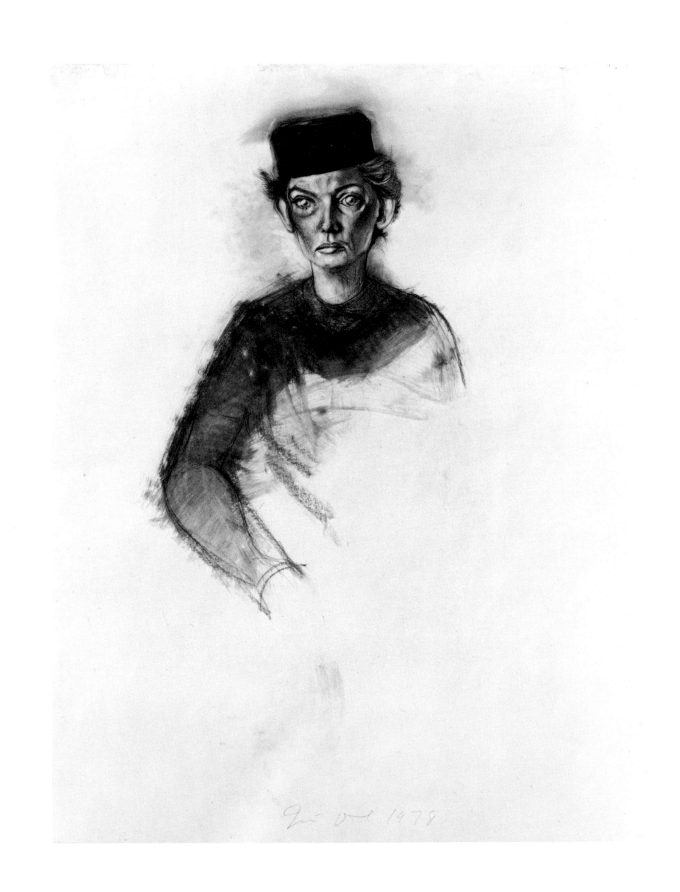

102. *Nancy.* 1978. Charcoal
on paper, 50 × 38¼".
Collection the artist

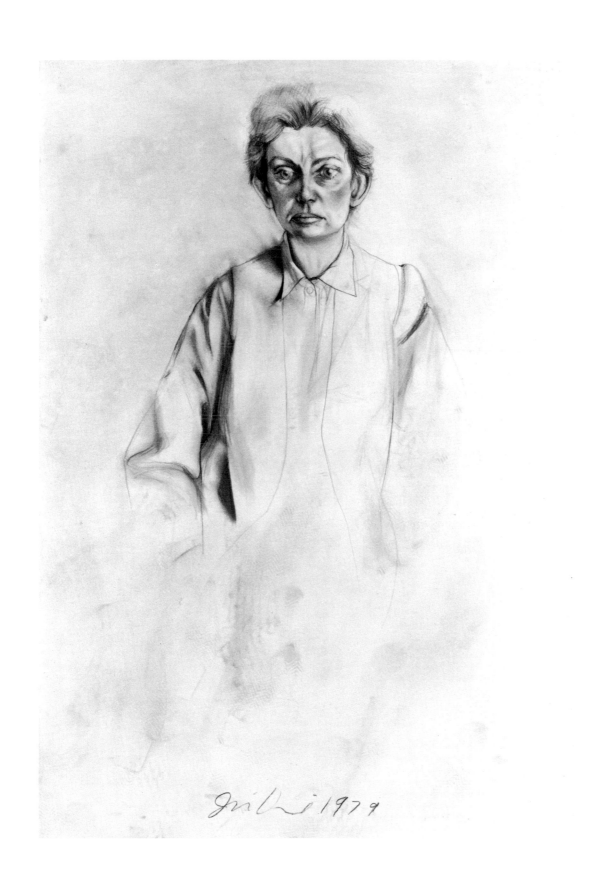

103. *Nancy*. 1979. Graphite
on paper, 50 × 34⅞″.
Collection the artist

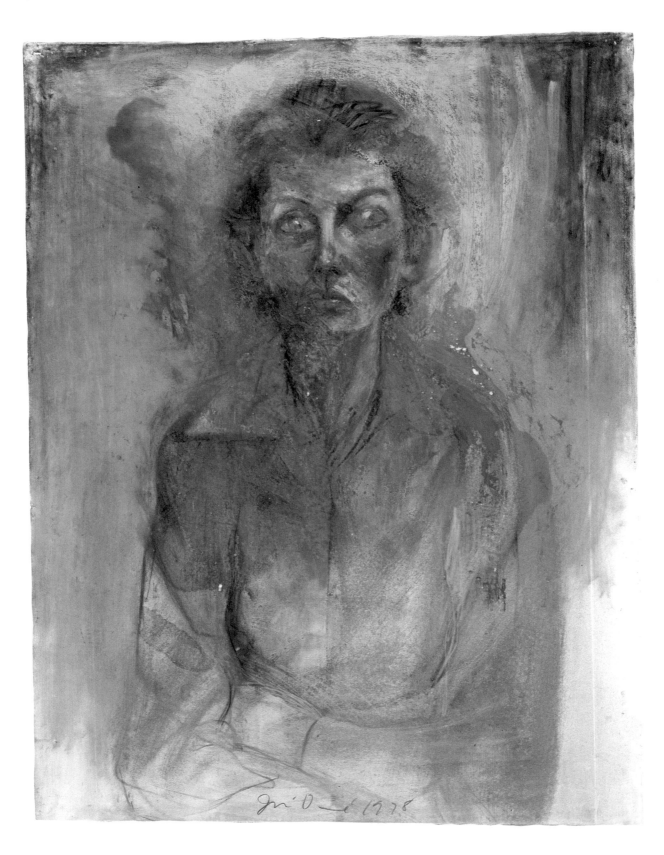

104. *Nancy.* 1978. Charcoal
and pastel on paper,
38 × 29⅜". Collection the
artist

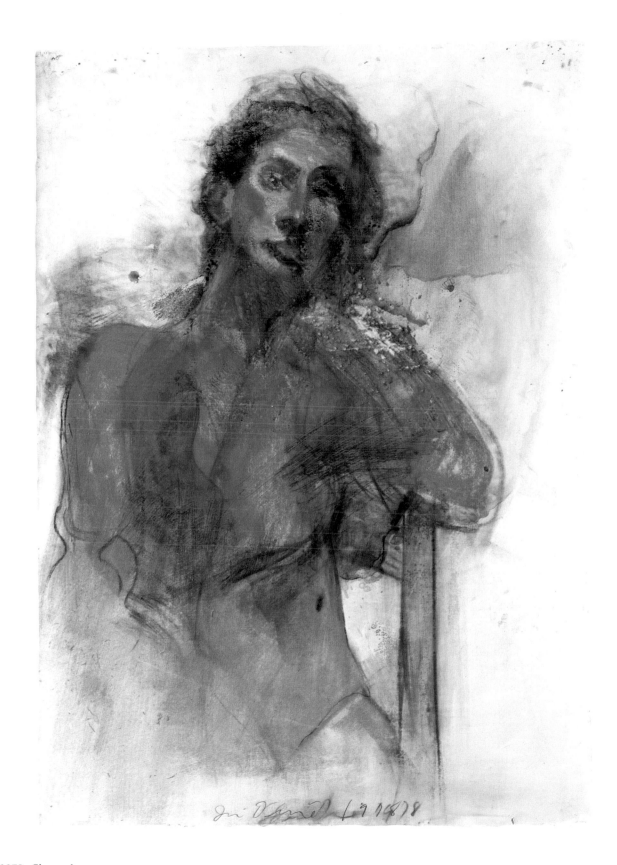

105. *Nancy*. 1978. Charcoal
and pastel on paper,
41½ × 29½″. Collection the
artist

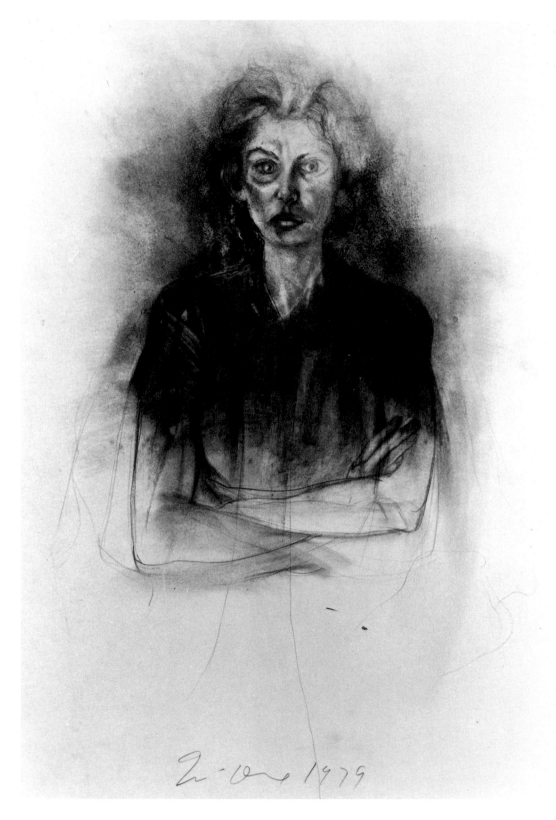

106. *Nancy Dine*. 1979.
Charcoal, graphite, oil, and
ink on paper, 44 × 31″.
Private collection, Deerfield,
Illinois

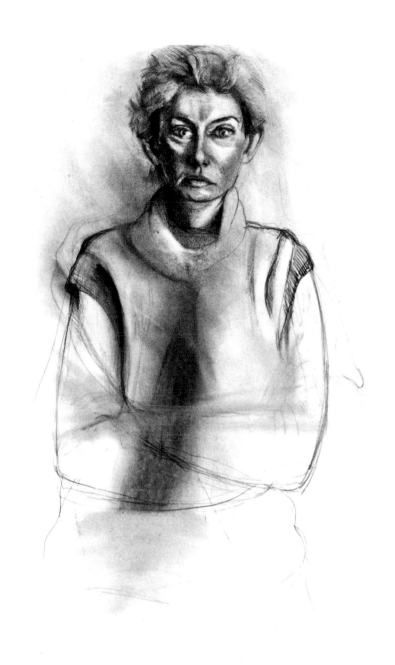

107. *Nancy with Crossed
Arms.* 1979. Charcoal and
graphite on paper,
50 × 38½″. Collection the
artist

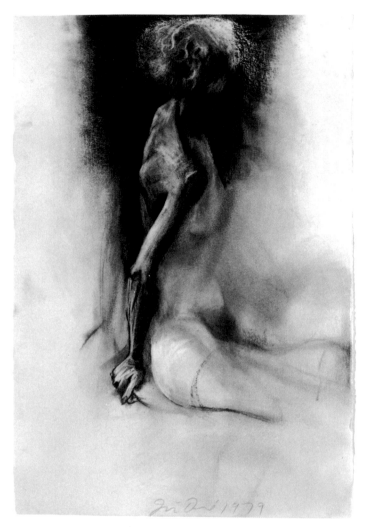

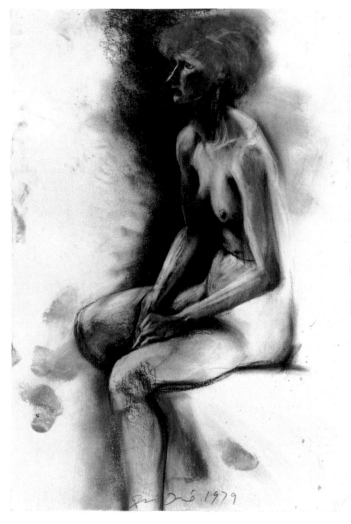

108. *Drawing, Jessie in the Spring on a Large Sheet #6.* 1979. Charcoal and chalk on paper, 59¾ × 40¼″. Collection L. H. Wexner, Columbus, Ohio

109. *Drawing, Jessie in the Spring on a Large Sheet #2.* 1979. Charcoal and pastel on paper, 59¾ × 40¼″. Collection Harold and Sandy Price

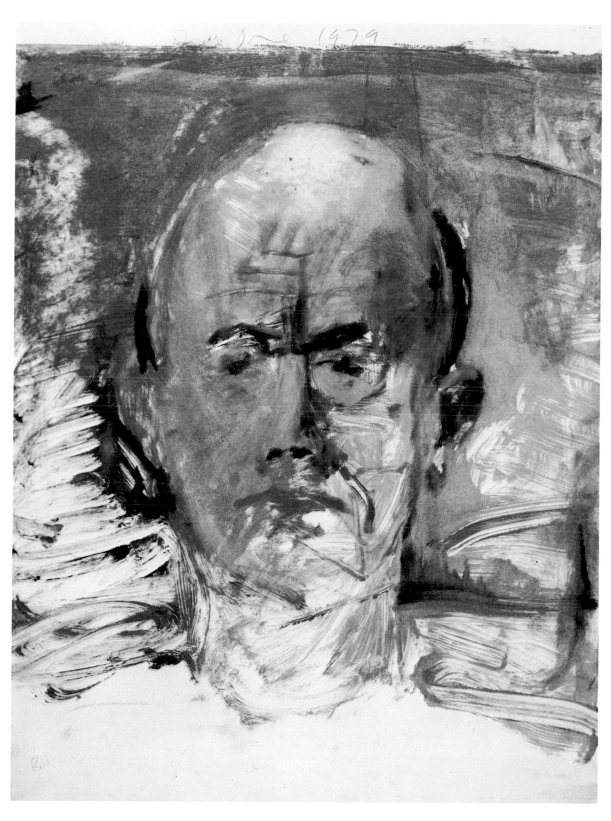

110. *Self-Portrait in Cambridge (#2).* 1979. Oil
and charcoal on paper,
30 × 22¼". Galerie Alice
Pauli, Lausanne

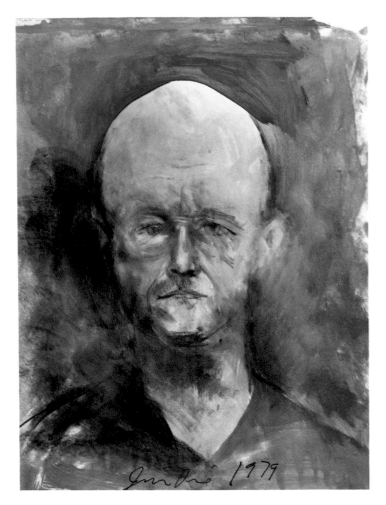

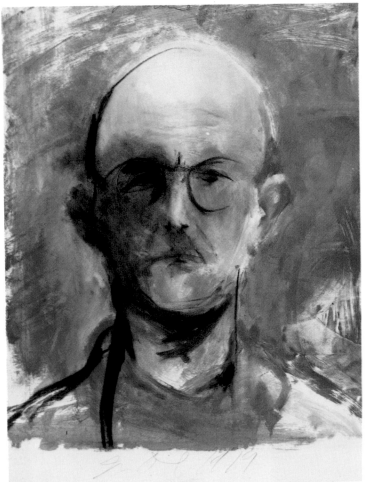

111. *Self-Portrait in Cambridge (#3)*. 1979. Oil and charcoal on paper, 28¾ × 22¼". Galerie Claude Bernard, Paris

112. *Self-Portrait in Cambridge (#1)*. 1979. Oil and charcoal on paper, 30½ × 22". Galerie Claude Bernard, Paris

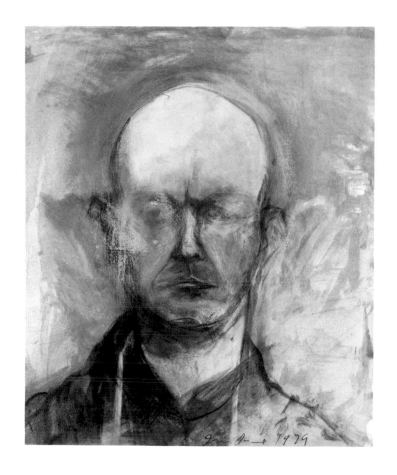

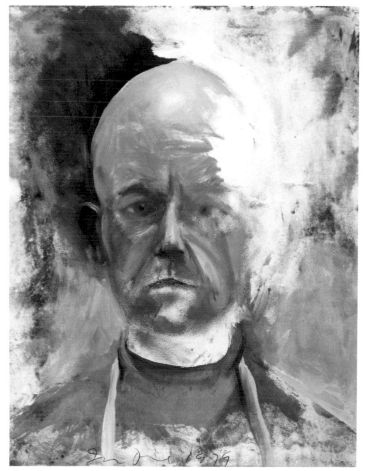

113. *Self-Portrait in Cambridge (#5)*. 1979. Oil and charcoal on paper, 26 × 22″. Private collection, Brooklyn, New York

114. *Self-Portrait in Cambridge (#4)*. 1979. Oil and charcoal on paper, 28¼ × 22¾″. Galerie Claude Bernard, Paris

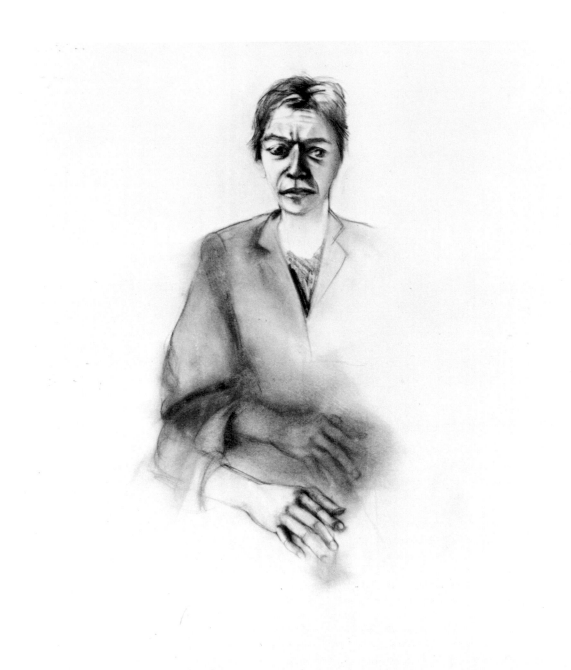

115. *The American Painter Susan Rothenberg*. 1978–79. Charcoal and graphite on paper, 50 × 38½″. Courtesy The Pace Gallery, New York

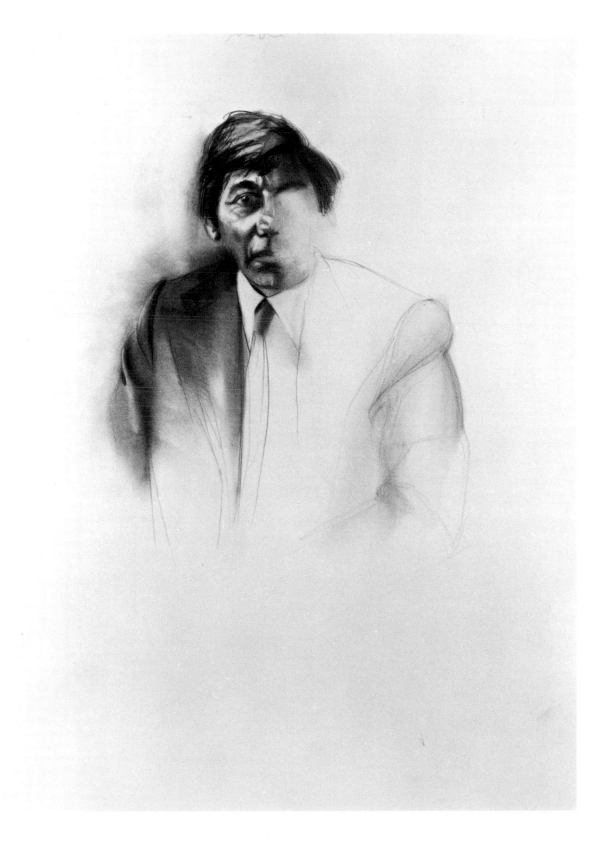

116. *Mr. Blitz (#5)*. 1979.
Charcoal and graphite on
paper, 50 × 38¼".
Collection the artist

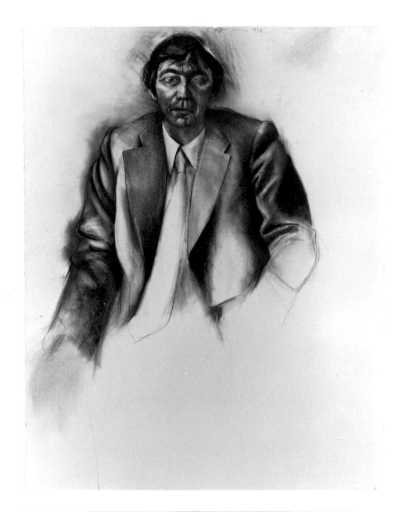

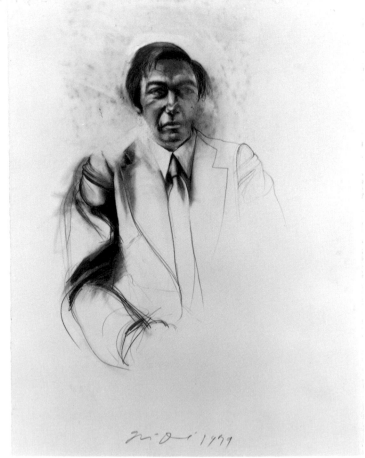

117. *Mr. Blitz (#2)*. 1979.
Charcoal and graphite on
paper, 50 × 38¼″.
Collection the artist

118. *Mr. Blitz (#4)*. 1979.
Charcoal and graphite on
paper, 50 × 38¼″.
Collection the artist

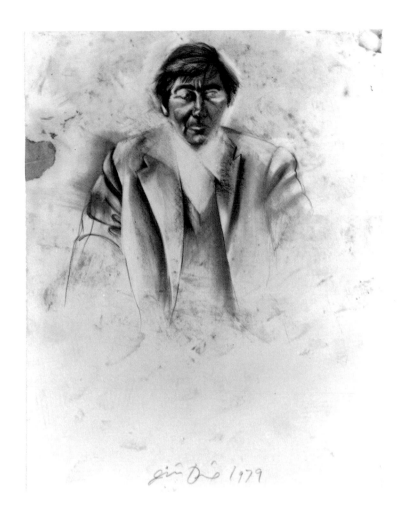

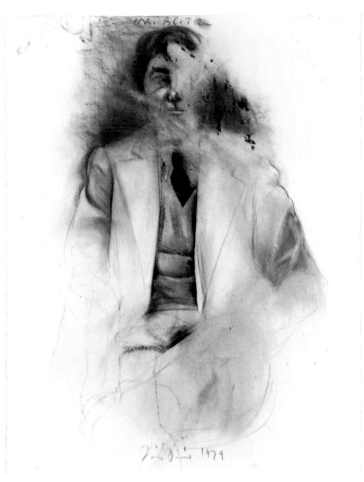

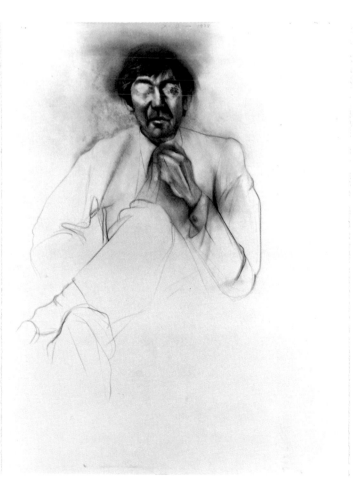

119. *Mr. Blitz (#3)*. 1979.
Charcoal and graphite on
paper, 50 × 38¼″. Richard
Gray Gallery, Chicago

120. *Mr. Blitz (#6)*. 1979.
Charcoal and graphite on
paper, 50 × 38¼″. Galerie
Alice Pauli, Lausanne

121. *Mr. Blitz (#1)*. 1979.
Charcoal and graphite on
paper, 50 × 38¼″.
Collection the artist

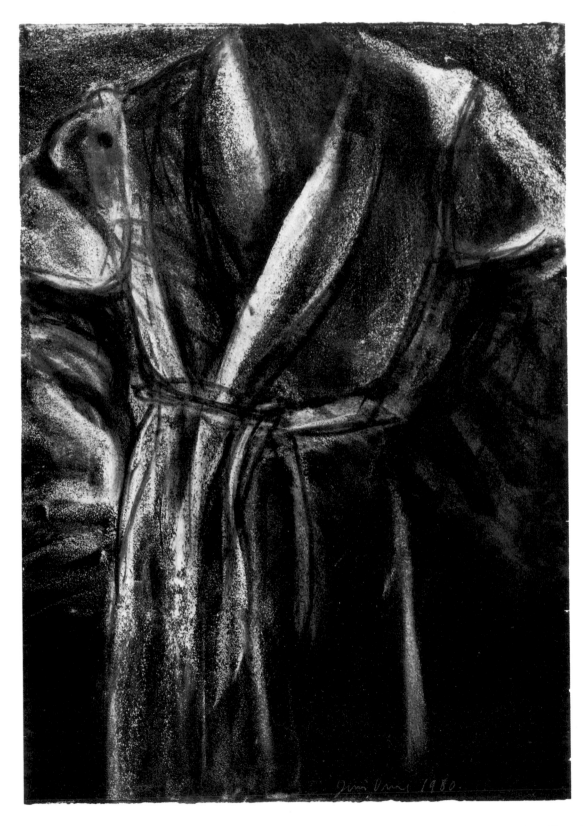

122. *Frosted Night Robe III.*
1980. Charcoal and chalk on
paper, 43 × 30½″. Courtesy
The Pace Gallery, New York

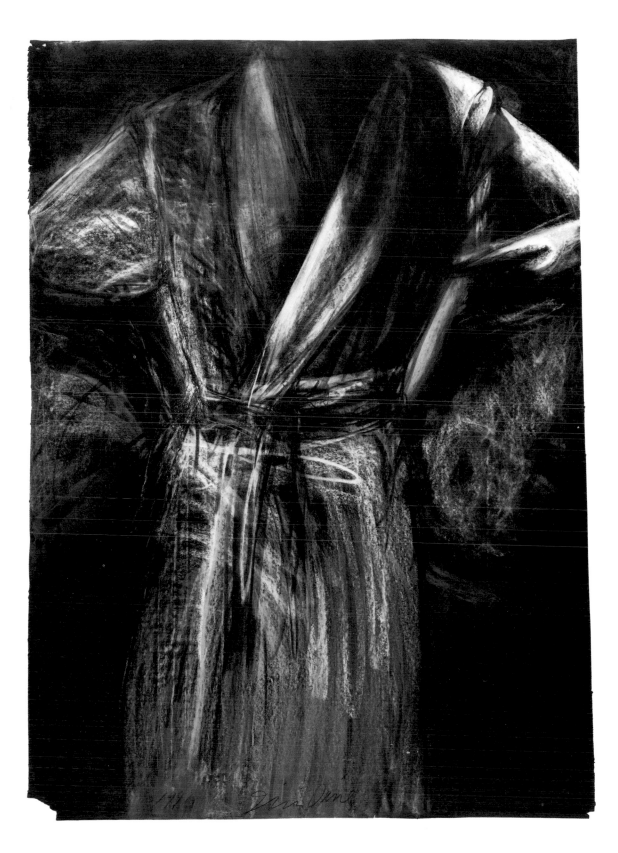

123. *Night Tailoring*. 1980.
Charcoal and pastel on
paper, 59 × 42″. Courtesy
The Pace Gallery, New York

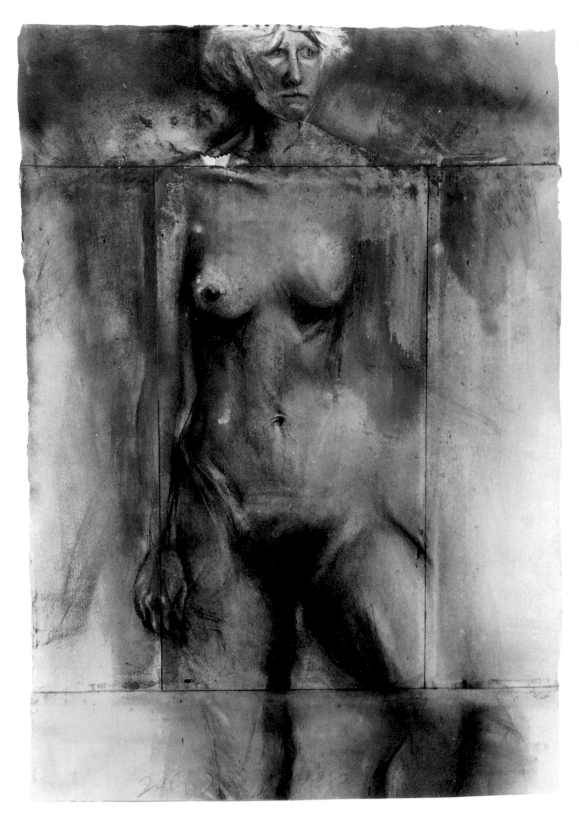

124. *Through the August Window*. 1980. Mixed mediums on paper, 57 × 39¾". Collection Mr. and Mrs. Aron B. Katz

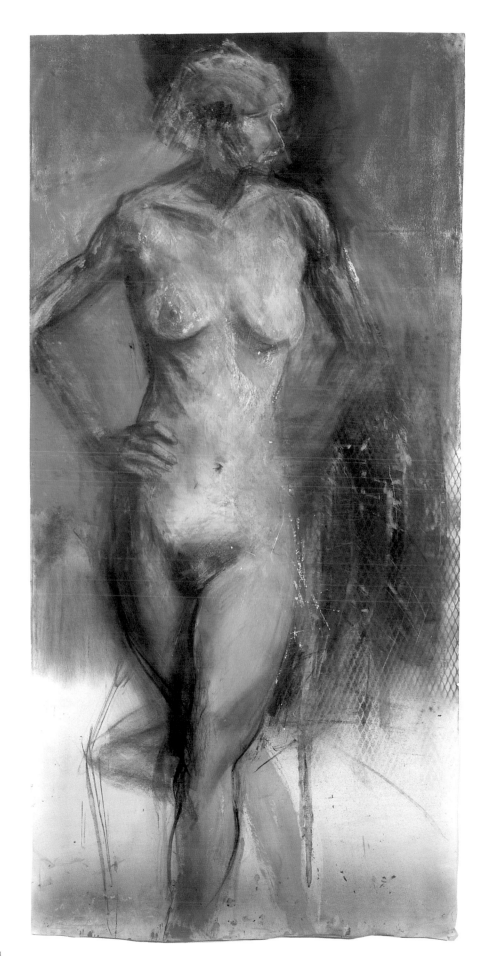

125. *Jessie (Big) Arms
Akimbo*. 1980. Mixed
mediums on paper,
75½ × 36″. Collection
William H. Plummer

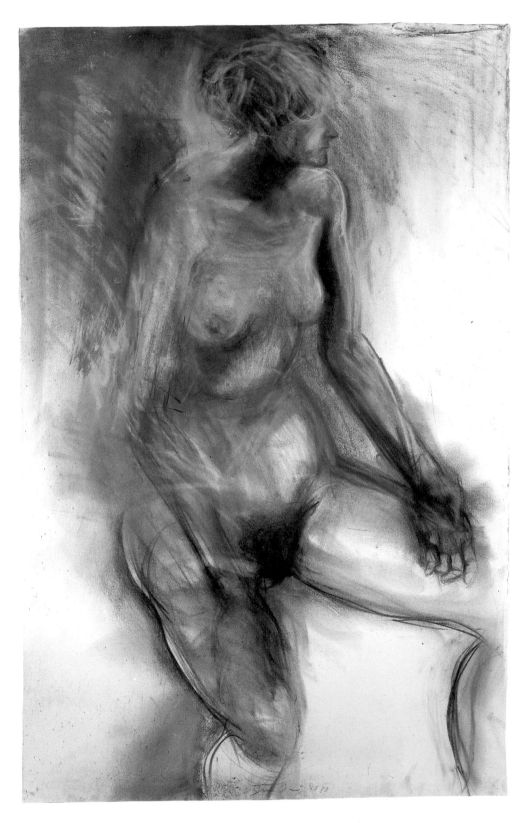

126. *Her Goofy Left Hand (In Charcoal)*. 1980. Mixed mediums on paper, 56 × 36¼". Collection Mr. and Mrs. Eduardo Zemborain

127. *Racing into Fashion
(Kenzo with Jess Over It).* 1980.
Mixed mediums on paper, 59¼
× 36¼". Collection Mr. and
Mrs. J. Camp Van Dyke

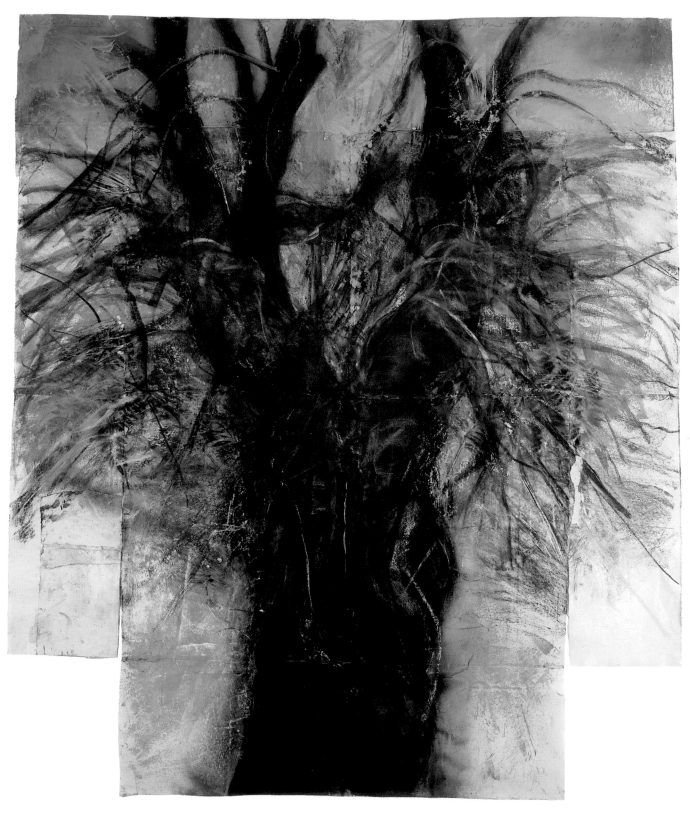

128. *The Tree (Kimono).*
1980. Mixed mediums on
paper, 71 × 60″. Museum of
Fine Arts, Boston.
Anonymous gift

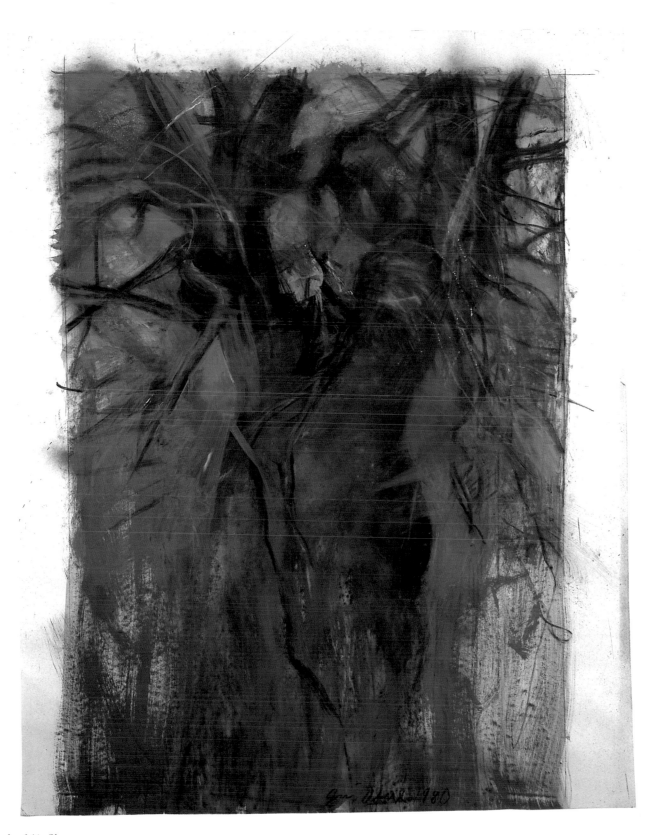

129. *A Touch of Air Shows Through*. 1980. Mixed mediums on paper, 74⅝ × 58⅝″. American Medical Association Art Collection

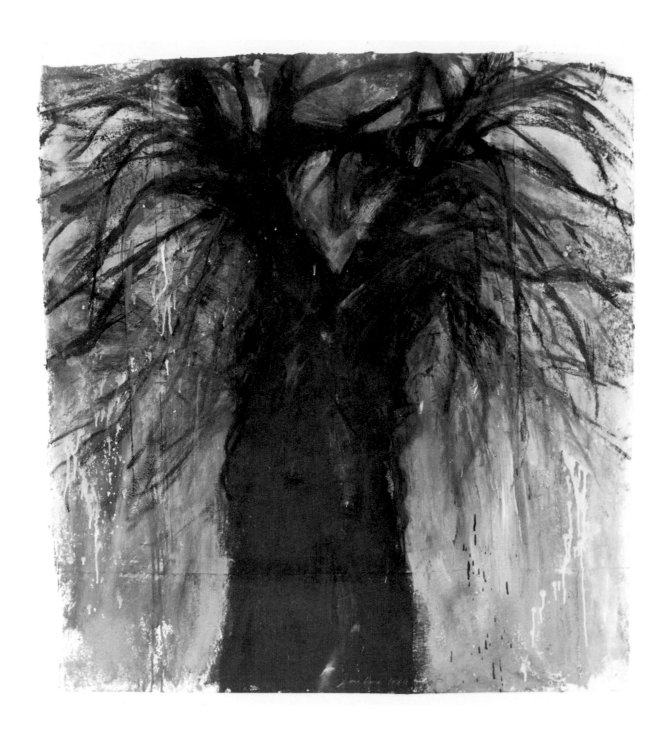

130. *Blue as Large as the Tree.* 1980. Mixed mediums on paper, 55 × 52″. Richard Gray Gallery, Chicago

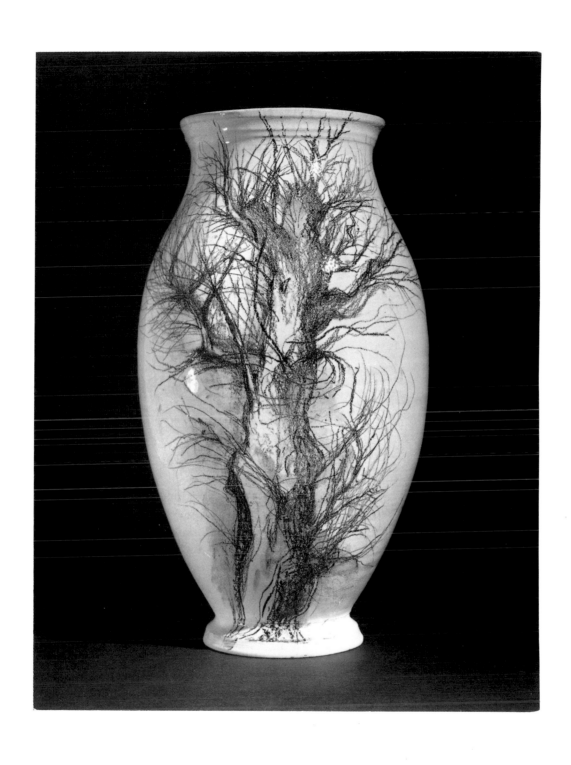

131. Ceramic pot. 1976.
(Mary Day Lanier, potter.)
Courtesy The Pace Gallery,
New York

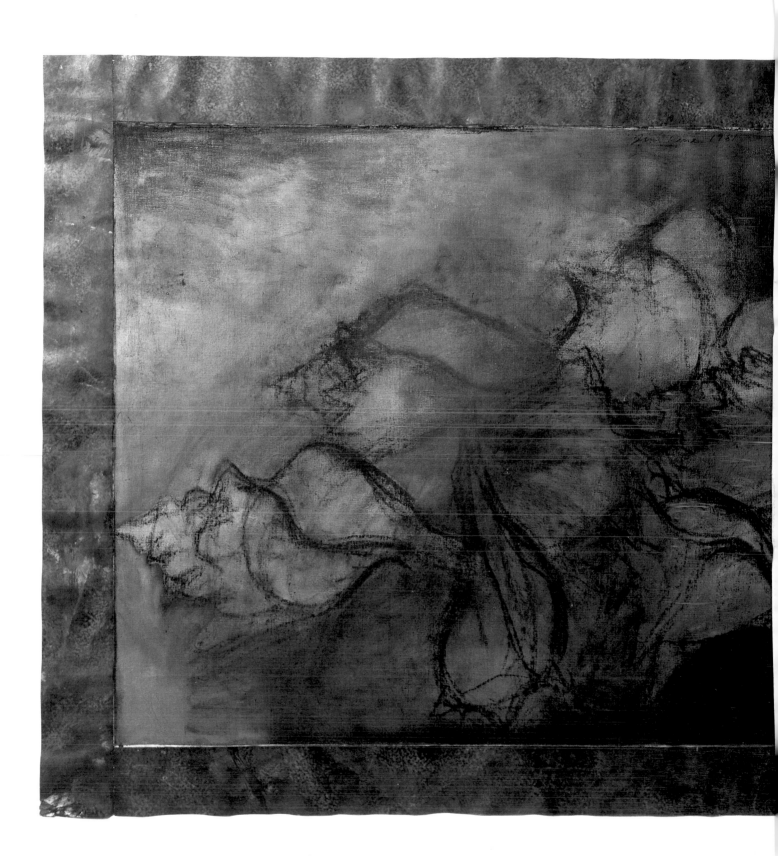

132. *Key West Picture*. 1981.
Oil, acrylic, charcoal, and
pastel on linen and paper,
44½ × 88″. Collection Mr.
and Mrs. Edward L.
Gardner, New York

133. *Desire (A Study)*. 1981.
Mixed mediums on paper,
39⅜ × 83″. Private
collection, Switzerland

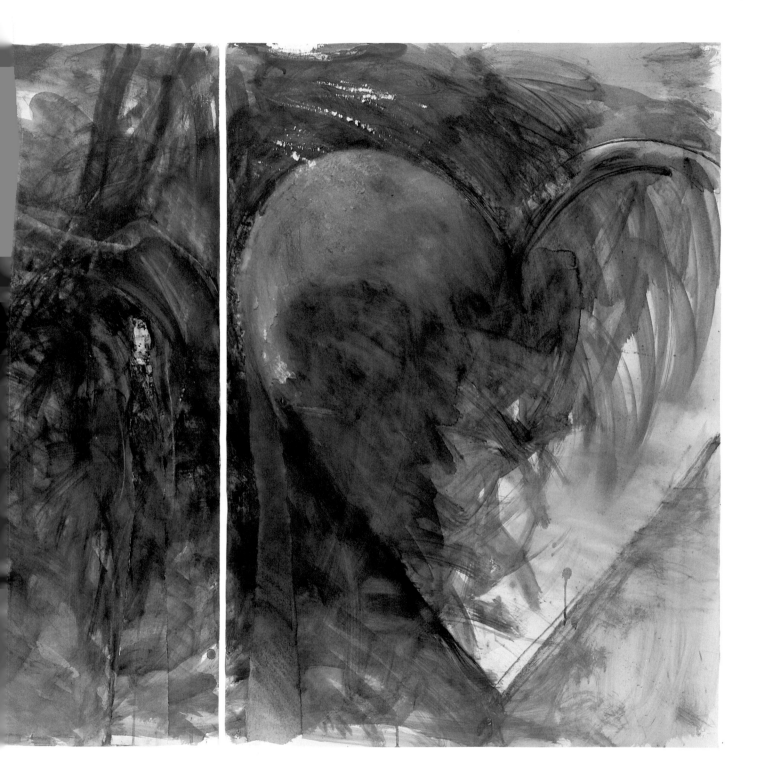

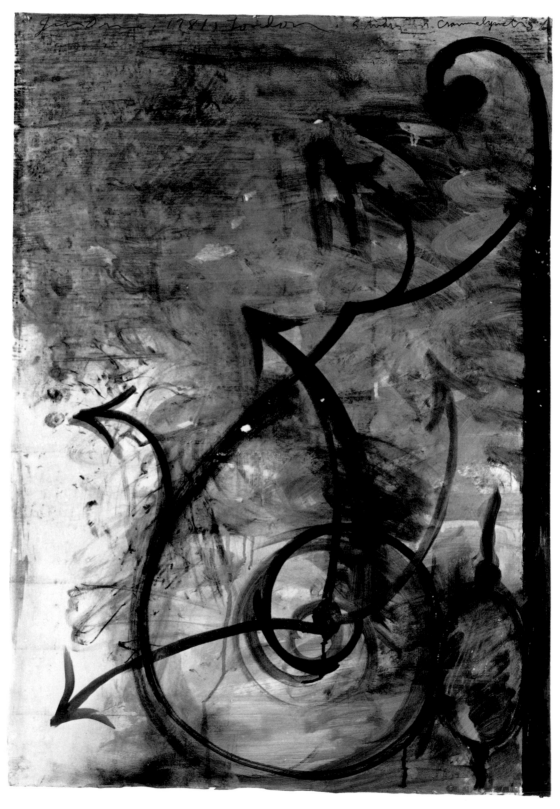

134. *Fragment of the Gate.*
1981. Mixed mediums on
paper, 42 × 29″. Courtesy
Waddington Galleries,
London

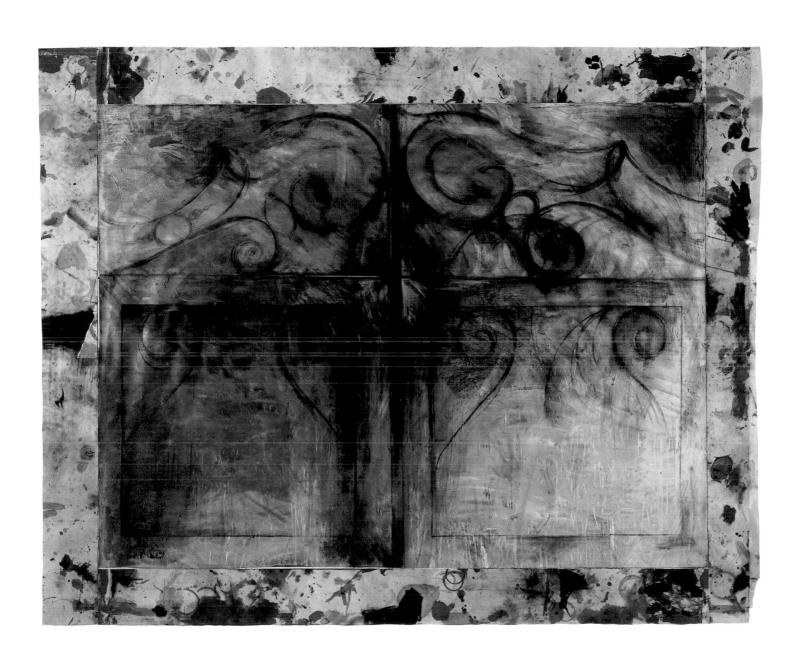

135. *The Crommelynck Gate
(The Quilt)*. 1981. Shellac,
charcoal, oil, acrylic, and
pastel on linen and paper,
69 × 86¾″. Collection the
artist

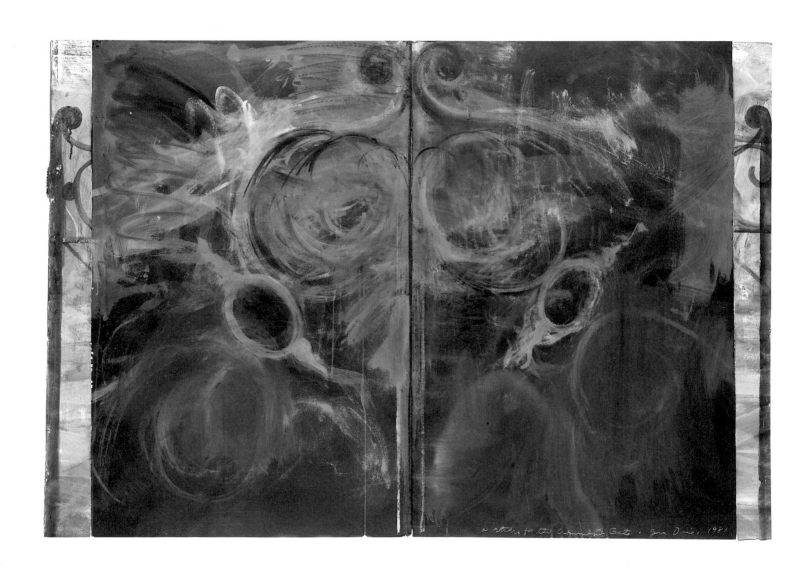

136. *A Black and White Gate
Study.* 1981. Mixed mediums
on paper, 39½ × 57⅜".
Courtesy Waddington
Galleries, London

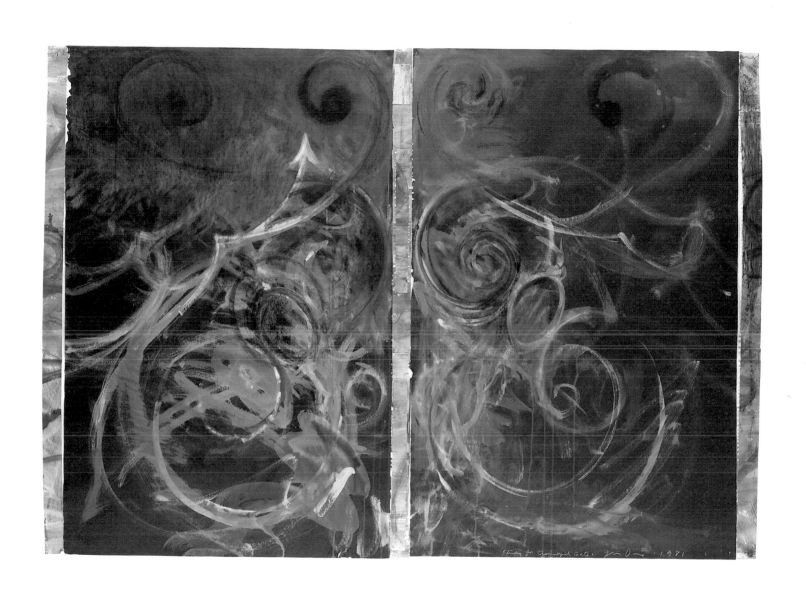

137. *The Gate in Black*.
1981. Mixed mediums on
paper, 39½ × 55⅜".
Courtesy Waddington
Galleries, London

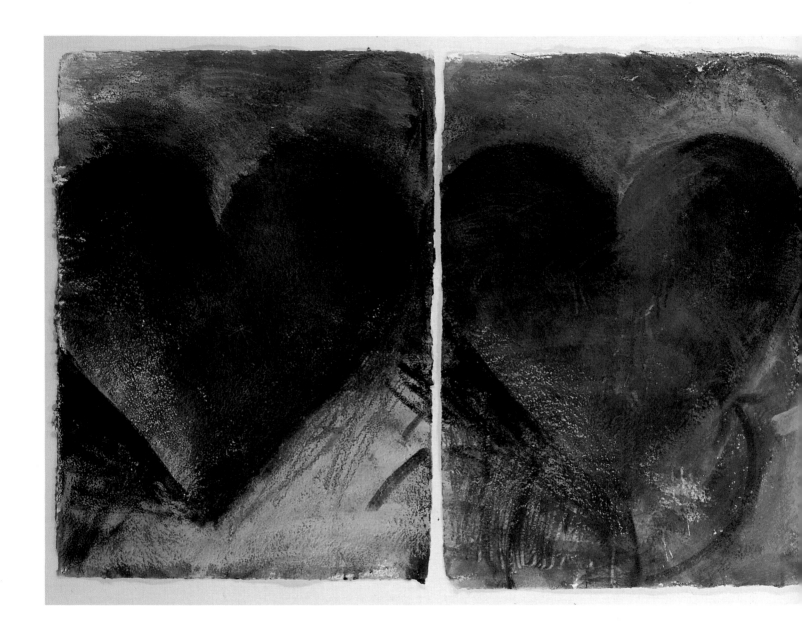

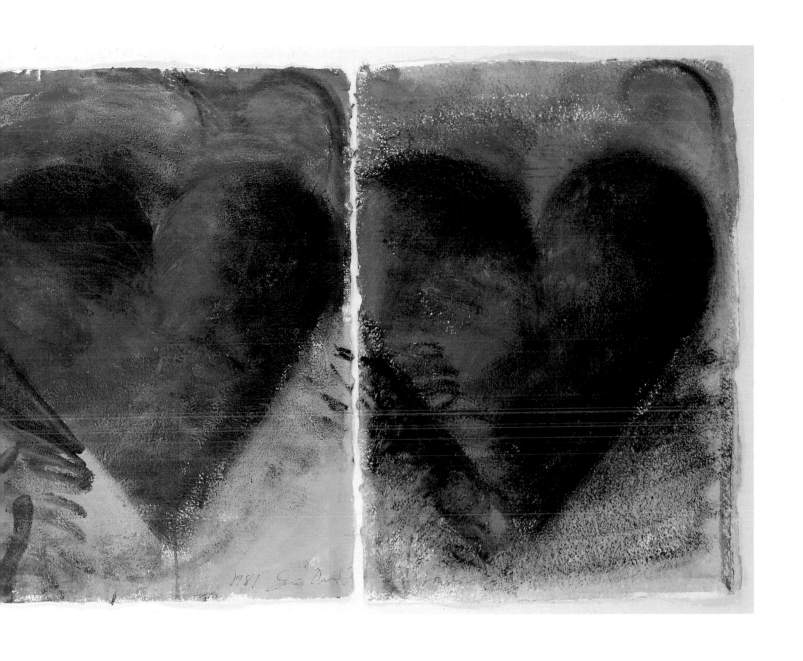

138. *4 Hearts (Grain)*. 1981.
Mixed mediums on paper,
31½ × 90″. Private
collection

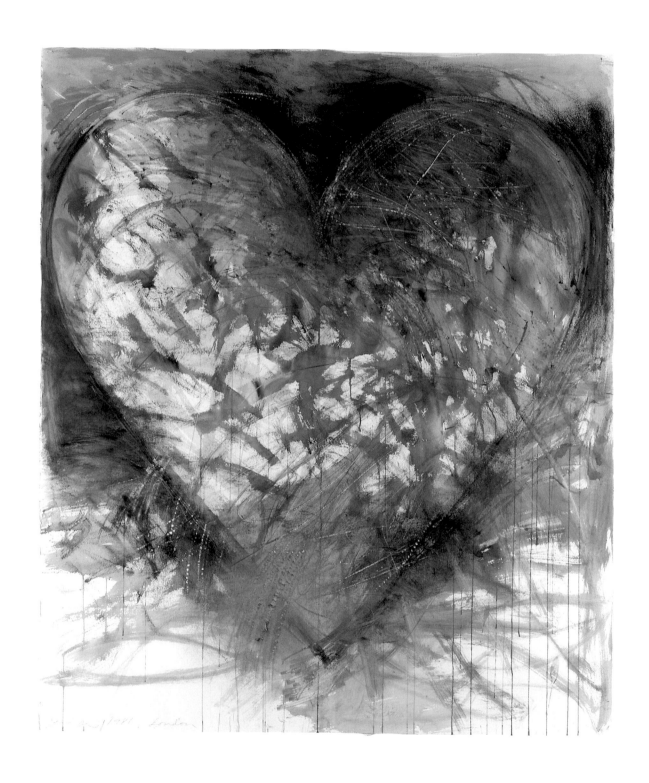

139. *The Heart as Landscape.*
1981. Mixed mediums on
paper, 53¾ × 45½″.
Private collection, Athens

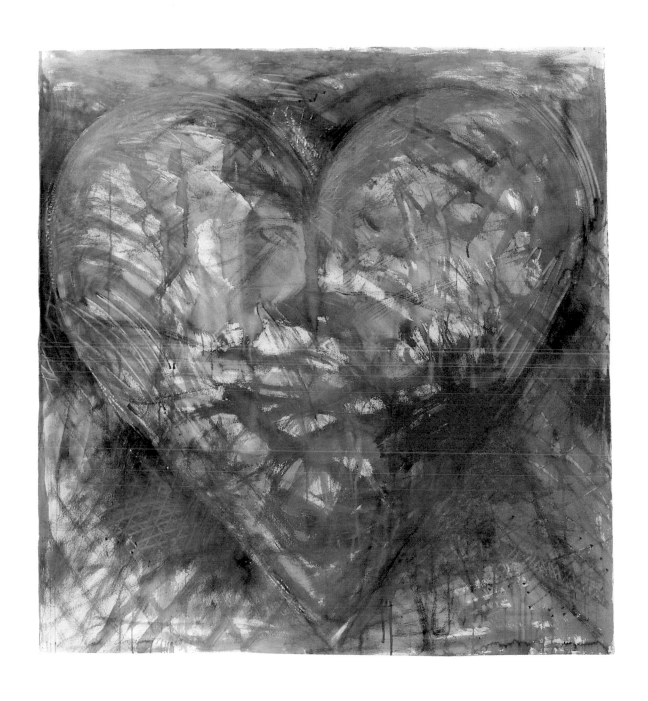

140. *Sun in England*. 1981.
Mixed mediums on paper,
48 × 45¼″. Private
collection

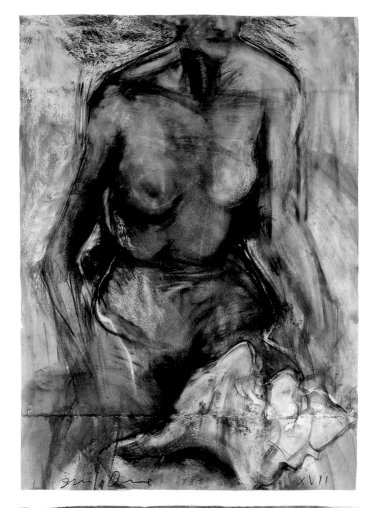

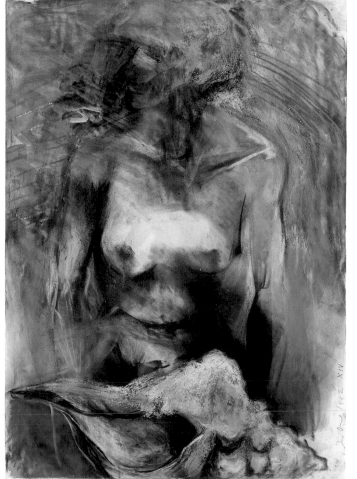

141. *Jessie with a Shell XVII.*
1982. Mixed mediums on
paper, 43 × 30½".
Collection Mr. Clement
Stone, Lake Forest, Illinois

142. *Jessie with a Shell XIV.*
1982. Mixed mediums on
paper, 43 × 30½".
Collection Mr. Clement
Stone, Lake Forest, Illinois

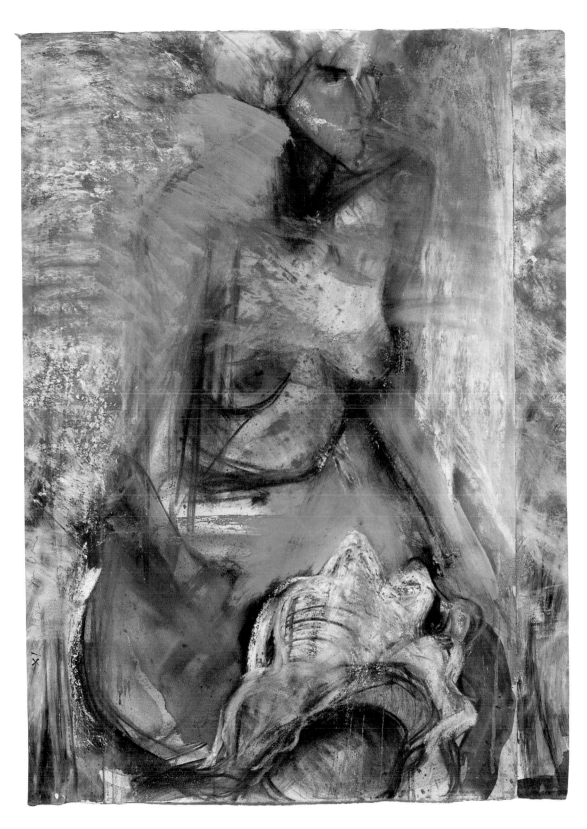

143. *Jessie with a Shell XI*.
1982. Mixed mediums on
paper, 43 × 30½".
Collection Richard and Mary
L. Gray

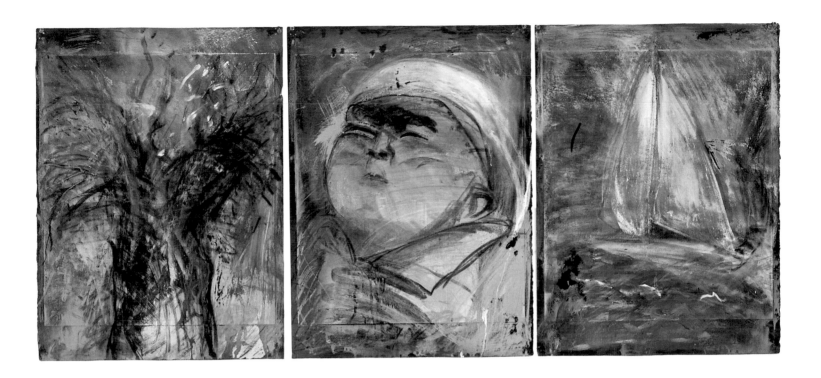

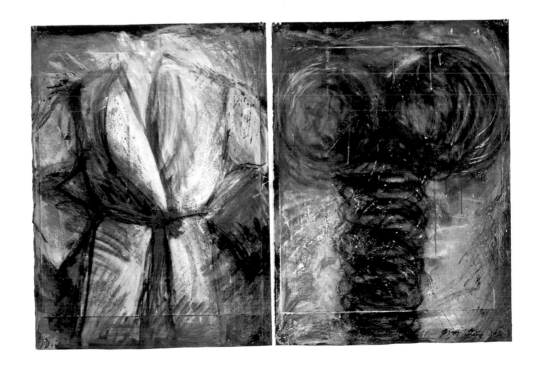

144. *The Lessons in Nuclear
Peace, Second Version.* 1982–
83. Mixed mediums on
paper, eleven sheets,
30 × 22″ each. Courtesy
The Pace Gallery, New York

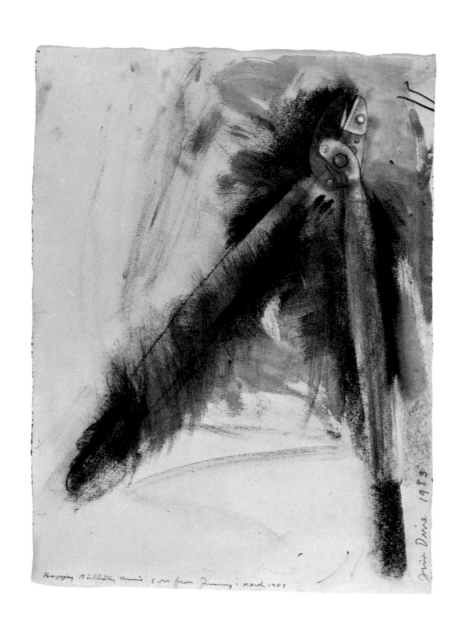

Happy Birthday, Annie. Love from Jimmy. March 1983

Jim Dine 1983

145. *Untitled.* 1983. Mixed
mediums on paper,
30 × 22½″. Collection
Arnold Glimcher

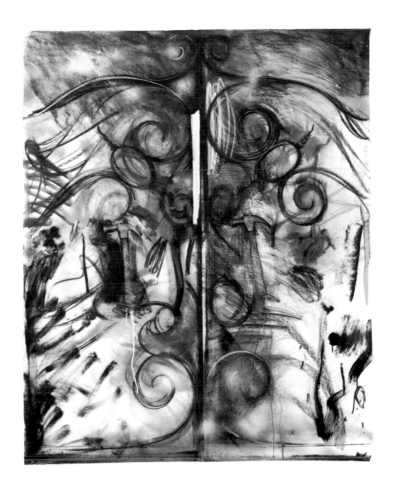

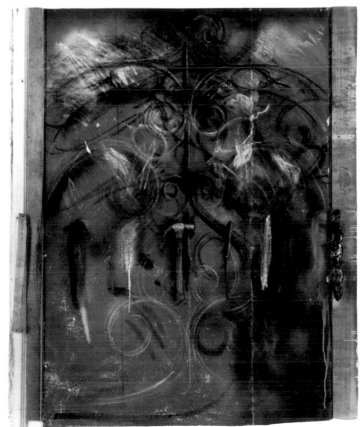

146. *Study for The
Crommelynck Gate with Tools
(Chippendale)*. 1983. Mixed
mediums on canvas and
collage, 72 × 60″. Private
collection, Kansas City,
Missouri

147. *Study for The
Crommelynck Gate with Tools
(Two Hammers)*. 1983.
Mixed mediums on canvas
and collage, 73 × 59″.
Andrew Crispo Gallery,
New York

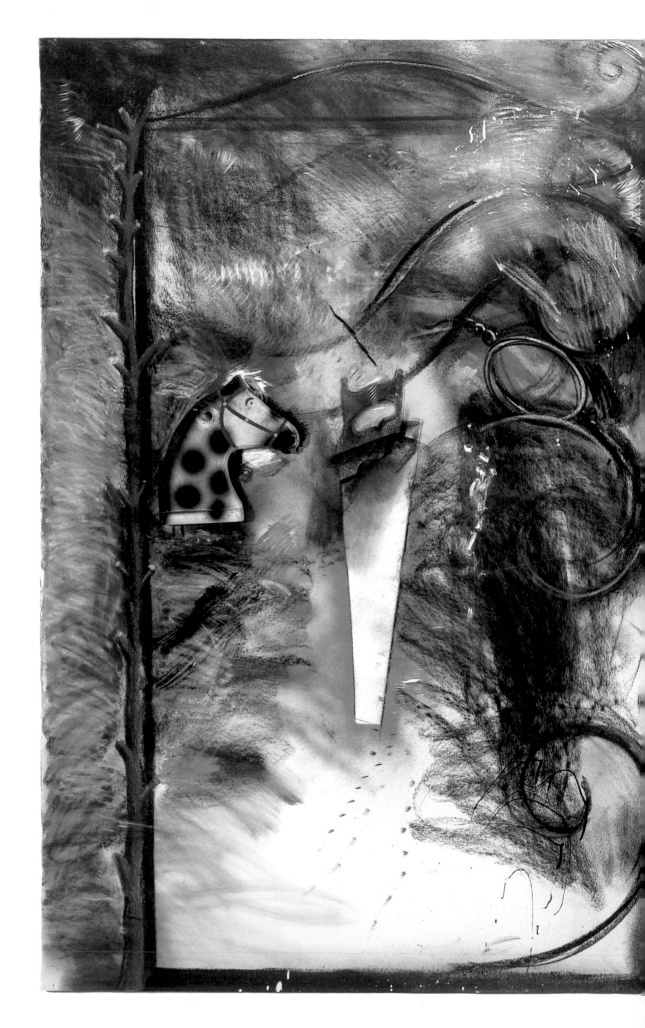

148. *Study for The Crommelynck Gate with Tools (Hobby Horse)*. 1983. Mixed mediums and collage on paper, 69 × 91″. Collection Alan Shayne

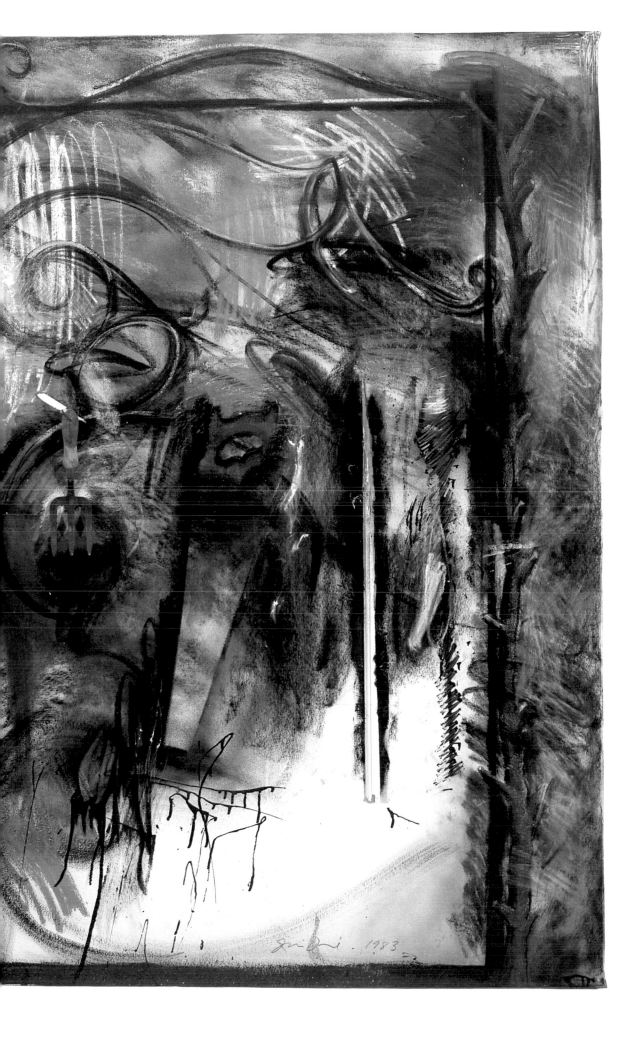

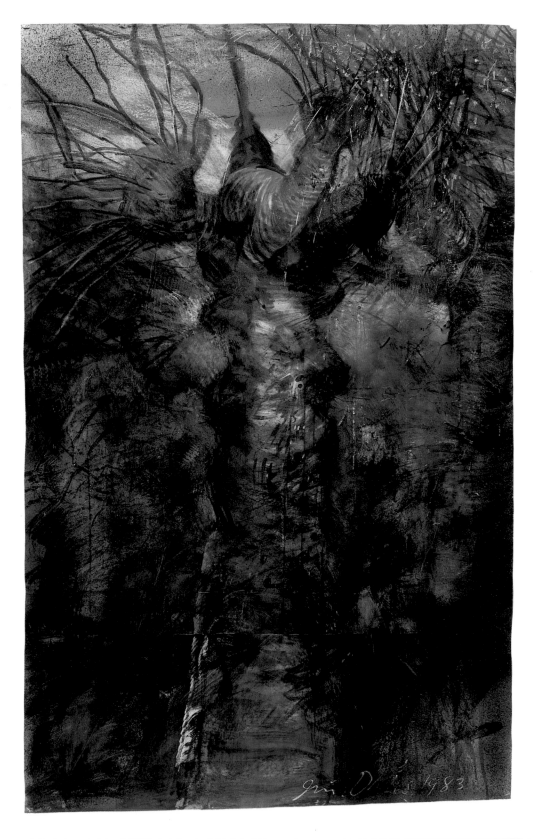

149. *Drawing from Van Gogh II.*
1983. Mixed mediums on
paper, 77¾ × 48¾″. Courtesy
The Pace Gallery, New York

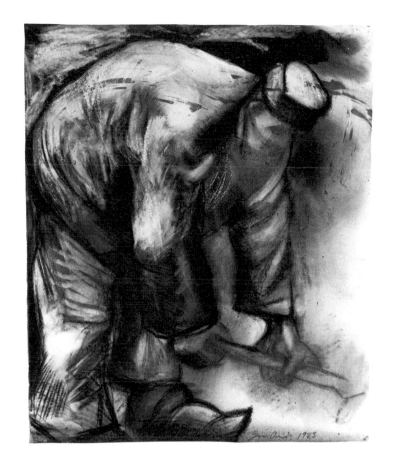

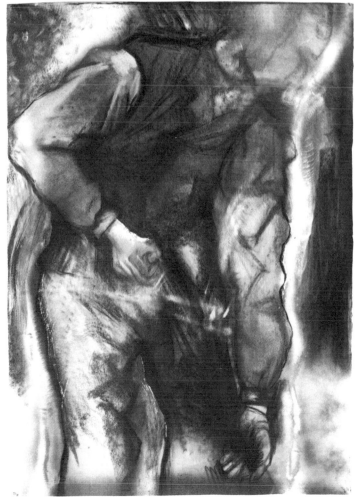

150. *Drawing from Van Gogh VII*.
1983. Mixed mediums on
paper, 54½ × 45½".
Collection Ralph and Phyllis
Scott, Bel Air, California

151. *Drawing from Van Gogh VIII*.
1983. Mixed mediums on
paper, 65 × 45". Courtesy
The Pace Gallery, New York

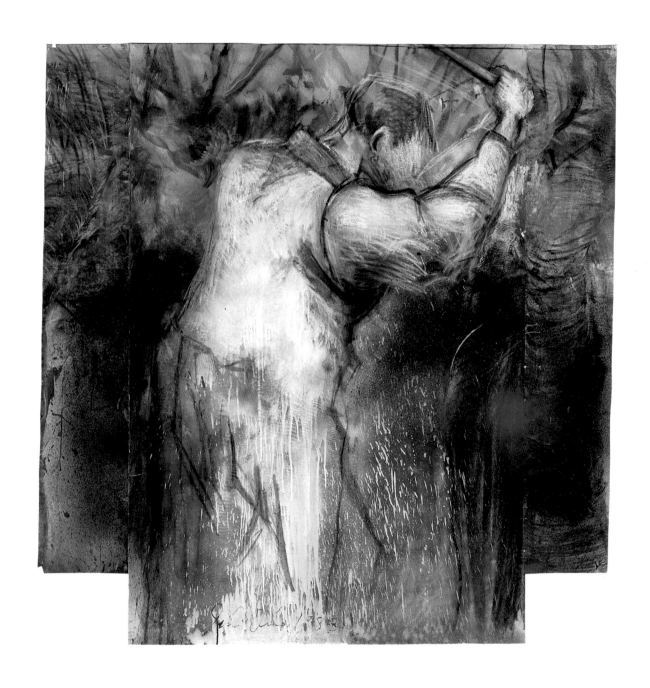

152. *Drawing from Van Gogh IX*.
1983. Mixed mediums on
paper, 68¼ × 65″. Courtesy
The Pace Gallery, New York

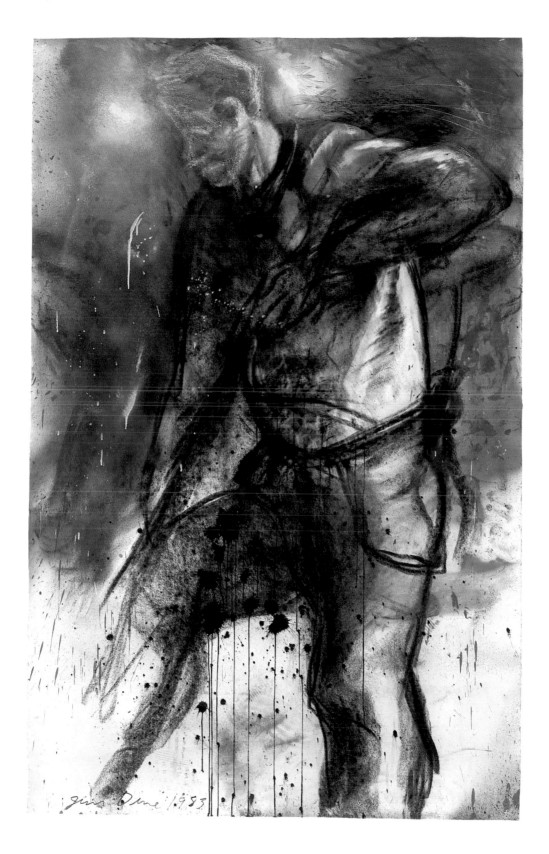

153. *Drawing from Van Gogh X.*
1983. Mixed mediums on
paper, 71½ × 45¼″. Courtesy
The Pace Gallery, New York

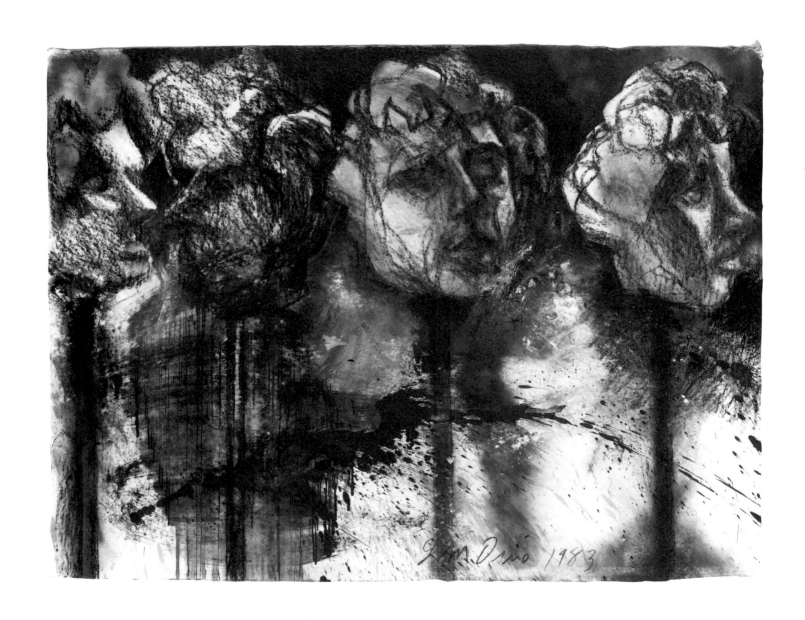

154. *Study for Big Sculpture Heads (No. 1)*. 1983. Mixed mediums on paper, 60½ × 83½". Courtesy The Pace Gallery, New York

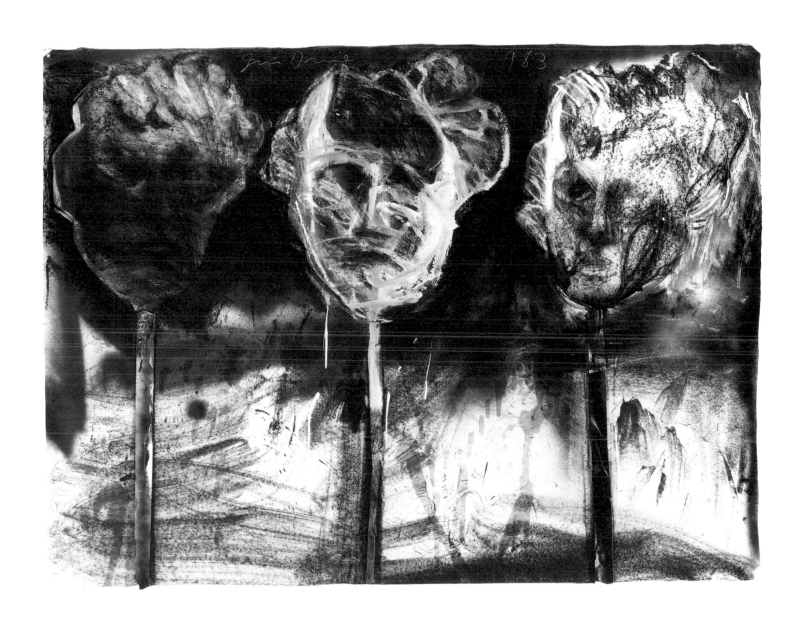

155. *Study for Big Sculpture Heads (No. 3)*. 1983. Mixed mediums on paper, 60¾ × 83½″. Courtesy The Pace Gallery, New York

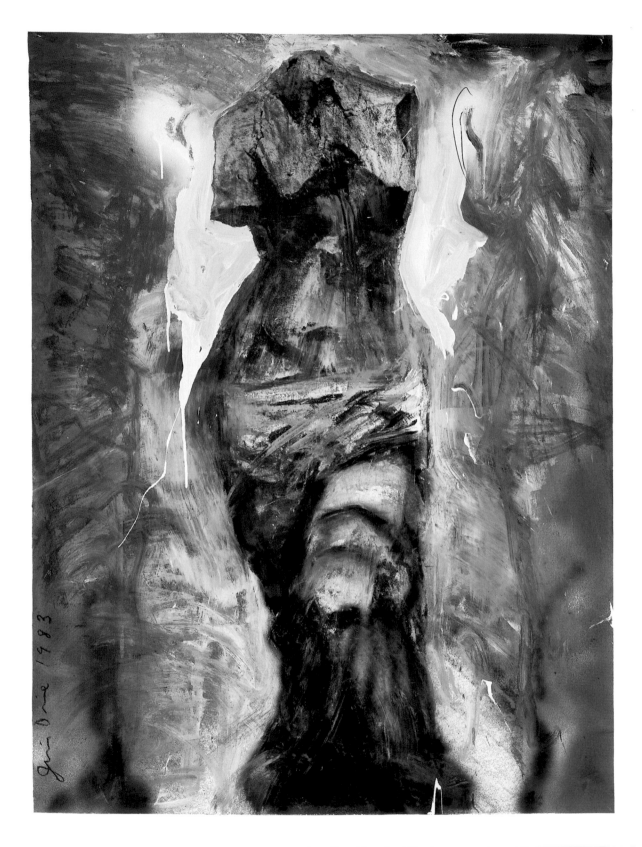

156. *Venus in the Red Air.*
1983. Mixed mediums on
paper, 60 × 44⅝″. Courtesy
The Pace Gallery, New York

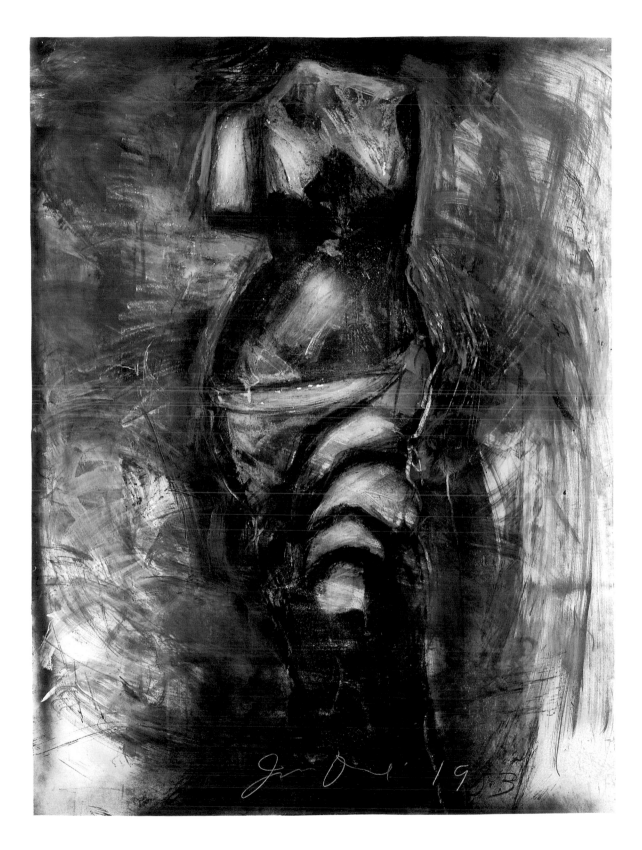

157. *Venus Outlined in Blue.*
1983. Mixed mediums on
paper, 60 × 44¾″. Private
collection, New York

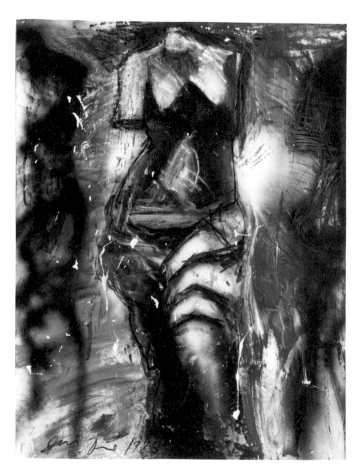

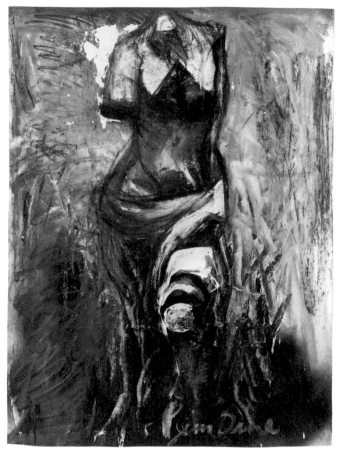

158. *Black Dust Venus.*
1983. Mixed mediums on
paper, 60 × 44⅝″.
Collection Mr. and Mrs.
Renny B. Saltzman

159. *Three Venuses Coming
Through.* 1983. Mixed
mediums on paper,
60 × 44¾″. Courtesy The
Pace Gallery, New York

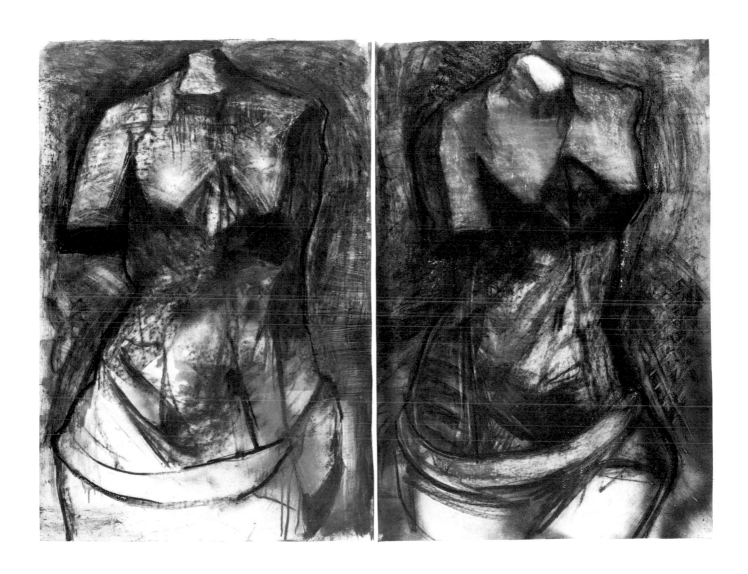

160. *Two Studies for the
Venus in Black and Gray.*
1983. Mixed mediums on
paper, two sheets,
46½ × 31½″ each. Irving
Galleries, Palm Beach,
Florida

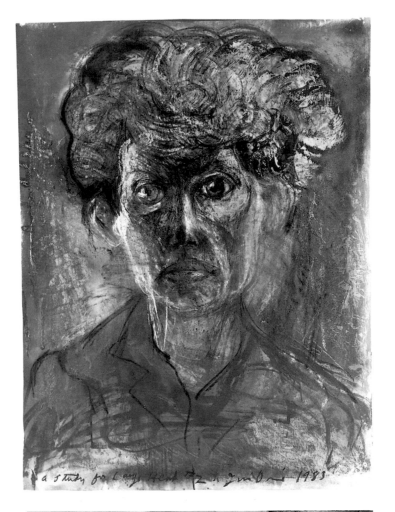

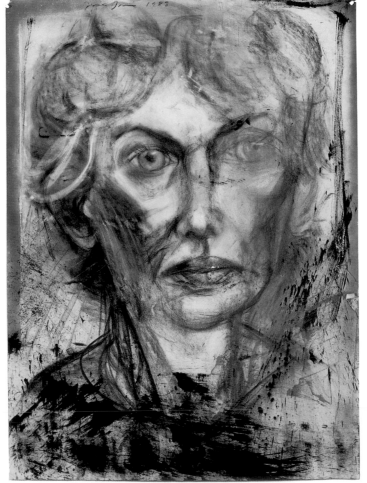

161. *A Study for the Large Head (Sculpture) # 2.* 1983. Mixed mediums on paper, 51 × 37½″. Courtesy The Pace Gallery, New York

162. *Large Portrait of Nancy (Study for Sculpture).* 1983. Charcoal and enamel on paper, 55 × 40⅛″. Collection the artist

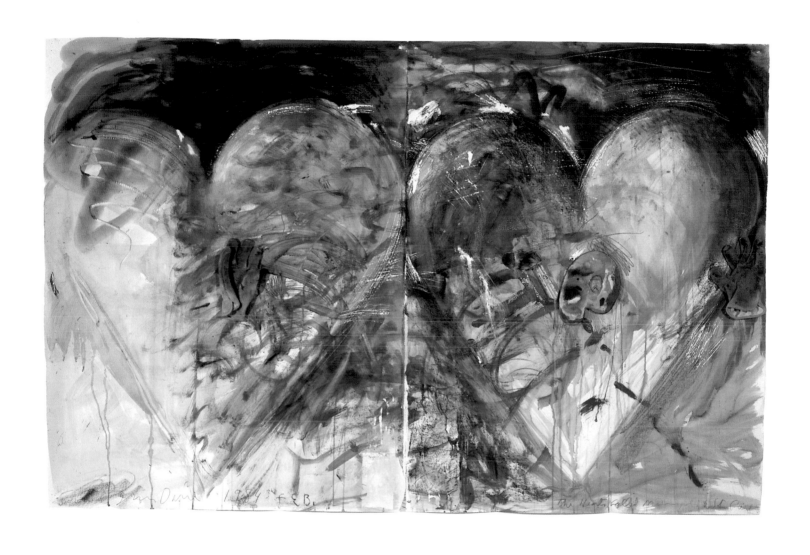

163. *The Hearts Called
Minneapolis and St. Paul.*
1984. Watercolor and collage
on paper, 50 × 76″.
Collection the artist

# DINE ON DRAWING

*Romanticism is precisely situated neither in choice of subjects nor in exact truth, but in a mode of feeling.*   CHARLES BAUDELAIRE[33]

## 1966

I like to put down information and facts very straight sometimes. I went and bought these beautiful hand-made papers and I couldn't use them, because what does it mean when you use them?

[I'm particularly interested in composition]. . . in a musical way. I really feel like a composer. Many times I feel suites of drawings are like string quartets. . . . [34]

I did a series of drawings depicting male and female sex organs, but I don't see these as pornography. I see them as objects. They represent a very natural part of my style. The object fascinates me. I think of the foot as an object, the hand, the leg and any other part of the anatomy. To me, sex organs are objects. Powerful objects.[35]

## 1967

The painting that has the sink in it, *Black Bathroom #2* . . . that really is just a drawing. That thing works as a negative space, but nobody gets past that sink. Nobody wants to get past it. They want to harp on the sink, they want to wash their hands in the sink, they want water to come out of it. Art does not work that way. Art is not a game.[36]

## 1968

The original drawings in the *Dorian Gray* book were done for a production that was going to take place. The reason it didn't go on was, on the surface, because of my costumes; the star said that they were obscene and wouldn't wear them. . . . So we (Paul Cornwall-Jones and I) just decided to publish them in a book. It was the logical thing to do . . . I feel at a certain level it's just a costume book; this is a valid thing to make—a book of costumes. On another level it's a book of some highly articulated colour lithographs. It's in certain ways a *tour de force*, the velvet cover and that sort of thing—although I do like it as a total object. I think one of the things about making it was that it fulfilled a need in me. There aren't many places today where you can still use your hands and still talk straight about something that's contemporary. Here was the opportunity to scribble again . . . I'd jump at any opportunity to do that. As an object itself the book's quite pretty, I think, and it's one of the most indulged things I ever made. In a certain way that's how Dorian Gray was—completely indulged—and that's why I felt it was in keeping.[37]

## 1970

I always liked to draw and use crayons and paint in school, but was frustrated by girls usually, who could make their hands do what they wanted them to while my left hand smudged everything in its way and still does.[38]

## 1976

I said once in an interview that drawing was like having a good meal. Well, it's more than that. It's the way I can speak the best, the clearest. Essentially I'm a draftsman, I think.

When I made the bathrobes and called them self-portraits, I was looking for a way to make a self-portrait without it being called "figurative" in a traditional manner. I wouldn't do it that way now. I would make a self-portrait. I mean, I'd make a real one. That kind of skirting of the issues is all through the modern movement, to keep it so-called "avant-garde," to keep it "in the

forefront." One is not confronted with what you have to do to make a self-portrait. Instead you put together sticks or do something like that and call it a self-portrait that is always very clever, in a literary way.

Although I was able to draw with a certain degree of efficiency, I denied it. I always wanted to hide it because it wasn't American. It wasn't enough, it wasn't in the Duchamp aesthetic that we all came to revere, which I feel is such an empty one, although very intelligent.

Prints and drawings stimulate each other for me since the way I print is in a draftsmanlike way rather than a painterly way. I've rarely used a brush in making a print although in coloring some lithographs, I have. But I can only think of a few lithographs that were really like a painting. Prints trigger drawings for me because they seem so throwaway and so you can be cavalier with them. Because someone else has to finish it for you, you know, and you don't have to stand there for the final thing. It is somehow removed, so symbiotically you are not attached to it like you are to drawings. I was able to be freer not necessarily in technique but in making decisions about the content and what the thing looked like.

The reason I use the smudging is because I like the way it looks. I mean, it is purely formal; if it has any other connotations, great. I'm delighted if that's what it does. But I don't mean that. I just like to smudge.

I think there's a lot of identity between my visual art and writing . . . because I feel close to literature and feel comfortable with language. It so happens that I'm a visual artist, but I covet the language and would hope that my work was comparable to literature that I understand. I haven't written in years now. I stopped because I am not a writer. I like to write, but I'm just not one.[39]

. . . every night that summer [1971] we drew each other, my cousin and I, or my kids and I. It was the first time in a very long

time that I got back to that kind of thing. We had walls of figure drawings of heads. They were rather casual, but I started to feel like an artist. Before, it sounds dumb, I know, but I didn't necessarily feel like one. I felt like a showman... I was on this treadmill of avant-gardism....

Someone else whom I admire very much and have never spoken about before is Joseph Beuys. I have never pretended to understand him, but I have been moved by his stance towards art, by his life with art and by his draughtsmanship. . . . in the last couple of years I have been confronted by it more and more, mainly in drawing shows. I've found his work super-moving and very beautiful. I was looking at the catalogue... of the Beuys show, I think it was called *The Secret Block for a Secret Person in Ireland*. . . . Those drawings from the '40s are just superb, like Chinese paintings. In those drawings you can see what a great artist he is. They are very moving. They are charged with romance about what he is doing. . . . he really draws beautifully. That never hurt a great artist.

My attitude towards drawing right now is a more elaborate attitude than I had earlier in my career. I am not as easily satisfied now as I was then. I need more of a full blown drawing for myself now. My attitude towards drawing is not necessarily about drawing. It's about making the best kind of image I can make, it's about talking as clearly as I can. I am much more comfortable making these very elaborate, rich drawings and prints than I am with painting.

The *Eight Sheets from an Undefined Novel* were all based on lengthy and elaborate preparatory drawings. The undefined novel defines itself, or it can be practically anything that you want it to be. I took a group of drawings I had been working on and decided to put them together in a series of prints. It also gave me the chance to use some words that I liked. Someone once told me about a Sufi baker, which seems like a strange combination of things—a Sufi and a baker. So I just used that word. It was like a free association. *A Nurse* or *The Cellist* or *The Swimmer*, I think

all of those are nice titles for things, and they would be nice characters in an undefined novel because there is nothing specific about it. It seems that they could all go together.

The *Russian Poetess* was actually inspired by a photograph of a head. The drawing was changed a lot as I reworked it many times. The woman, Akhmatova, was a Russian poetess, a friend of Mayakovsky's, I think. I just liked her face. She had a tremendous hooked nose which I liked very much.

Once I had the drawings finished I wanted to get the same proportions on a smaller scale for the prints. So I had all the drawings photographed and 24 x 20 inch enlargements made from all the negatives. Then I traced the photographs, not elaborately, just a linear tracing, and a soft pencil tracing down on a soft ground copper plate. After the soft ground outline was on the plate I went to work on the plates one at a time through many states. I think some of the pages had as many as fourteen states. I worked with soft ground, etching tools, and a great deal of reworking and erasing on each plate directly. I erased with a die grinder's tool and then burnished with steel wool and then reworked those areas of the plate with more soft ground. They were bitten in the acid very carefully, not deeply at all. I used roofer's copper instead of engraving plates. Roofer's copper is used in the construction industry so the plates are unprotected; they are scratched and marked, and instead of beginning with a blank surface, you begin with a totally full surface. And you add to that—drawing and erasing and drawing and erasing and rubbing out and wiping out—drawing and leaving your tracks and then going back. It's also a way to metamorphose things.

With the show that I had at Sonnabend of the tool drawings [1974], I felt for the first time I could control my hand and make it give me the image that I really wanted. That show was a true turning point for my work. It began simply out of an urge to draw—to draw and not rely on anything but my ability to communicate through my drawing. And you are absolutely right. It has taken me twenty years to learn how to draw.

I have great confidence in my drawing... I didn't always have it. I was always eager to turn out a whole bunch of things. I was very glib with my line. I could do toothbrushes. I could knock them out. There was a kind of excitement. Now the excitement for me comes in working over a thing and in continuing to work on it because I'm positive that when it really does work, when the drawing is finished, that something profound will happen if I have something profound to say, in the sense that I'm allowing all of myself to come out in the drawings.

I'm interested only in going where my strongest urges direct me, and that feeling is best expressed in the prints like *Eight Sheets from an Undefined Novel* and in drawings like the nudes and baby drawings that I am working on right now. For me those drawings represent the purest way to speak. It's also the simplest way not to lie. It doesn't require the build up, let's say, that painting does. I approach my prints like drawings. I feel most comfortable drawing with that tool in my hand, making that mark.[40]

1977
I didn't want to decorate pottery. I wanted to make full-blown drawings *on* pottery, because I love pots for one thing, but I also thought it would be nice to see a real drawing on pottery, rather than a border or dots. I chose to make plant drawings on the pots because I thought it was appropriate.... It seemed in some sort of pottery tradition....

[With regard to figure drawing] What I first try to do is I try to leave my traces and marks that are guides for me, for how to build the face, rather than to try and capture the likeness immediately. I'm trying to make a surface that interests me. I'm left-handed and I couldn't make my hand work for a long time. I seem to have some sort of learning disability—that way—I mean about my hand registering with my brain, so it's taken me twenty years to harness it. As I draw, I smear right across [the drawing], and for a long time it hindered my so-called drawing speech because I was unable to speak clearly.... But really, I've learned mainly by looking and drawing, and by forcing myself to draw.

You teach drawing in front of something, drawing from something—it needn't even be a model. It can be a still life. And you keep forcing, and keep forcing. You keep telling them to tear it up, to observe it more closely. What you really have to teach is observation. . . . if something is closely observed by a gifted person, it can be a beautiful thing. . . . It's about looking at things.

[The immediacy of drawing attracts me.] I don't mean the quickness of drawing. I mean the fact that you can take your finger and make a drawing. You don't have to wait for things to dry. It's a direct thing to do. It seems to me to be a rather primary act . . . and it suits me.

I just happen to like the look of the surface that's been erased and left. It's . . . like a strata. I think it enriches the surface and ultimately, if the drawing works at all, it will make it a richer drawing to look at. It's about the history of the drawing. I like to leave the history in.

Does the drawing [itself] take over? It happens on and off all the time, I think. You don't need to deal with it, or think about it, or talk about it because it's just going to happen because of your knowledge—knowledge that is in you, in your hands. It's about inventing. That's where the fun happens—the excitement of inventing things.

[Drawing is] about concentration, which I've taught myself. I've taught myself concentration mainly through running, so that I know if I can breathe a certain way and run for a certain distance with ease, I know also that I can sit a certain way and force my mind to work.

I don't come from anywhere. It's a question of looking, and schooling yourself, and learning by assimilating. I happen to be partial to nineteenth-century French drawings. In [regard to] the twentieth century, I've learned a lot by looking at Matisse drawings—over and over again—and rejecting the things that I couldn't do, because I'm not him and obviously not French.

What I'm drawing is how I feel about humans. I drew objects for years because I could not sit in the same room with a model, for a variety of reasons—one of them being that the model eventually has to move and has to leave. So I devised other things to do, other ways to draw until I was able—emotionally able—to sit down and look at a figure. . . .

The tool drawings, or any involvement with the tools—in paintings or constructions [were] metaphors for humans. In fact, the tool drawings led into this. . . . I wanted to make proper drawings. I didn't just want to flatten out a tool . . . and say that's a drawing now, which was thought to be terribly radical—that I did this thing—that I made a drawing of an axe and everyone said, "How beautiful." And it wasn't an axe lying down, with an illusion. It was just the axe itself put up there like a sign. That's all well and good. [The tools are] really handsome I think, at times, but I don't think [they are] as handsome as the drawing of a person. And, as I say, it's not that I'm anti-abstraction or modernism, . . . it's just that . . . I found a way that I can speak that interests me. . . . I'm not interested in chronicling the age. I am interested in making a body of work that, when one comes upon it, it's disturbing in the sense . . . [that] you would recognize in it something of yourself or the way you felt about looking at things or how you felt about people.

I think Oldenburg is a great draftsman because he's a draftsman in a mainstream of tradition. The others have broken with it, and there are those who say, "Well then, they should have; that's an extension of history and therefore they're in the avant-garde." But I've lived with some of those drawings and they aren't as generous as other drawings are. I like the fact that Oldenburg can do absolutely anything he wants with his hands. I find that amazing, because for me it's a great struggle. He really is like a great athlete. He can do just what he wants.[41]

1979
These drawings have been my only work this year. I have looked very hard at my friends and myself. The works are about my

eyes. I've tried to teach them to be ruthless and kind. The ability to speak clearly consumes my interest in art. By looking hard I hope to become more lucid. I am interested in an art of unabashed passion. These drawings are baggage for the voyage.[42]

I read about a man who had open heart surgery just recently . . . . He described how it's done. I think they give curare as part of the anesthetic, which "stops" the body. That's the way I felt. I put a stop to my so-called art and tried to sit with myself and look harder.

I could make a hundred drawings for each one I get. I am positive that by rubbing out, and trying to do better, and knowing that I can do better, the whole drawing gains a kind of history and substance that it didn't have before.

I'm interested in all kinds of art, in art that hits the point—that sometimes makes it. Giacometti's drawings don't always make it, you know. I've looked so hard at them these past few years, almost every day, and they don't always make it. But when they do, they are exactly what I would like to achieve. I feel the same way about De Kooning. Abstract, figurative, what the hell's the difference?

The excitement and romance of anatomy—that's the most wonderful thing about the organism, about drawing the organism. It's the way the light hits the nose at the side; it's why I like to draw Nancy all the time, because she's my most familiar subject. This woman I have lived with all these years is a subject that I know so well that I don't have to waste a lot of time, and I become so charged up and excited over the way the light is hitting this particular eyelid this day. The romance of that is fantastic. I guess, in the traditional sense, they are portraits. They aren't just figure drawings, and I am interested in likeness. I'm not satisfied when I don't have a likeness. . . . there are two kinds of drawings, drawings of people and drawings from photographs. In those from photographs, I'm not interested in the likeness. I'm interested in getting something that's really expressive. In the portraits of people, I'm interested in getting

the portrait likeness. I've chosen the model for that reason—Jessie, my neighbor in Vermont. I'm interested in drawing her because she is extremely thin, extremely muscular, and everything is articulated, particularly in her collarbone area and where the arm joins the shoulder. I find that terribly exciting anatomically, and it's all explicit with the muscles showing. Also she has a certain kind of face—an inner face that I find particularly interesting. The same with Nancy but for different reasons. That's why I continue drawing her.

In Van Gogh's single figure drawings, he really saw, and when he saw, at his best, he was able to take his eyes like an animal and burrow into men's minds, into the shadow.

My perfect day would be to make still life paintings for four hours in the studio, then draw from nature for three hours, and then make paintings at night of myself—never have to sleep. It's getting worse now. . . . There is less time, and there is more to be done. When I was twenty-three I had a lot of energy but I didn't know what to do. There were other things that I wanted to learn to get to this point. I don't regret it. I don't want to be young.

Beginning in the winter of 1974–1975, I spent a year drawing. First I made four heads of Nancy. . . . There were some other things that I did from photographs that I still want to work on, people dancing, two dancers. . . . Then, I said, "It's enough. I don't want to go on with my 'career' as a modern artist. I am very good at this." Instead, I got models, students from college, and I drew every day. Then finally Jessie would come more often and I got rid of the other models. I made three drawings of Jessie that went together, like a triptych, hung them in my living room where I always like to look at things in the country, and someone said they were really electric drawings. I suddenly realized that I had gotten to some state, some point, where I could begin to do something once again, and think of it as art, rather than exercise.

Sometimes . . . I keep [a drawing] around for a time and then I go back. I do a lot of finishing work or ending of the drawing work

when no one is there, by taking out something totally and putting that same thing back in, but with color.

I had some very bright pastel [crayons] made, and I occasionally use them arbitrarily, just over the whole thing, and fix it very quickly so it's very brilliant, and then I draw over that with charcoal.[43]

I really consider it is *we*—the model and I—making the drawing. I don't draw anonymous people; I draw my family or friends very closely, and they talk all the time while I am drawing them. That is always very interesting, very sociable, and very inspiring. . . . I always talk while I am drawing because it's my hand that's doing it. I'm not drawing with my mouth. I do have one specific model I use in Vermont, and she's very helpful to me because she can sit very still for long periods of time—like an hour or so without moving at all, and that is a collaboration that way.

I come out of a tradition of European and northern European drawing and out of the American tradition of painting. By "American" I mean Abstract Expressionism—I believe Abstract Expressionism comes from Europe, so it is similar in attitude. Just like Giacometti, I have trained myself by looking a lot at northern European drawing: German, British, French, and Dutch drawing. . . . I didn't just grow like Topsy. I am highly trained, mainly by myself. I am still training, all of the time.

I'm not interested in illustration. . . . I'm interested in the subject being art, rather than the subject becoming something specific.

My interest in art, in art history, is in the single figure—the figure drawing, say, of Van Gogh. That interests me more than a landscape drawing does. I don't know how I came to that interest; I just like isolated things by themselves. I don't think a setting would corrupt, necessarily; it just isn't my interest to put a single object in an environment usually. Putting it in an environment makes it more illustrative and distracting, I think.

I really don't know how to make art. I start somewhere. (It's easier for me to talk about what I do when I draw than when I paint, because painting is more complicated.) When I start a drawing, I just look very hard and begin to make marks, and then erase the marks, and build up this history of marks. . . . I do know that I never see a figure totally; I always see just a part of it. I try to see how it is put together. But I just make marks. I like to sully the paper, to get into it and make a bit of a mess and get going.

My work is like me, I think. Definitely, it is me. I am it. I am the work. There is no question about that. I probably am as closely linked to my work as any artist I know. That is, if you know me, you know my work. I'm not closed off in *that* way.[44]

1981
Paintings without drawing . . . are ultimately boring.

The great failure is the lack of drawing. X would say that there's no need for it in modern art, but I think that's the weakness in the art, the automatic quality of everything, the manufactured quality. What everyone thinks is great freedom is a lack of draughtsmanship. And the forced ugliness is true ugliness, I think.

My interest has always been in the European sensibility, in the tradition of great European draughtsmanship: Giacometti, Balthus, people who are in that tradition of difficult work, of laboring over something, and finally getting something out of really hard work. That appeals to my sense of hard work.[45]

1983
In the sixties, the sense of avant-gardism and so-called "fun in art" was more prevalent. . . . I grew up in that time of Pop Art and the connotations for me were never serious . . . I had more ambitions for my own art. . . . I felt by the middle seventies that I was able to sit with my art and sit with my drawing and spend more time perfecting it and making a statement that would, for

lack of a better term, be more serious, not that the other work was not serious. . . .

In 1975, or 1974, I went to the Victoria and Albert Museum and saw a small exhibition called "Van Gogh in London" and it was about his sources from weekly newspapers, from the wood engravings . . . you could see how he cared about that black and white quality in the drawing, and that single image, which inspired me tremendously . . . those old men from the poorhouse that he could draw with top hats and that central image in the center like that really inspired me. . . . I never understood how he knew how to do such abstract things, like making angles on figures that don't seem to have anything to do with the anatomy. It's the invention. . . .

I came upon this drawing book . . . it was a book of his drawings and I just thought it would be great to use them as . . . still life material, just to draw from them, in a tradition like he drew from Delacroix, and painted from Rembrandt. So I ripped up the book and in Los Angeles made these big drawings after Van Gogh. . . .

I love people's tracks. I don't want to be spared anything about private life. I want all that history. I think it just makes it so much more interesting and rich. And that's what I try to do. I think drawing is a kind of autobiography or biography. I think that the kind of drawing that tells a lot is what I'm interested in. I'm not, obviously, a Minimalist and I'm not interested in that. I want to know everything.

. . . my feeling about a drawing . . . is no different than my feeling about a painting or the sculpture. It's the most major thing I can say at that time. I don't make sketches and I don't make studies, for anything. I feel it has to work. I make it accomplish something, and I give the same amount of emotion to it as I give to everything I do. . . . I'm just unable to make notes, unless I make notes within the major statement. . . . It [a drawing] means as much to me as any painting.

. . . right now I'm particularly interested in the way my arm moves full out; I mean, not absurdly, . . . my whole arm. I like to draw like that, like to swing my arm when I'm drawing, which is an Expressionist way of working, obviously. But it pleases me. It's exciting and, as I said before, it's very athletic. . . . I find that it's a need in the process for me to exert some physical energy while I work.

. . . sometimes I'd like to see all my drawings at one time. Other times I like to see a drawing by itself; some drawings stand alone better than others. I'm very lonesome when I go into a studio that I haven't been to for a while and there's only one thing. I like to surround myself with my work. I'm much more comfortable with a lot of things and working on them at once rather than *one* thing.

There's a drawing . . . called *The Skier* . . . where the face is ripped off and pinned back, there's . . . white, with part of the face left out and the bit is pinned over here, but I certainly wasn't doing anything personal to her. . . . it wasn't my intention. It becomes very formal for me. . . . If it's aggressive at all it's aggressive about me versus the paper. Me versus the drawing. Not me versus the content.

I feel that my work always had a literary side—that is it didn't refer specifically to books, but it had some sort of content other than formal content, and it has had and does have, I feel, a narrative side. . . . I've been as moved by books as I have been by pictures.

. . . the scale of my drawings has just gotten bigger and bigger through the years, as have my paintings. I'm very comfortable with the big size. The only thing that stops me from making a tremendous drawing . . . is the glass—the glare would be too great. . . .

. . . drawings take as much time as a painting does most of the time for me and, many times, my drawings are as layered and have as much paint on them as a painting. It's just that they're on paper; I think that's about the only difference in them.

The things that interest me and the things that inspire me I consider that I'm romantic about; that is, I charge them with a certain emotion that is about me being in love with that feeling—not with the specific object. . . .

The drawings I've made of tools are of hand tools, and in that sense they are autobiographical because—it's stale news but I spent my early life amongst people who sold them and who were carpenters and things, and they were my prints and drawings and opera records. I mean that was my culture, it was in hardware stores . . . also, hand tools are about this extension of your hand and . . . I get a lot of pleasure out of having them near me . . . it's like the artifacts of the society. I like the objects of society. And, at times, that's very autobiographical because of the experience one has had. I spend a lot of time when I travel going to department stores and looking at what the objects of that particular society are about because it tells you alot about where you are. And I usually find something that I'd like to draw.

. . . I really feel I can't fail, in the sense that it's all grist, so I make it work. The failure is underneath the picture. Maybe actually on top, but I never throw it away. Ever.[46]

# NOTES

1. Alan R. Solomon, "Jim Dine: hot artist in a cool time," *Dine Oldenburg Segal: painting/sculpture* (Toronto: Art Gallery of Ontario, 1967), unpaginated. Published by permission of the Art Gallery of Ontario.

2. John Loring, "Graphic Arts: Hairy, Alive, Purple, Sexy, Rich," *Arts Magazine*, January, 1974, p. 53.

3. Unless otherwise noted, all quotes are from conversations (1979–1984) between the author and the artist. Some of the artist's comments appeared previously in Constance W. Glenn, *Jim Dine Figure Drawings 1975–1979* (New York: Harper & Row, Publishers, Inc., 1979), and have been quoted elsewhere.

4. "A Conversation with Jim Dine," an interview with Clifford Ackley, associate curator, Department of Prints, Drawings, and Photographs, Museum of Fine Arts, Boston. (A public event at the Museum of Fine Arts, March 23, 1983).

5. Alan R. Solomon, "Jim Dine and the Psychology of the New Art," *Art International*, October, 1964, p. 53.

6. John Steinbeck, *The Winter of Our Discontent* (New York: The Viking Press, 1961), p. 143.

7. John Gordon, *Jim Dine* (New York: Whitney Museum of American Art, 1970), unpaginated.

8. Excerpted, in differing order, from *Webster's Third New International Dictionary* (Springfield: G. & C. Merriam Co., Publishers, 1966), p. 1121.

9. Nicolas Calas, "Jim Dine: Tools and Myth," *Metro 7*, 1962, p. 76.

10. Wright Morris, *Earthly Delights, Unearthly Adornments* (New York: Harper & Row, Publishers, Inc., 1978), p. 172.

11. Lou Keplac, *Contemporary Drawing: 1977 Perth International Survey of Drawing* (Perth: The Western Australian Art Gallery, 1977), p. 7.

12. "A Conversation with Jim Dine," *op. cit.*, Museum of Fine Arts, Boston.

13. Charles Baudelaire, from *The Mirror of Art, Critical Studies by Baudelaire*, translated and edited by Jonathan Mayne (London: Phaidon Press, 1955), p. 42.

14. "A Conversation with Jim Dine," *op. cit.*, Museum of Fine Arts, Boston.

15. Thomas Krens, ed., *Jim Dine Prints: 1970–1977* (New York: Harper & Row, Publishers, Inc., 1977), p. 35.

16. *Ibid.*, p. 32

17. Pablo Picasso, in Wylie Sypher, *Rococo to Cubism in Art and Literature* (New York: Vintage Books, 1960), p. 300.

18. With regard to the creation of series (and sub-series) of works as characteristic of Dine's particular approach to drawing, Alan Solomon noted, ". . . he draws obsessively: this means the activity is a significant source of gratification for him. Like Picasso, he draws sequentially, working with undiminished invention through marvelously subtle and everfresh variations on single images, doing long series on the same theme, which give him untold pleasure, just in the sheer doing, and in the complication and variation of ideas. Such men belong to a chosen group. They have outlets almost beyond the

comprehension of the rest of us, who struggle for a few brief moments of grati-fication and fulfillment." Alan Solomon, "Jim Dine: hot artist in a cool time," in *Dine Oldenburg Segal: painting/sculpture.*

19. Lee Friedlander and Jim Dine, *Photographs & Etchings* (London: Peters-burg Press, 1969).

20. James Lord, *Alberto Giacometti* (catalogue) (New York: Sidney Janis Gal-lery, 1976), unpaginated.

21. The Reuben and Judson galleries were known in the late fifties and early sixties for presenting avant-garde, experimental, even highly controversial, work by young artists. The Judson Gallery (housed in the basement of the Judson Memorial Church in Greenwich Village) was founded in 1958–59 by Bud Scott, the assistant minister, and artists including Dine, Marc Ratliff, and Claes Oldenburg. At the same time Anita Reuben founded the Reuben Gallery. Both were "outpost(s) for the human image in art in a sea of Abstract Expressionism"—showing work (or providing space for Happenings) by Red Grooms, Dine, Claes Oldenburg, Lucas Samaras, Allan Kaprow, Robert Whitman, and George Segal. (See *Eleven From The Reuben Gallery* [New York: The Solomon R. Guggenheim Museum, 1965] by Lawrence Alloway.) Dine's work was seen at the Reuben Gallery in a group exhibition entitled "Below Zero," December 18, 1959–January 5, 1960, and in a one-man exhi-bition there April 1–14, 1960. His Happenings, *Vaudeville Act, Car Crash,* and *A Shining Bed,* were also presented there in 1960. Oldenburg participat-ed in exhibitions and created Happenings at the Reuben Gallery during the same period. They also exhibited together at the Judson Gallery, November 14–December 3, 1959. Oldenburg showed paintings and drawings—primar-ily female figures. Reviewing the Judson exhibit, A.V. noted in *Arts* (Decem-ber, 1959) that, "James Dine is having a lot of fun making faces. . . . and a series of connected panels on which appear increasingly large heads. . . ."

22. J.J. in *ARTnews* (January, 1962) referred to Dine's exhibit at Martha Jackson/David Anderson (January 9–February 3, 1962) as "his first big post-'Happenings' show." The exhibition included ties, coats, shirts, the black derby and spectator shoe canvases, *Hair,* and *Ten Formal Fingers.* By the fall of 1962, his bathroom images and tools were being featured at the Sidney Janis Gallery (October 31–December 1).

23. Paul J. Sachs, *Modern Prints and Drawings* (New York: Alfred A. Knopf, 1954).

24. Jim Dine married Nancy Minto in 1957. They have three grown sons.

25. In 1964, years before Dine began thinking about how he might seriously focus his own work on the Van Gogh images, Alan Solomon wrote: "Dine's handling varies enormously from picture to picture and often within the same painting, ranging from a juicy curvilinear impasto which painfully reveals the bombastic overindulgence of Van Gogh's expressionism to excruciatingly delicate wishy washes of color which become almost obscene in their attenu-ation." Solomon's article, "Jim Dine and the Psychology of the New Art," remains one of the most perceptive pieces ever written about the artist.

26. Dine studied Van Gogh drawings periodically, over many years: in the Sachs book; in an exhibition at the Victoria and Albert Museum, London, devoted to Van Gogh's sources among nineteenth-century English illustrators

(see Ronald Pickvance, *English Influences on Vincent Van Gogh* [Nottingham and London: Arts Council of Great Britain, 1974]); and in the book *Van Gogh Drawings* by Evert van Uitert, translated by Elizabeth Willems-Treeman (Woodstock, New York: The Overlook Press, 1978).

27. The images that comprise *The Desire (Lessons in Nuclear Peace)*, 1982 (the painting in the collection of Louisiana, Humlebaek, Denmark), and *The Lessons in Nuclear Peace, Second Version*, 1982–83 (the drawing), were derived from *Unforgettable Fire/Pictures Drawn by Atomic Bomb Survivors*, edited by the Japanese Broadcasting Corporation for Pantheon Books, New York, 1977, and from *The New York Times Magazine* (nd.).

28. The book in question is James Lord's *A Giacometti Portrait* (New York: The Museum of Modern Art, 1965); however the story to which Dine refers actually appears in the 1976 Sidney Janis Gallery catalogue, *Alberto Giacometti*, by James Lord.

29. *Paris efter kriegen, 1945–1954*, Louisiana, Humlebaek, Denmark, June 26–August 22, 1982; presented at Barbican Center, London, as *Aftermath: Paris after the War New Images of Man* (catalogue).

30. Clyfford Still, from a letter published in *Clyfford Still* (San Francisco: San Francisco Museum of Modern Art, 1976), p. 120.

31. Frank Stella, from an interview broadcast, WBAI–FM, Pacifica Radio in New York, 1964.

32. Stéphane Mallarmé, in Wylie Sypher, *Rococo to Cubism in Art and Literature* (New York: Vintage Books, 1960), p. 141.

33. Baudelaire, *op. cit.*, p. 43.

34. Robert Fraser, "Dining with Jim," *Art and Artists*, Sept. 1966, p. 52.

35. John Gruen, "All Right, Jim Dine, Talk," *World Journal Tribune Sunday Magazine*, November 20, 1966, p. 34.

36. Solomon, "Jim Dine: hot artist in a cool time," *op. cit.*, unpaginated.

37. Jim Dine, in "Lithographs and Original Prints, Two Artists Discuss their Recent Work," *Studio International*, June, 1968, Supplement, p. 337.

38. Gordon, *op. cit.*

39. Frank Robinson and Michael Shapiro, "Jim Dine at 40," *The Print Collector's Newsletter*, September–October, 1976, pp. 101–103. Reprinted with permission by *The Print Collector's Newsletter*.

40. Krens, *op. cit.*, pp. 16–36.

41. *Seeing Through Drawing*, a color production by Michael Dibb, 1977. Quoted by permission of the British Broadcasting Corporation and Jim Dine.

42. *Jim Dine: Oeuvres sur papier 1978–1979* (Paris: Galerie Claude Bernard, 1979).

43. Glenn, *op. cit.*, unpaginated.

44. Susie Hennessy, "A Conversation with Jim Dine," *Art Journal*, Spring, 1980, pp. 168–175. Reprinted from *Art Journal* by permission of the College Art Association of America and Jim Dine.

45. David Shapiro, *Jim Dine: Painting What One Is* (New York: Harry N. Abrams, Inc., Publishers, 1981), pp. 206–210. Reprinted with permission by Harry N. Abrams, Inc.

46. "A Conversation with Jim Dine," *op. cit.*, Museum of Fine Arts, Boston.

# BIOGRAPHY

Jim Dine was born June 16, 1935, in Cincinnati, Ohio. As a child he attended art lessons at the Cincinnati Art Museum. After the death of his mother in 1947 he went to live with his maternal grandparents. During high school he enrolled in evening classes at the Cincinnati Art Academy. From 1953 to 1957 Dine studied at the University of Cincinnati, the Boston Museum School, and Ohio University in Athens, Ohio, from which he was graduated in June 1957 with the B.F.A. degree. In the same year he married Nancy Minto. They have three sons. Dine continued at Ohio University for a year of graduate study with Frederick Leach, but having made frequent visits to New York through the mid-1950s, he moved there in 1958.

In New York Dine was one of the founders of the Judson Gallery, where *The Smiling Workman*, his first Happening, was presented in 1959. Though Dine was closely associated with Allan Kaprow and the circle of artists who created many of the early Happenings, he turned away from performance to concentrate on painting. His first one-man exhibition was at the Reuben Gallery in 1960.

Showing in New York at the Martha Jackson and Sidney Janis galleries and in Paris at the Galerie Ileana Sonnabend, Dine worked on a series of themes during the early 1960s that would continue to occupy him throughout his career: tools, items of personal apparel, household objects, and studio materials such as palettes and brushes. By the mid-1960s the Robe and Heart motifs had been added to his repertoire, and he had created cast aluminum sculpture. During this period Dine was also a guest lecturer at Yale University, artist-in-residence at Oberlin College, and visiting critic at Cornell University.

In 1967 Dine and his family moved to London. There he wrote poetry, concentrated on printmaking, and collaborated with friends such as Lee Friedlander and Ron Padgett. His designs for sets and costumes for a production of *A Midsummer Night's Dream* were published by The Museum of Modern Art in 1968. Always a prolific and innovative printmaker, Dine has worked with Petersburg Press, London and New York; Pace Editions, New York; Universal Limited Art Editions, Long Island, New York; Pyramid Arts Limited, Tampa; Atelier Crommelynck, Paris; and the Arion Press, San Francisco. In the 1970s he was visiting artist at the Graphicstudio, University of South Florida; a visiting printmaker at Dartmouth College; and artist-in-residence at Williams College.

The Whitney Museum of American Art, New York, held a major retrospective of Dine's work in 1970, and in 1971 the family left London for Putney, Vermont, where, in a new studio and environment, Dine began drawing from the figure. In 1976 he joined The Pace Gallery, New York. Major exhibitions of *Robe* paintings, still life paintings, and large figure drawings were held there. In 1980 Jim Dine was elected a member of the American Academy and Institute of Arts and Letters.

In the early 1980s Dine began to use the Tree and Gate motifs, combining them in multi-panel works. He also executed large, mural-sized works in Los Angeles and Copenhagen. During this same period Dine has focused much of his energy on sculpture, casting monumental works in bronze in London, Walla Walla, Washington, and Los Angeles. In 1984 an exhibition of new sculpture and related drawings was held at The Pace Gallery, and a major traveling retrospective was organized by the Walker Art Center, Minneapolis.

# BIBLIOGRAPHY

*Catalogues*

Amsterdam, Stedelijk Museum. *Jim Dine; Tekeningen* ("Dine Drawings" by Alan R. Solomon), 1966.

Berlin, Galerie Mikro. *Jim Dine; Complete Graphics* (essays by John Russell, Tony Towle, and Wieland Schmied), 1970.

Bern, Kunsthalle. *Jim Dine* (introduction by Carlo Huber; essay by Christopher Finch; statement by Jim Dine), 1971.

Bordeaux, Centre d'Arts Plastiques Contemporains de Bordeaux. *Jim Dine* (statement by Jim Dine), 1975.

Chicago, Richard Gray Gallery. *Jim Dine, An Exhibition of Recent Figure Drawings, 1978–1980* (text by David Shapiro), 1981.

———, Richard Gray Gallery. *Jim Dine, New Paintings and Figure Drawings* (statement by Jim Dine), 1983.

Cincinnati, Cincinnati Art Museum. *Dine Kitaj* (essays by R. J. Boyle, Jim Dine, and R. B. Kitaj), 1973.

Ferrara, Galleria Civica d'Arte Moderna. *Jim Dine* (text by Paola Serra Zanetti), 1977.

Geneva, Galerie Gerald Cramer. *Jim Dine: Estampes originales, Livres illustrés, Divers*, 1972.

Hannover, Kestner-Gesellschaft. *Jim Dine*, 1970.

La Jolla, La Jolla Museum of Contemporary Art. *Jim Dine: The Summers Collection* (introduction by Jay Belloli), 1974.

London, Gimpel Fils Gallery. *Jim Dine: Seven New Paintings*, 1973.

———, Robert Fraser Gallery. *Jim Dine* (text by Cyril Barrett), 1966.

———, Waddington and Tooth Galleries II. *Jim Dine Works on Paper 1975–1976* (text by R. B. Kitaj), 1977.

———, Waddington Galleries. *Jim Dine*, 1982.

———, Waddington Graphics. *Jim Dine* (statement by Jim Dine), 1982.

Long Beach, University Art Museum. *Centric 8 Jim Dine: Apocalypse, The Revelation of Saint John the Divine* (brochure, text by Constance W. Glenn), 1983.

Los Angeles, Los Angeles County Museum of Art. *Jim Dine in Los Angeles* (brochure, text by Maurice Tuchman), 1983.

Munich, Kunstverein. *Jim Dine*, 1969.

New York, The Jewish Museum. *XXXII Esposizione Biennale Internazionale d'Arte Venezia 1964* ("United States of America: Four Germinal Painters, Four Younger Artists" by Alan R. Solomon), 1964.

———, Martha Jackson Gallery. *New Forms–New Media I* (essays by Lawrence Alloway and Allan Kaprow), 1960.

———, The Museum of Modern Art. *Drawing Now* (text by Bernice Rose), 1976.

———, The Museum of Modern Art. *jim dine designs for A MIDSUMMER NIGHT'S DREAM* (introduction by Virginia Allen), 1968.

————, The Museum of Modern Art. *Jim Dine's Etchings* (text by Riva Castleman), 1978.

————, The Pace Gallery. *Jim Dine: Sculpture and Drawings* ("Methods and Metaphors: The Sculpture of Jim Dine" by Michael E. Shapiro), 1984.

————, The Pace Gallery. *Jim Dine: Recent Work* (statement by Jim Dine), 1981.

————, The Pace Gallery. *Jim Dine* (essay by James R. Mellow), 1980.

————, The Pace Gallery. *Jim Dine: New Paintings*, 1978.

————, The Pace Gallery. *Jim Dine: Paintings, Drawings, Etchings 1976*, 1977.

————, Sidney Janis Gallery. *Jim Dine*, 1964.

————, Sidney Janis Gallery. *Jim Dine* ("Someone Says: IT REALLY LOOKS LIKE IT" by Oyvind Fahlstrom), 1963.

————, Sidney Janis Gallery. *New Paintings, Sculpture and Drawings by Jim Dine*, 1966.

————, Sonnabend Gallery. *Jim Dine* (text by John Russell), 1970.

————, Whitney Museum of American Art. *Jim Dine* (essay by John Gordon), 1970.

Nuremberg, Kunsthalle Nürnberg am Marientor. *Jim Dine*, 1969.

Paris, Galerie Claude Bernard (also Lausanne, Galerie Alice Pauli). *Oeuvres sur papier 1978–1979* (statement by Jim Dine), 1979.

————, Galerie Ileana Sonnabend. *Jim Dine* (texts by Alain Jouffroy, Gillo Dorfles, Lawrence Alloway, and Nicolas Calas), 1963.

Rotterdam, Museum Boymans-van Beuningen. *Jim Dine; Schilderijen, Aquarellen, Objecten en het Complete Grafische Oeuvre* (text by Christopher Finch), 1971.

Stockholm, Moderna Museet. *Amerikansk pop-konst* (introduction by K. G. Hultén, essays by Alan R. Solomon, et. al.), 1964.

Toronto, Art Gallery of Ontario. *Dine Oldenburg Segal: painting/sculpture* (preface by Brydon Smith and essay "Jim Dine: hot artist in a cool time" by Alan R. Solomon), 1967.

*Books*

Alloway, Lawrence. *American Pop Art*. New York, Collier Books (in association with the Whitney Museum of American Art), 1974.

————. *Topics in American Art Since 1945*. New York, W. W. Norton, 1975.

Ashton, Dore. *American Art Since 1945*. New York, Oxford University Press, 1982.

Beal, Graham. *Jim Dine: Five Themes* (introduction by Martin Friedman; statements by Jim Dine; essays by Robert Creeley). New York, Abbeville Press (in association with the Walker Art Center), 1984.

Boatto, Alberto. *Pop Art in U.S.A.* Milan, Lerici Editori, 1967.

Calas, Nicolas, and Calas, Elena. *Icons and Images of the Sixties*. New York, E. P. Dutton, 1971.

Codognato, Attilio (ed.). *Pop Art: evoluzione di una generazione*. Milano, Electa Editrice, 1980.

Glenn, Constance W. *Jim Dine Figure Drawings 1975–1979*. New York, Harper & Row, 1979.

Hunter, Sam, and Jacobus, John. *American Art of the 20th Century*. New York, Harry N. Abrams, 1973.

Kaprow, Allan. *Assemblage, Environments & Happenings*. New York, Harry N. Abrams, 1966.

Krens, Thomas (ed.). *Jim Dine Prints: 1970–1977* (essays by Thomas Krens and Riva Castleman). New York, Harper & Row, 1977.

Lippard, Lucy R. *Pop Art*. New York, Frederick A. Praeger, 1966.

Russell, John, and Gablik, Suzi. *Pop Art Redefined*. London, Thames & Hudson, 1969.

Shapiro, David. *Jim Dine: Painting What One Is*. New York, Harry N. Abrams, 1981.

Solomon, Alan R. *New York: The New Art Scene* (with photographs by Ugo Mulas). New York, Holt, Rinehart, Winston, 1967.

*Articles and Interviews*

Ackley, Clifford S. "Face in a Frame," *ARTnews*, September 1982, pp. 63–64.

Alloway, Lawrence. "Apropos of Jim Dine," *Oberlin College, Allen Memorial Art Museum Bulletin*, Vol. 23 (Fall 1965), pp. 21–24.

Ashbery, John. "New Dine in Old Bottles," *New York Magazine*, Vol. 11 (May 22, 1978), pp. 107–9.

Barrett, Cyril. "Jim Dine's London," *Studio International*, Vol. 172 (September 1966), pp. 122–23.

Calas, Nicolas. "Jim Dine: Tools and Myth," *Metro 7* (1962), pp. 76–77.

Coleman, Victor. "look at my product: notes more or less specific on Jim Dine," *Artscanada*, Vol. 27 (December 1970/January 1971), pp. 50–51.

Dienst, Rolf-Gunter. "Die Ironisierung des Gegenstandes Zu Den Arbeiten von Jim Dine," *Kunstwerk*, Vol. 21, October 1967, pp. 11–22.

Dine, Jim. "Lithographs and Original Prints: Two Artists Discuss their Recent Works," *Studio International*, June 1968, Supplement, p. 337.

Fraser, Robert. "Dining with Jim," *Art and Artists*, Vol. 1 (September 1966), pp. 48–53.

Glenn, Constance W. "Artist's Dialogue: A Conversation with Jim Dine," *Architectural Digest*, November 1982, pp. 74, 78, 82.

Goldman, Judith. "Jim Dine's Robes: The Apparel of Concealment," *Arts Magazine*, Vol. 51 (March 1977), pp. 128–29.

Gruen, John. "All Right, Jim Dine, Talk!" *World Journal Tribune Sunday Magazine*, November 20, 1966, p. 34.

————. "Jim Dine and the life of objects," *ARTnews*, Vol. 76 (September 1977), pp. 38–42.

Hennessy, Susie. "A Conversation with Jim Dine," *Art Journal*, Spring 1980, pp. 168–175.

Hughes, Robert. "Self-Portraits in Empty Robes: Show at Manhattan's Pace Gallery," *Time*, Vol. 109 (February 14, 1977), p. 65.

Johnson, Ellen H. "Jim Dine and Jasper Johns," *Art and Literature*, Autumn 1965, pp. 128–40.

Jouffroy, Alain. "Jim Dine, au télescope/through the telescope," *Metro 7* (1962), pp. 72–75.

Koch, Kenneth, and Dine, Jim. "Test in Art," *ARTnews*, October 1966, pp. 54–57.

Kozloff, Max. "The Honest Elusiveness of James Dine," *Artforum*, Vol. 3 (December 1964), pp. 36–40.

Kramer, Hilton. " 'The Best Paintings Jim Dine Has Yet Produced,' " *The New York Times*, January 9, 1977, Section D.

Lechaux, Jöel. "Jim Dine—Galerie Maeght," *Artistes Magazine*, No. 16 (Summer 1983), p. 143.

Lipke, William C. "Perspectives of American Sculpture: 'Nancy and I at Ithaca'—Jim Dine's Cornell Project," *Studio International*, October 1967, pp. 142–145.

Loring, John. "Hairy, Alive, Purple, Sexy, Rich," *Arts Magazine*, Vol. 48 (January 1974), pp. 52–53.

"Métamorphoses L'École de New York Un film de Jean Antoine," *Quadrum* 18, 1965, pp. 161–164.

Robinson, Frank, and Shapiro, Michael. "Jim Dine at 40," *The Print Collector's Newsletter*, Vol. 7 (September/October 1976), pp. 101–5.

Shapiro, David. "Jim Dine's Life-in-Progress," *ARTnews*, Vol. 69 (March 1970), pp. 42–46.

Smith, Brydon. "Jim Dine—Magic and Reality," *Canadian Art*, Vol. 23 (January 1966), pp. 30–34.

Solomon, Alan R. "Jim Dine and the Psychology of the New Art," *Art International*, Vol. 8 (October 1964), pp. 52–56.

Swenson, Gene R. "The New American 'Sign Painters,' " *ARTnews*, Vol. 61 (September 1962), pp. 44–47, 60–62.

————. "What is Pop Art?" Part I, *ARTnews*, Vol. 62 (November 1963), pp. 24–25, 61–62.

Tomkins, Calvin. "Profiles," *The New Yorker*, June 7, 1976, pp. 42–76.

Towle, Tony. "Notes on Jim Dine's Lithographs," *Studio International* (April 1970), pp. 165–168.

Willard, Charlotte. "Drawing Today," *Art in America*, Vol. 52 (October 1964), pp. 49–67.

Zack, David. "A Black Comedy . . . The San Francisco Actors' Workshop invites Jim Dine to design sets and costumes for 'A Midsummer Night's Dream,' " *Artforum*, Vol. 4 (May 1966), pp. 32–34.

*Artist Books and Texts Created or Illustrated by Jim Dine*

1967

*Nancy and I at Ithaca.* Ithaca, New York, Andrew Dickson White Museum of Art, Cornell University. Design and collage by Jim Dine, notes by William C. Lipke, photographs by William C. Lipke and John White.

1968

*The Poet Assassinated* by Guillaume Apollinaire, translated by Ron Padgett, illustrated by Jim Dine. New York and San Francisco, Holt, Rinehart and Winston.

*the big green day.* London, Trigram Press. Poems by Tom Raworth, drawings by Jim Dine. An edition of 100, each copy signed and numbered by the artist and the poet.

*The Picture of Dorian Gray.* London, Petersburg Press. A working script for the stage from Oscar Wilde's novel with original images and notes on the text by Jim Dine. The book was published in three editions: A, an edition of 200, with six additional signed, loose lithographs, is bound in red velvet; B, an edition of 200, with four additional signed, loose etchings, is bound in green velvet; and C, an edition of 100, with six additional signed, loose lithographs and four additional signed, loose etchings, is bound in red leather.

### 1969

*Welcome Home Lovebirds.* London, Trigram Press. Poetry and drawings by Jim Dine.

*Photographs & Etchings* by Lee Friedlander and Jim Dine. London, Petersburg Press. An edition of 75 with fifteen artist's proofs, sixteen loose images of photographs and etchings on paper; each image is numbered and signed by the artists.

*Work From the Same House.* London, Trigram Press. A paperback edition of *Photographs & Etchings.*

### 1970

*The Adventures of Mr and Mrs Jim and Ron* by Ron Padgett and Jim Dine. London, Cape Goliard Press.

### 1977

*Mabel.* Paris, Atelier Aldo Crommelynck. Prose piece by Robert Creeley and twelve etchings by Jim Dine. An edition of 60 with ten artist's proofs, each set of prints encased in a cloth-covered box.

### 1982

*The Apocalypse: The Revelation of Saint John the Divine* (the last book of the New Testament, from the King James Version, 1611). San Francisco, Arion Press. With twenty-nine prints from woodblocks cut by Jim Dine.

### 1983

*Nancy Outside in July: Etchings by Jim Dine.* West Islip, New York, Universal Limited Art Editions. Statements by Jim Dine, Nancy Dine, and Aldo Crommelynck; essay, "Nancy Outside in July: A Portrait in Time," by Clifford Ackley.

### 1984

*The Temple of Flora.* San Francisco, Arion Press. With twenty-eight copper engravings by Jim Dine. Introductory notes by Jim Dine and Nancy Dine. A text leaf precedes each plate with botanical notes and a literary reference. Boxed and bound with sculptured relief in bronze by the artist on the lid.

# INDEX OF DRAWINGS

# PHOTOGRAPH CREDITS

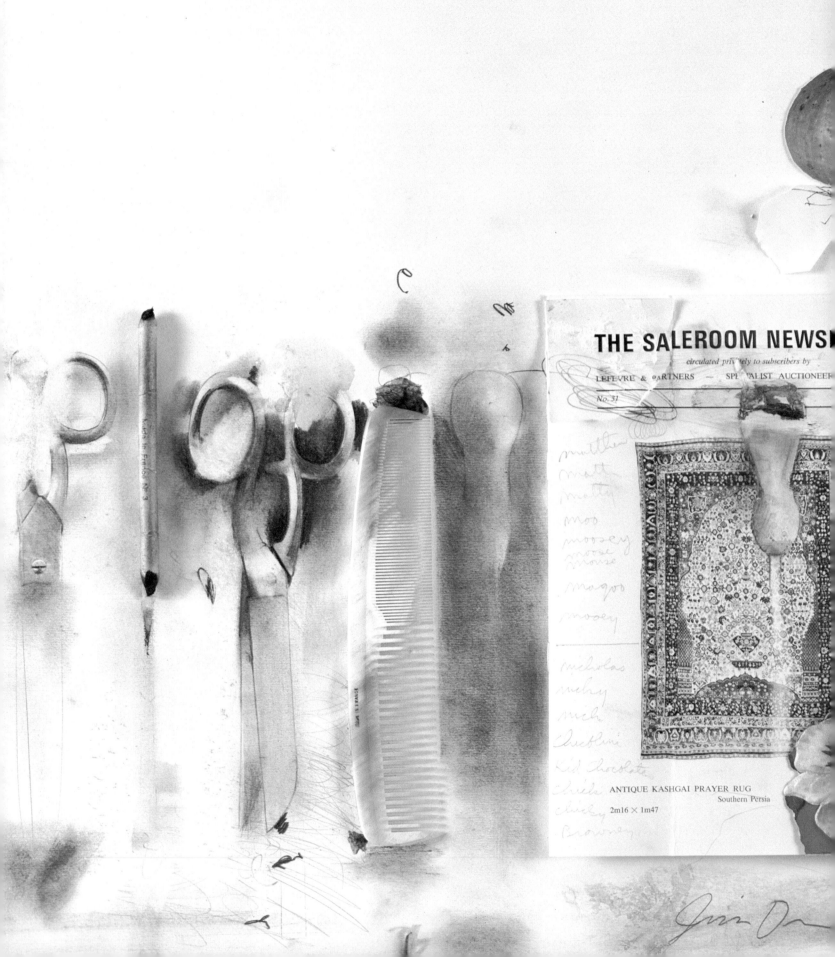

THE SALEROOM NEWS

circulated privately to subscribers by

LEFEVRE & PARTNERS — SPECIALIST AUCTIONEER

No. 31

matthew
matty
matty
moo
moosey
mouse
mouse
magoo
mooey

nicholas
nicky
nick
nicolini
kid chocolate
nicola
nicky
Browney

ANTIQUE KASHGAI PRAYER RUG
Southern Persia
2m16 × 1m47